A Soldiers' Portfolio

# THIS IS OUR WAR

▷ Servicemen's Photographs of Life in Iraq

**Devin Friedman & the Editors of GQ // Foreword by General Wesley Clark**

ARTISAN ❙ NEW YORK

Copyright© 2006 by The Condé Nast Publications, Inc.
Foreword copyright© 2006 by Wesley Clark

Published by Artisan
A Division of Workman Publishing, Inc.
708 Broadway
New York, NY 10003-9555
www.artisanbooks.com

Library of Congress Cataloging-in-Publication Data is on file.

10 9 8 7 6 5 4 3 2 1
Printed in Singapore

RIGHT

**08.2003//STAFF SERGEANT ALVIN BENJAMIN, U.S. ARMY//Samarra East Airfield**
"I slept in the gun," the photographer says, referring to the howitzer he commanded in
Iraq for nearly a year. "I wanted to be near the radio, because if a mission comes down,
I'm responsible." His cannoneer, on the other hand (at left), slept alfresco, under camouflage
netting. Here Staff Sergeant Benjamin takes a self-portrait to show his wife that "she's a much
more attractive person to be sleeping near."

PREVIOUS PAGES

**03.25.2003//SPECIALIST ADAM NUELKEN, U.S. ARMY//Northwest of An Najaf**
A massive three-day sandstorm with sixty-mile-per-hour winds and raining mud engulfs
the photographer's unit as it pushes toward Baghdad during the first week of the war.
"I never imagined the earth could be that color," he says.

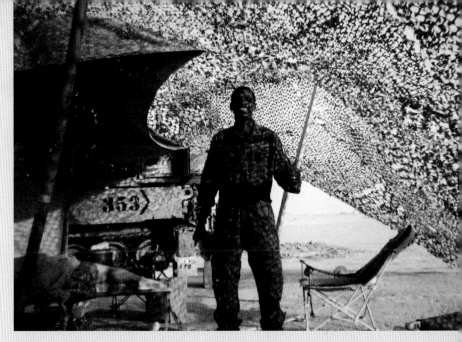

# CONTENTS

**SOLDIERS' STORIES**
Five servicemen, five experiences of the war.

⇨THIS IS

# OUR WAR

# Foreword by
# GENERAL WESLEY CLARK

Look at their faces. At their eyes. In them we see the intensity of battle, the pain of separation, the exhilaration of success, the pride of comradeship. It's all reflected in these photos. This is their book.

These are the men and women who patrol, fly, and sail to serve our country, and who, when called upon, fight for it. They are young. And they bring to their mission all the vitality of their youth. In these pages we find the energy, diversity, dedication, and courage of America. There are heroes here: those who braved the enemy's fire to strike back, those who risked their lives to aid a wounded buddy, those who held their cool to move through an ambush. They are the reservoir of our strength.

Not one of these men or women came to this place of battle seeking selfish gain. Not one. They expected no booty, no spoils of war. They are here because they answered the call of duty, because they have volunteered for service. And for many, they are volunteers more than once over: first, to enlist; then to gain skills; and sometimes to undertake assignments of extraordinary hazard. They are here because they have looked deep inside their own character to will themselves to serve, to risk, and to sacrifice. Theirs is a daring that is noble, not because of what they gain but because of what they give. Many of the men and women are married. Almost all left loved ones behind. They have one another, of course, but they also have their own loneliness, uncertainty, boredom, and fear.

They have aimed, shot, radioed, signaled, carried, and loaded. They have planned, organized, drilled, rehearsed, and trained. They have led, and they have followed in support. It is dangerous and difficult work, performed many times in extraordinarily uncomfortable circumstances. But they've also laughed and cried, hugged and argued, endured and tried simply to live their lives, day after day.

The purpose—well, that's "above our pay grade," as they might say; their orders come down the chain of command. But these are men and women who believe in one another. They're serving because the people of America asked them to. And for most, that's really purpose enough. There's a solid nobility in these faces, in their posture, indeed in their lives. It's not a matter of where they came from

**01.20.2005//PETTY OFFICER FIRST CLASS BRIEN AHO, U.S. NAVY**
**Norfolk International Airport, Virginia**
As the photographer prepared to board his plane to Iraq for his second deployment, he took a picture of his unit partner, Photographer's Mate First Class Steven Harbour, with his wife and sons. "I had my pregnant wife by my side, and I was telling her I was sorry for leaving her at that time," Aho remembers. "She told me to hurry back—and that if the baby came early and I missed the event, she would kill me."

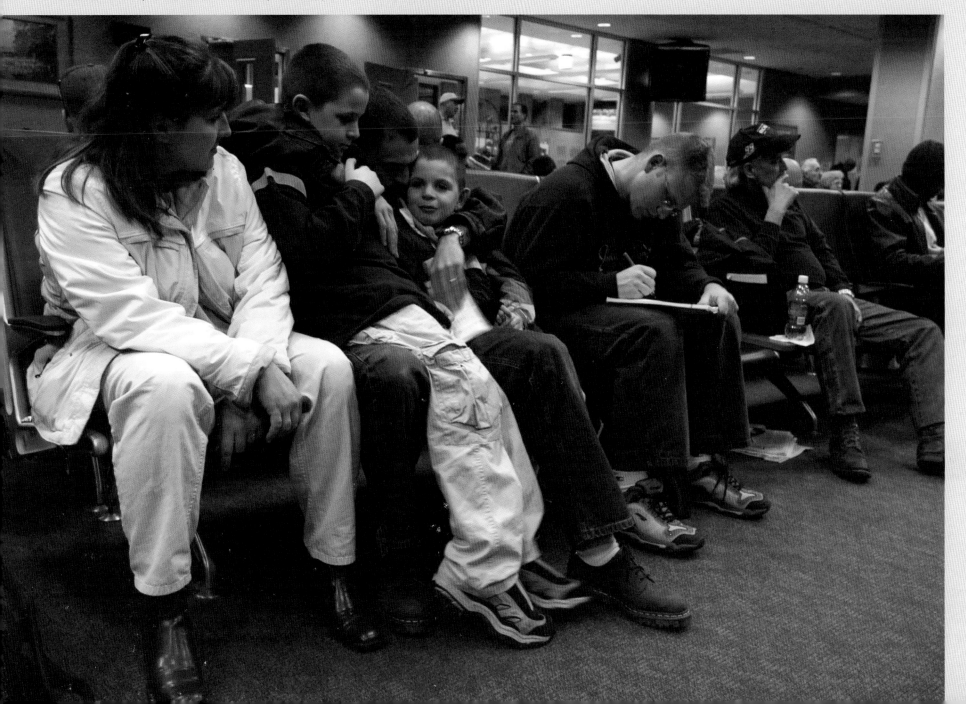

or who their ancestors may have been. Rather, it's about their commitment and their selflessness. These photos memorialize that.

The truth is, the America that sent them knows precious little of who they are, how they feel, or what they do. And that's one of the reasons this gallery is important: so that we who haven't been there can try to comprehend. For the war can't be found in Pentagon statistics, or clips on the nightly news, or even the quick flashes we see, rarely, of the most horrid tragedy.

No, the war is in these faces—and in the posture, the uniforms, the stark contrasts of order and disorder, light and darkness, joy and fear that endure on these pages. These are images that will etch themselves into your soul. You'll ask, Who could have raised such men and women? Whose values could they have taken? What nation could muster forth such a group of heroes, so selfless, so noble in motive, so accomplished in skill, so human in response?

The answers are found in the images. They are us—our children, husbands, wives, brothers, sisters, and neighbors. And perhaps there is no better reflection of a nation than those who choose to serve. This book is for them—and for all of us.

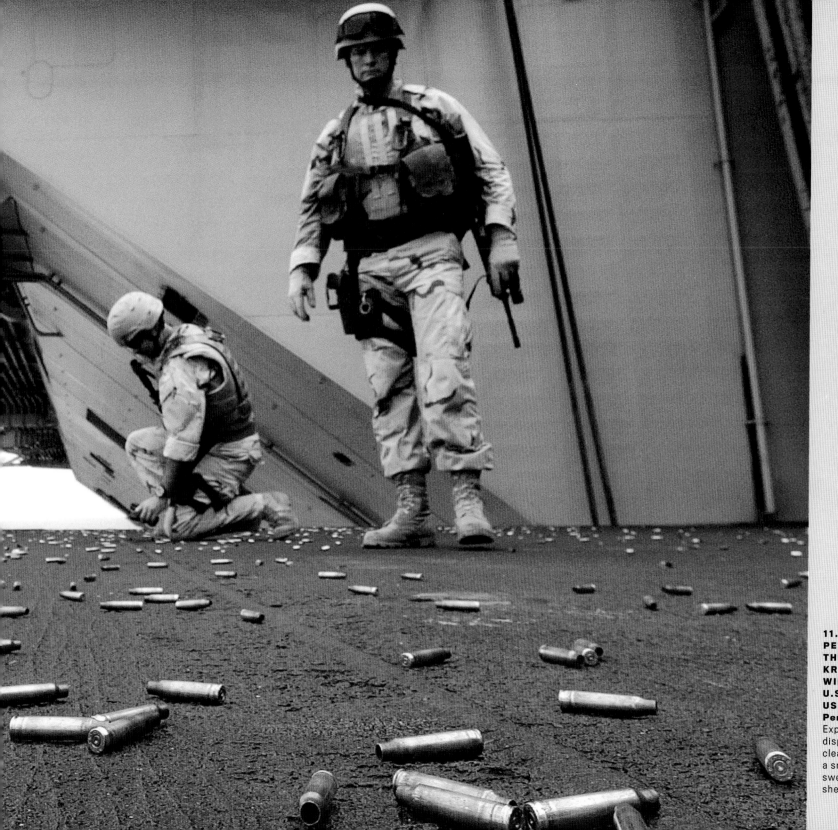

**11.16.2004**
**PETTY OFFICER**
**THIRD CLASS**
**KRISTOPHER**
**WILSON,**
**U.S. NAVY**
**USS *Harry S. Truman*,**
**Persian Gulf**
Explosive-ordnance-
disposal personnel
clean up the deck after
a small-arms exercise,
sweeping the used
shells into the water.

# Introduction by
# DEVIN FRIEDMAN

The idea for this book came from a sense of failure. That sense of journalistic failure any writer who's telling the truth will admit to experiencing whenever he or she is charged with telling readers how it really feels to be someone else. In this case, I was in Iraq, unable to fully explain what it's like to be one of the hundreds of thousands of American men and women who are serving there.

It was about three o'clock in the morning in the heart of Baghdad, at an American base that had formerly been a swanky club used by officers in Saddam Hussein's army. I was sitting around with a half-dozen soldiers eating semi-lethal cinnamon buns, drinking Tang, and discussing the bylaws of a role-playing game that a lot of the enlisted men were obsessed with. This was two years ago, and I was about three weeks into an assignment for *GQ* magazine. I'd been sent to take the temperature of the occupation (or whatever it is called) and to tell *GQ* readers what it felt like (as you may have guessed) to be a regular soldier fighting, and not fighting, in Iraq. And in service of the latter, I'd gotten myself embedded with a National Guard unit out of Florida. That night I'd been sleeping on the floor with a bunch of guys from another unit who'd just convoyed in. I was lying there listening to someone snore, pulverized mirrors littering the floor around me (the place must have looked like a disco in its functional days), and pleased that I'd be able at least to write about what it felt like to sleep on the floor in the ruins of a former Republican Guard playpen, when I heard a heated discussion break out in the mess area. Six soldiers, ages 18 to 23, were under the fluorescent lights, slaphappy about something. I went to join them. Suffice it to say they were pretty heavy into the Mountain Dew.

These were kind of the misfits of the company: skinny guys, fat guys, one guy who was way too smart—the type of kids you'd expect to be talking about role-playing games in the middle of the night. The intricacies of the game were center stage; I was clearly out of my depth, though I pretended not to be so that I wouldn't seem even more like an outsider than I already did. There was gunfire in the distance, tinny little pops from AK-47's, which seemed noteworthy to me but didn't register on any of

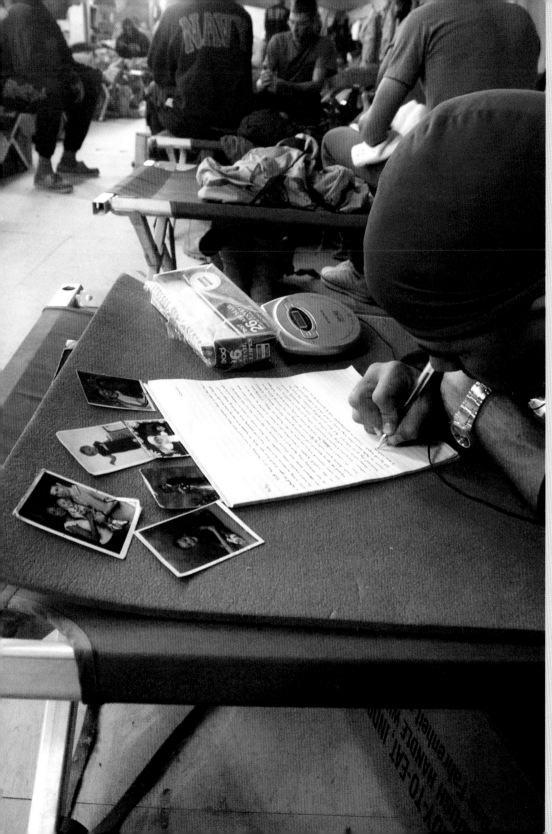

**02.11.2003**
**PETTY OFFICER FIRST CLASS**
**BRIEN AHO,**
**U.S. NAVY**
**Kuwait**
Before combat begins,
one Seabee takes a
moment to write a letter
home in his newly
erected sixty-man field tent.

⇩

# THIS IS OUR FIRST DIGITAL WAR, AND EVERY SOLDIER BECAME A PHOTOGRAPHER.

their faces. Occasionally men in what's called "full battle rattle" (flak jackets, Kevlar helmets, etc.) would pass through the mess, either coming from or going on the patrols that pulsed out from the base at regular intervals 24-7. One little guy, a sergeant of Puerto Rican extraction, jogged past us with regularity; he'd calculated that it took about twenty loops around the tiny base to make a mile. "That guy," said one of the men I was with, "has totally lost his marbles. All he does is run, run, run. All hours, day and night."

I wasn't the first reporter these guys had met. Maybe half a dozen or so had come through, writers from *The Nation* and *The Houston Chronicle* and some other places I can't remember. The last one had written something that pissed off a commander, so journalists were no longer allowed in the barracks where the soldiers lived (though I was able to get up there a couple of times).

One of the guys in the mess hall, a hyperverbal 19-year-old who'd been an engineering student when he got called up, started doing bits from *Dr. Strangelove*. The metalhead with the mustache busted up, though he probably didn't realize the material wasn't original. Another soldier, with red hair, pale complexion, and thick eyeglasses (he

introduced himself as Skeeter), was practically jumping out of his skin trying to get someone to listen to him. Sugar, caffeine, sleep deprivation—it's as close to drunk as you can get when you're on an army base in the middle of Baghdad.

The guy I talked to most was a quiet young man named Pete. He'd been kind of troubled before joining the army, which isn't unusual: in and out of group homes; fought all the time with his stepfather, who sounded like a pretty terrible guy. They got in a fight one night, things got physical, and that was the last time Pete had been home, which was fine with him except that he missed his little sister very much. Today, in fact, was her birthday.

"You want to see a picture of her?" he asked.

He took a little plastic thing from a lanyard around his neck and plugged it into my computer. It was a flash drive, and it contained maybe a hundred pictures—some that he'd taken, some that had been taken by other guys from the company, and some that people had sent from home. There were photographs of the guys from his unit as they moved up through the desert in the opening days of the war. There were pictures of every man his unit had killed: a picture of a body slumped in

the front seat of a sedan with a grapefruit-sized hole where his face should be; a picture of a young Iraqi in Nike sweats, his head in a pool of deep red blood reflecting splinters of desert sunlight. Then Pete pulled up a picture of his sister, who held a sign that said PETER PETER PUMKIN EATER, GET YOUR ASS HOME AND DON'T BRING SKEETER!

"She took that today," he said. "She'd heard that there'd been a roadside bomb in our neighborhood, and she was worried about me. So I sent her a picture of me and Skeeter, proving we were safe and sound, and this is what she sent back."

At that moment, it dawned on me that if something truly remarkable (or not remarkable at all) happened to a guy on patrol in Baghdad, he could share it with his family the very same day. Operation Iraqi Freedom is different from every war that's come before; you could say that about any conflict and it would be true. But specifically, I thought sitting there looking at Pete's pictures: This is our first digital war. Not because of the laser-guided smart bombs and distance-reading nightscopes. We've seen that before, in the first Gulf War. It's that, at least in this country, technology has become almost completely democratized. Digital equipment is now cheap enough that it's

a part of daily life for most people. Every soldier marching toward Baghdad seemed to have a digital camera. And once the supply lines were set up, the soldiers who hadn't brought their laptops started getting them through the military mail service. Every other guy I saw here at the formerly swanky officer's club had a flash drive around his neck. *GQ* had sent me to Baghdad so that people back home could understand the war, feel what it was like to be there and to live it. That was the point of the military's supposedly grand experiment with embedding journalists. But in the end, a journalist is still a journalist. He's still on the outside. Here in Baghdad, I didn't speak their language, didn't know their role-playing games, wasn't part of their world. I couldn't even spend time in the barracks without giving the public-affairs officer the slip. But I could look at the pictures they'd taken of their lives when I wasn't there.

Sitting in this mess hall eating shitty cardboard cinnamon buns with lonely, geeky, barely postpubescent, kind of frighteningly smart army grunts, I had two thoughts. One: the familiar panic at realizing that the rabbit hole goes way deeper than you thought, that the lives of the people you're trying to write about are more vast,

# THESE PICTURES REVEAL NOT ONLY WHAT THEY SAW BUT WHAT THEY WERE CURIOUS ABOUT. WHAT FELT REMARKABLE.

rich, mysterious, and moving than suspected, that you've barely scratched the surface. Thought two: Just imagine the untapped resources, the files and files of beautiful, honest, intimate, hilarious, harrowing pictures that exist on the hard drives and Memory Sticks of a nation of soldiers, a collective memory of the war in Iraq probably far superior to whatever's on the photo servers at *The New York Times* or *Newsweek*. Superior not in terms of technical skill and artistic composition (though often that, too) but in terms of capturing that brittle, fleeting sense of *what it's like,* that shy animal that tends to make itself scarce around journalists except in brief interludes. The pictures taken at Abu Ghraib by soldiers, when the media weren't around, have already changed the course of the war and the way we understand it. While media outlets around the world were spending millions of dollars to ship scruffy men in safari

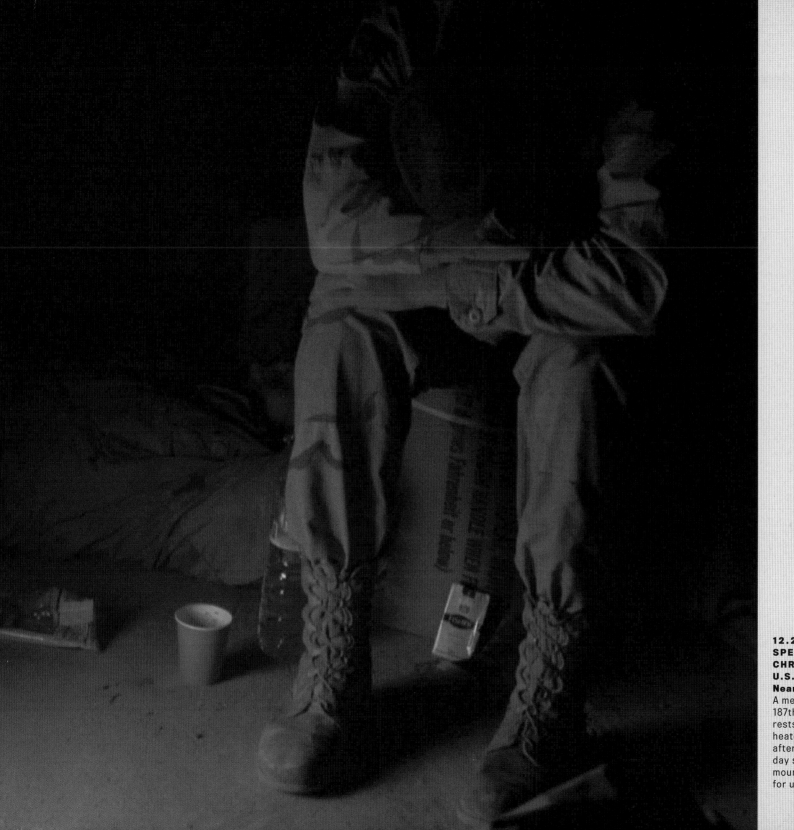

12.24.2003
**SPECIALIST
CHRIS JONES,
U.S. ARMY
Near Mosul**
A member of the
187th Infantry Regiment
rests by an electric
heater on Christmas Eve
after spending another
day sweeping the
mountains above Mosul
for unexploded bombs.

vests to Iraq with thousand-dollar cameras, more than 140,000 American servicemen were compiling the most extensive documentation of a war that's ever existed.

Normally, I would have thought *I bet there are tons of amazing photographs out there,* and that would have been the end of it. But I work for a magazine with great resources and a very motivated, smart, and able staff. One morning, after I'd returned, I went into the office of Fred Woodward, the brilliant, energetic, legendary, and long-suffering (you should see him around the time we have to ship the issue to the printer) art director of the magazine. I told him about the vast, unseen trove of Iraq war photography, and he got the concept immediately, adopted the project, and injected it with a sense of energy and practicality (if it weren't for Fred, it'd still be a kind of "wouldn't it be cool if" idea instead of the book you're holding in your hands). Then we took it to Jim Nelson. The brilliant, visionary and extraordinarily creative and risk-taking editor-in-chief of *GQ*. He, too: He got it, adopted, injected, and set us forth. At which point we obtained the services of Greg Pond, a photo editor and creative director, who brought the project

one layer further into practicality; he started getting pictures in—using word of mouth, posting messages on veterans' Web sites, talking to writers at the *Army Times*—and leveling his critical gaze upon them. Kyla Jones, in the *GQ* research department, then began the process of interviewing the soldiers about their pictures, organizing the information-gathering effort. And Mary Gail Pezzimenti, our managing editor, kicked everyone's ass and made the project a reality. We began to receive a deluge of pictures. In 2005, *GQ* published a photo essay featuring our initial crop of submissions. Over the next six months, we received more than 10,000 photographs. And from those thousands, 256 were selected to become *This Is Our War.*

The photographs, of course, and the men and women who took them, eclipsed any creative or journalistic efforts anyone at *GQ* had made. Witness the eyes of the girl sitting in a truck in full battle rattle—who couldn't be more than 18—in a picture Sergeant Tori L. Porter sent in; or Specialist Eric Bigham wielding his M16 in front of a homemade sign that read HOTEL BAQUBAH; or the self-portrait Staff Sergeant Alvin Benjamin took as he rode with his howitzer unit; or Captain

John Wayne Paul, who caught his fellow soldiers midair, leaping into one of Saddam's pools on a hot day. The pictures became personal; instead of the head shots of the fallen shown on television, we were sent a photograph of Lance Corporal Taylor B. Prazynski, who was killed in an explosion in Al Karmah. It may be the most affecting picture in the book, because you see a glimpse of what he must have looked like to his mother or brother, a guy any of us could have known. These men and women who submitted their photographs hadn't taken them for money or to further their careers. Their purpose was to record what they'd experienced, to make it seem real to their families and friends, and to make it seem real to themselves. They were out in the world and saw something beautiful, horrific, ugly, remarkable; and for the simple reason that there was no one else around to do it, they felt it incumbent upon themselves to record it. They may not have set out to make art, but art is what they made.

Even if, there in the mess hall, I'd experienced a moment exactly as a soldier would have, or if I'd been let in on an authentic moment of soldierdom while on patrol with a sergeant from South Padre Island, I could never be totally sure of it. I'd always wonder if things would have been different had I not been around. And if this book does one thing, hopefully it removes that layer of doubt, of intention, of artificiality. These pictures reveal not only what the servicemen and women saw but the way they saw things. What they were curious about. What they felt proud of. What felt remarkable to them, what felt funny. You don't need a journalist to tell you that when Captain Larry E. LaRoe caught First Sergeant Terry Cox sleeping on the hood of a Humvee, he saw instantly the absurdity of war, but also just wanted to make fun of his friend who was sleeping on a car. The basic rule of good writing, as any student learns in his first writing class, is: Show, don't tell. And herein lies the power of these photographs, as it became clear to us at the magazine with each JPEG file that appeared in our email inboxes. They showed us their war.

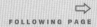

FOLLOWING PAGE

**03.07.2003//PETTY OFFICER FIRST CLASS TOM SPERDUTO, U.S. COAST GUARD//Persian Gulf, off Iraqi Coast**
Petty Officer Second Class Anthony E. Aston, on port-security duty, awakens in his inflatable home—a Zodiac boat on an Iraqi oil terminal off the coast. "There was a real problem with roaches," the photographer says. "I went to bed inside the terminal, and when I turned out the light, it felt like the room was moving. I turned the light back on, and there were roaches everywhere: in the bed, on the floor, everywhere. I slept outside after that. It was near that oil terminal that one of our Coast Guard men was killed in a suicide attack by a boat."

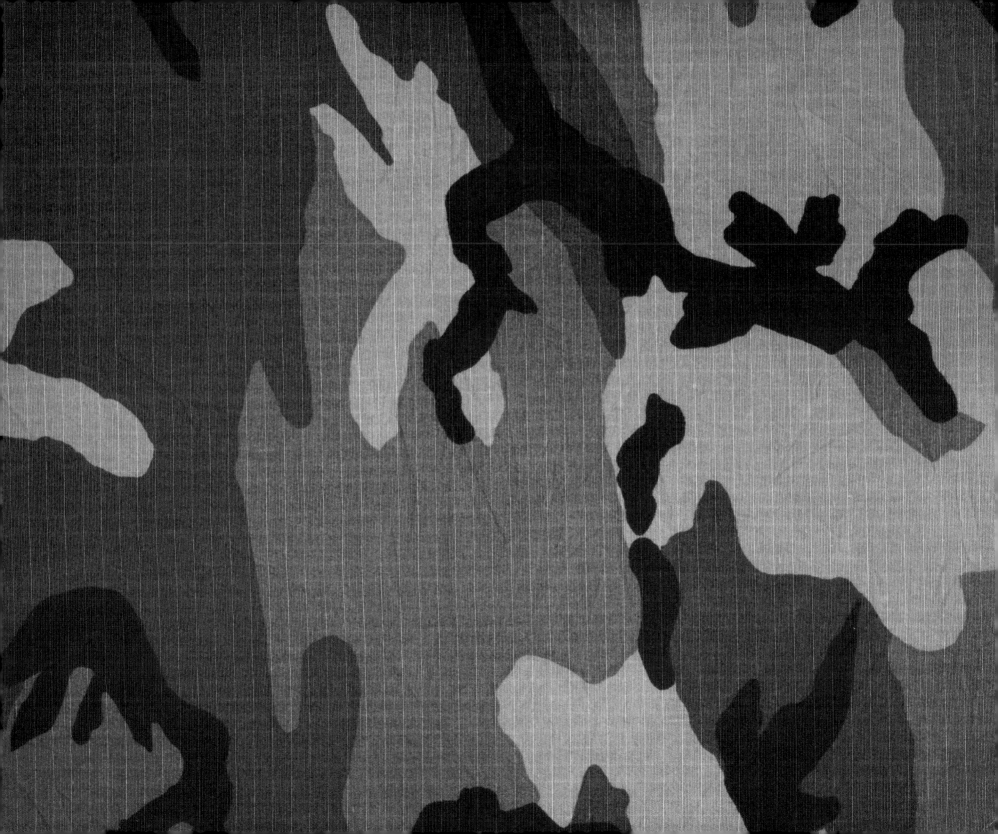

⇩

"EVERYONE CRIED WHEN I LEFT. I HAVE TO ADMIT, THAT WAS THE MOST DIFFICULT BATTLE I EXPERIENCED. IT WASN'T EVEN ON IRAQI SOIL. IT WAS LEAVING THEM."
— STAFF SERGEANT ALVIN BENJAMIN, U.S. ARMY

# 1. MOVING OUT

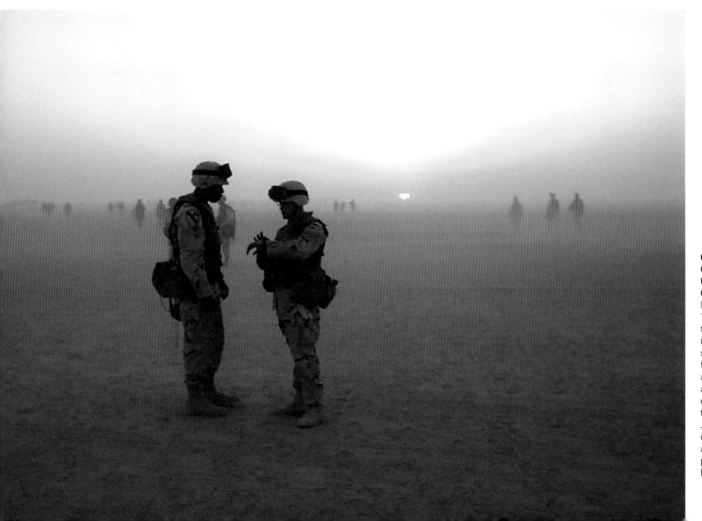

**05.05.2003**
**CAPTAIN CHRISTOPHER L'HEUREUX,**
**U.S. ARMY**
**Camp New Jersey, Kuwait**
Members of the 1st Armored Division make the
1.5-kilometer trek from their sleeping quarters
to their camp's dining area as a sandstorm kicks
up. This camp is a temporary stop: Soldiers will
spend the next ten days here preparing for the
forty-two-hour drive north to Baghdad. Weapons
and tanks must be maintained, incoming troops
and supplies organized, and skills kept sharp
on practice ranges. Foremost on soldiers' minds,
though, was keeping cool. "We came to Camp
Jersey from Germany, where there was still snow
on the ground," says the photographer. "Getting
acclimated to triple-digit temperatures in forty
pounds of body armor was draining. If you didn't
have water on you at all times, you were *wrong*."

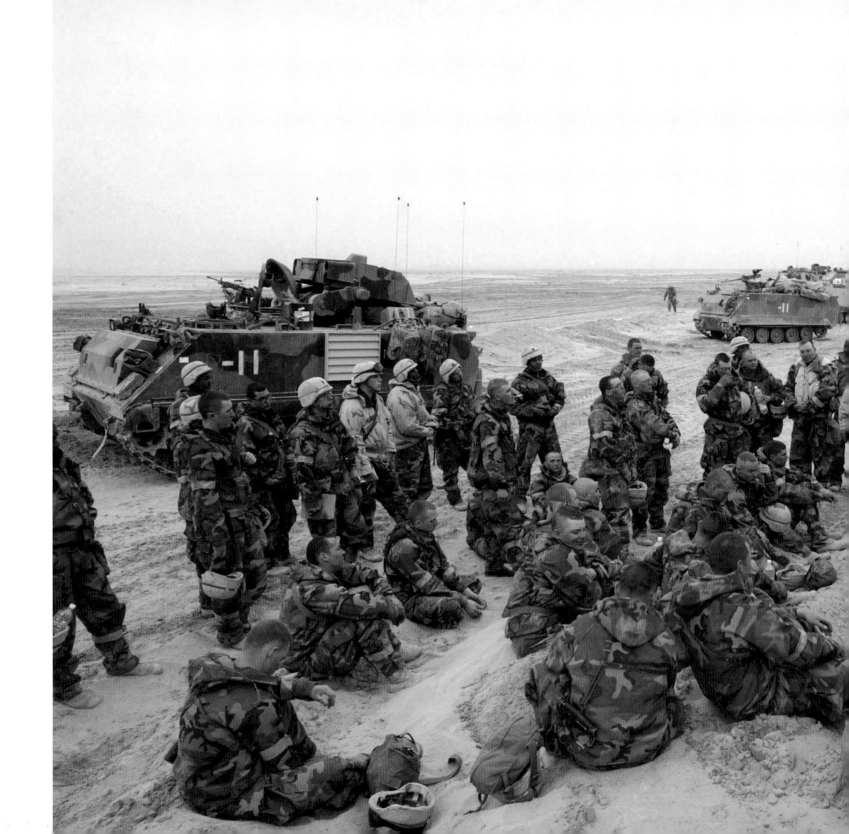

**03.24.2003**
**FIRST LIEUTENANT**
**TRAVIS HOWELL,**
**U.S. ARMY**
**Near An Najaf**
The men of Company A,
2nd Battalion, 70th
Armor Regiment, listen
to their sergeant during
a short tactical stop
en route to Baghdad.

**06.2003**
**SERGEANT**
**TORI L. PORTER,**
**U.S. MARINE CORPS**
**Toledo Air Base,**
**An Nasiriyah**
After helping to secure
An Nasiriyah in the
first days of the war,
members of the 15th
Marine Expeditionary
Unit board a C-130
that will take them to
their temporary
home—the USS *Tarawa*
on the Persian Gulf.
They'd been routed to
Iraq in the buildup
before the war while on
a regular Western Pacific
deployment, says the
photographer, a former
reservist who now plans
humanitarian operations
for the Marines.

**11.2004
STAFF SERGEANT
EDWARD T. STAYSTORK,
U.S. ARMY
Kirkuk**
This was how the photographer saw much of Iraq—through his windshield, while on patrol with the 823rd Security Forces Squadron. It's often calm and quiet like this before an attack. "They'll bury an IED [improvised explosive device] right in the road, in an animal carcass," says Staystork. "Just driving scares the living hell out of you."

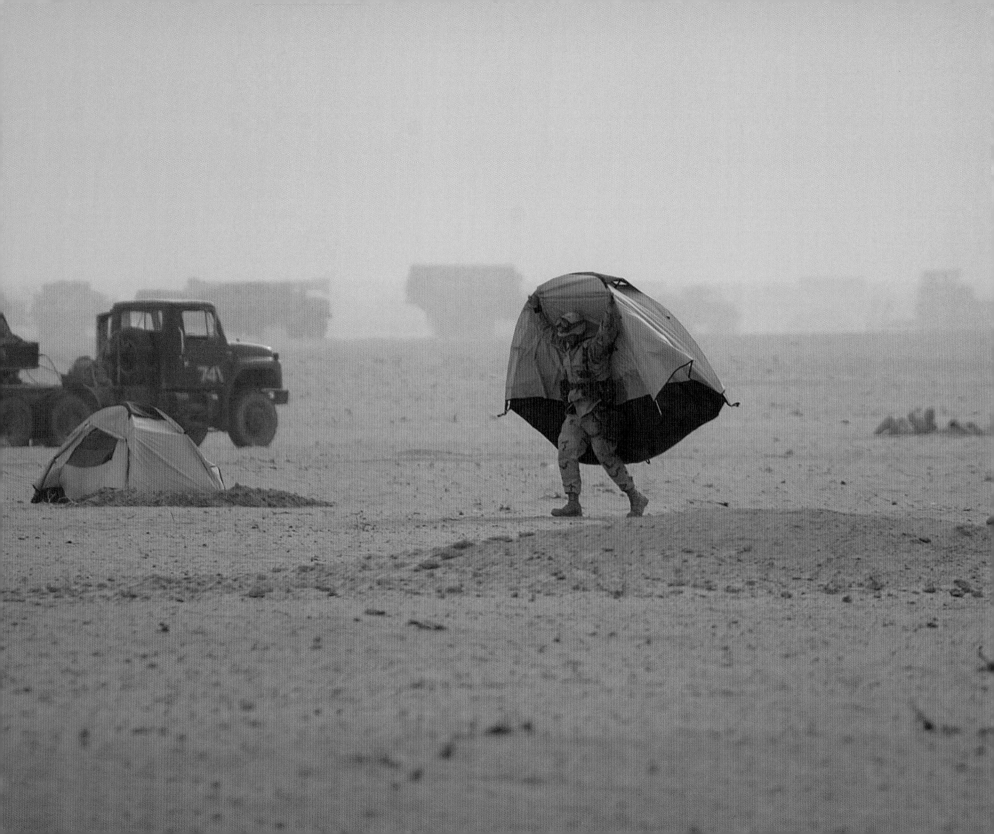

**03.21.2003**
**PETTY OFFICER**
**FIRST CLASS**
**AARON ANSAROV,**
**U.S. NAVY**
**Kuwait, near the**
**Iraqi border**
On the first night of
the invasion, this Seabee's
commander told him to
move his tent. "He just
picked it up and walked
with it, with all his stuff in
there," says Ansarov.
Everyone was keyed
up that night; the
photographer says that
if he'd been asked to
move his tent, he
would have been glad to.
"If you had wanted me
to dig a ten-foot tunnel,
I would have said
all right. At least I'd be
doing something."

**01.2004**
**FIRST LIEUTENANT**
**RYAN KELLY,**
**U.S. ARMY**
**Qayyarah Tar Refinery**
The photographer's
platoon was on its
way to provide
security for their
brigade commander
while he directed
the opening of a local
civic center. "Soon
after this picture was
taken," Kelly says, "we
were ambushed, but no
one was injured."

# "IT STARTS TO HIT YOU: OKAY, THIS IS FOR REAL NOW. I MIGHT ACTUALLY NEED TO START USING THAT WEAPON."

— PETTY OFFICER FIRST CLASS AARON ANSAROV, U.S. NAVY

**03.21.2003//PETTY OFFICER FIRST CLASS AARON ANSAROV, U.S. NAVY//Kuwait, near the Iraqi border**
"That was the night we were going in," the photographer says. "And everybody was trying to get down this one road." While his Seabee unit stayed put, they watched as "convoy after convoy" passed by. He captured their plodding advance in trails of head- and tail-light.

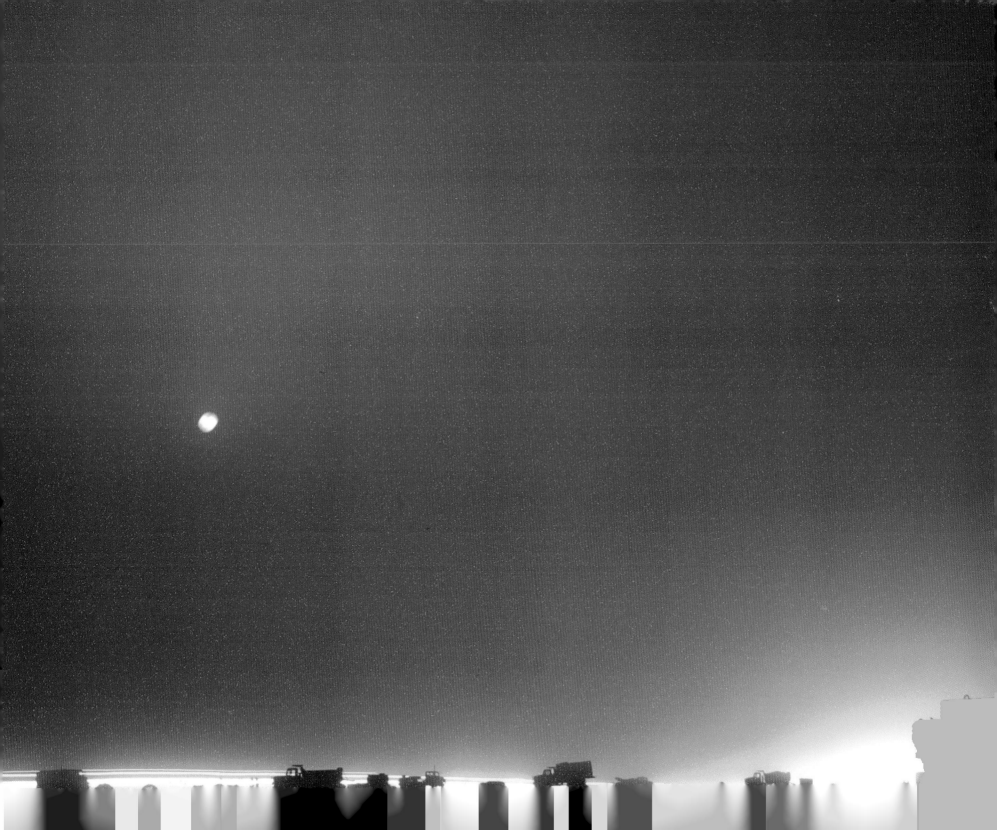

## 11.2003
### STAFF SERGEANT JONATHON BLUE, U.S. ARMY
### En route to Balad

Having completed the first half of his tour, the photographer headed for Balad Air Base to fly out for R&R. On his way, he snapped this photo of one of the army's new Stryker vehicles. "The guys in that unit are pretty much supposed to be the best, and none of us had ever seen these kinds of vehicles before," he says. The Strykers, which are designed to be lighter, faster, and safer than other army vehicles, were first introduced in Iraq in late 2003 as part of the army's goal of transforming itself to face twenty-first-century threats.

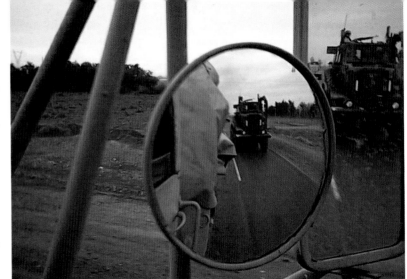

## 04.20.2003
### MAJOR ANDREW DeKEVER, U.S. ARMY
### Iraq-Kuwait border

The photographer's driver put up a picture of her husband in their vehicle. Soon after, DeKever put up a picture of his fiancée, Mary (now his wife). It was Easter Sunday, he says, "and I wanted to feel like she was close to me as we crossed the border."

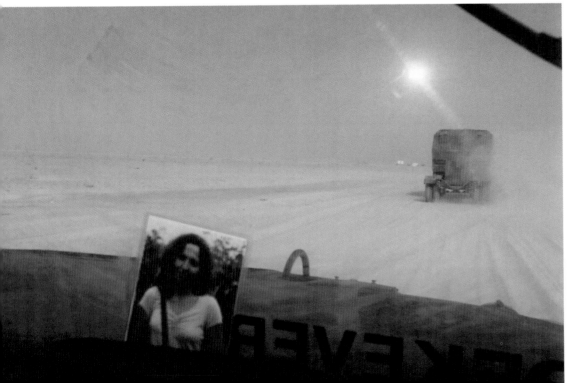

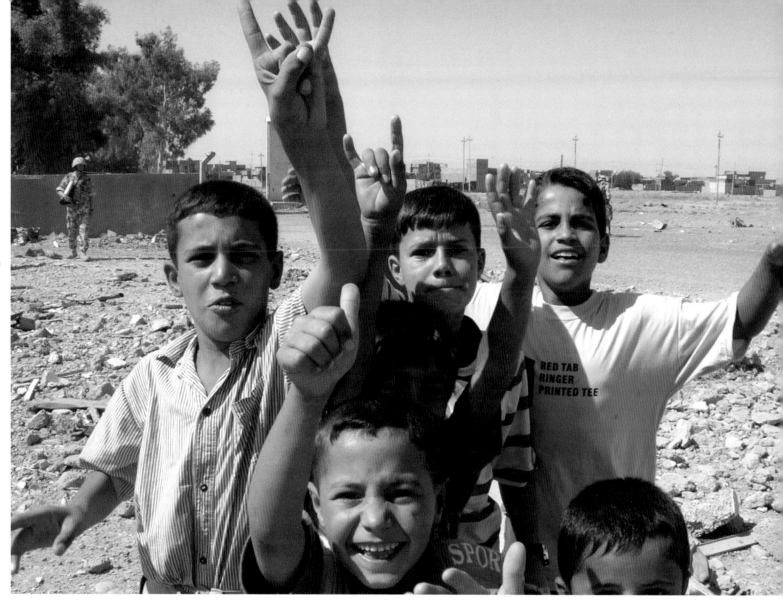

**07.2003
STAFF SERGEANT
MICHAEL TEEGARDIN,
U.S. ARMY
Kirkuk**
While out with his unit,
assessing the accuracy
of the initial air bombing
campaign, Teegardin
took this photo of local
children. "These kids were
amazing," he says. "What
they really loved is having
their picture taken. And
because I had this digital
camera, I could show them.
They would go wild."

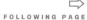
FOLLOWING PAGE

**02.2004//SPECIALIST EDOUARD H. R. GLUCK, U.S. ARMY//Between An Najaf and Basra, southen Iraq**
En route to Kuwait at the end of his deployment, the photographer captured this image of a young Marsh Arab
who had just made a sale of handmade trinkets to U.S. troops; she carries American bills in her hand. "The Marsh Arabs
are Shia," says the photographer, "and they had been persecuted to no end. Saddam drained all of their farmland.
This is one of my favorite pictures of the whole war, because here, on my way home, I got to see the empowerment of
the people we were supposed to be helping all along. This young girl is selling her products in a free market here."

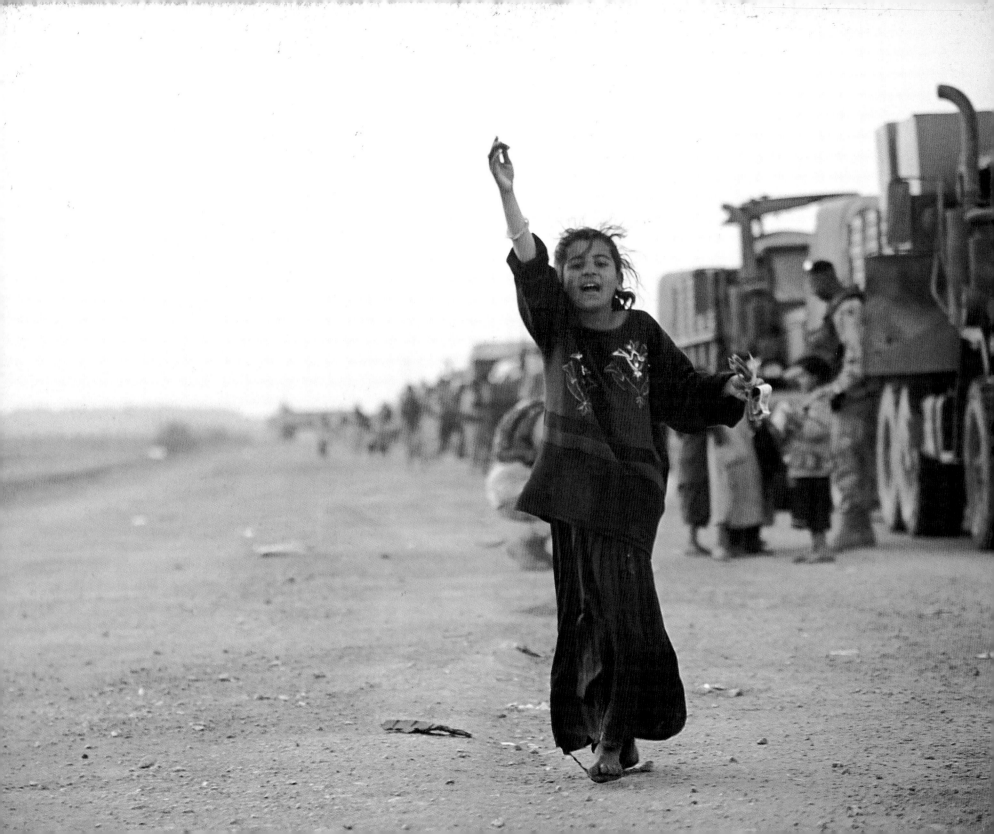

# 2. BAND OF BROTHERS

⇩

"WE WERE FROM ALL DIFFERENT WALKS. WE HAD A
BUNCH OF US CORN-FED BOYS AND A BUNCH OF
CITY GUYS. WE HAD LATINOS AND EVERYTHING ELSE.
WE JUST BONDED AND BECAME A GROUP."
—SPECIALIST COLE AUGUSTINE, U.S. ARMY

**04.22.2003//PHOTOGRAPHER UNKNOWN//Jalibah**
Members of the 7th Engineer Support Battalion pose around an Iraqi rocket launcher that they destroyed
just a week earlier. Sergeant James Kimmerle, who contributed the photo, says, "You can see the spray-painting
on it, where we all put our names. At the time, we thought we were leaving. It was right around the time
Bush said the war was over. We were like,'Yeah, let's go home!' But it was actually a while before we left."

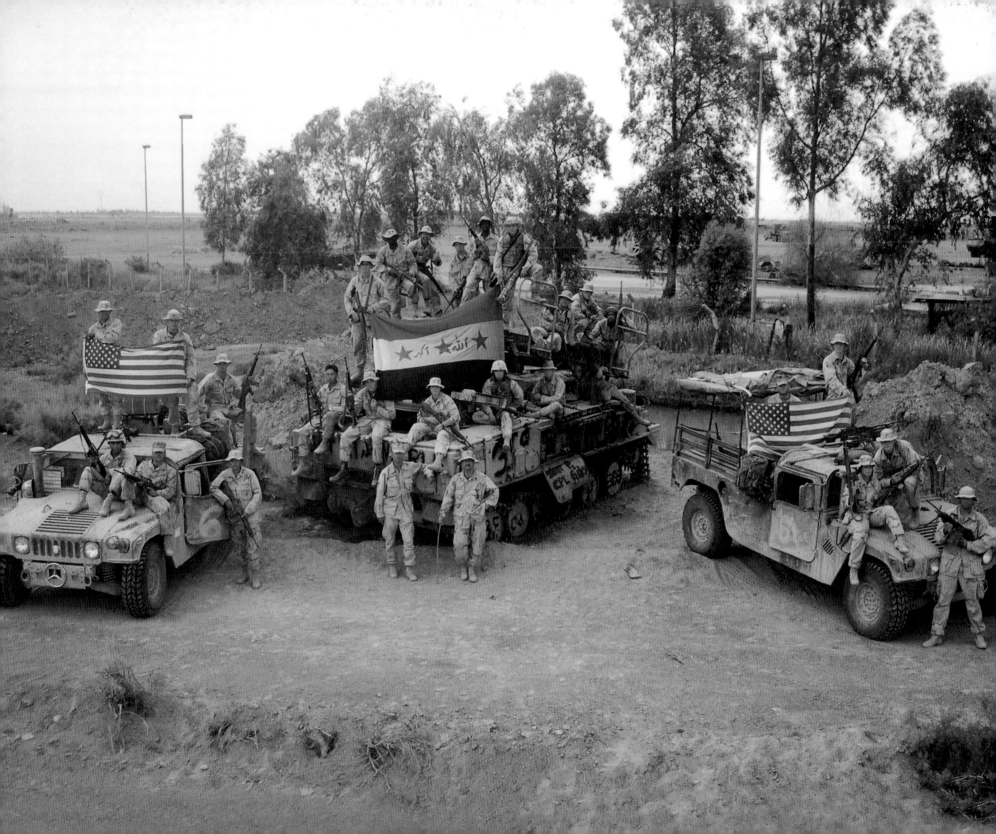

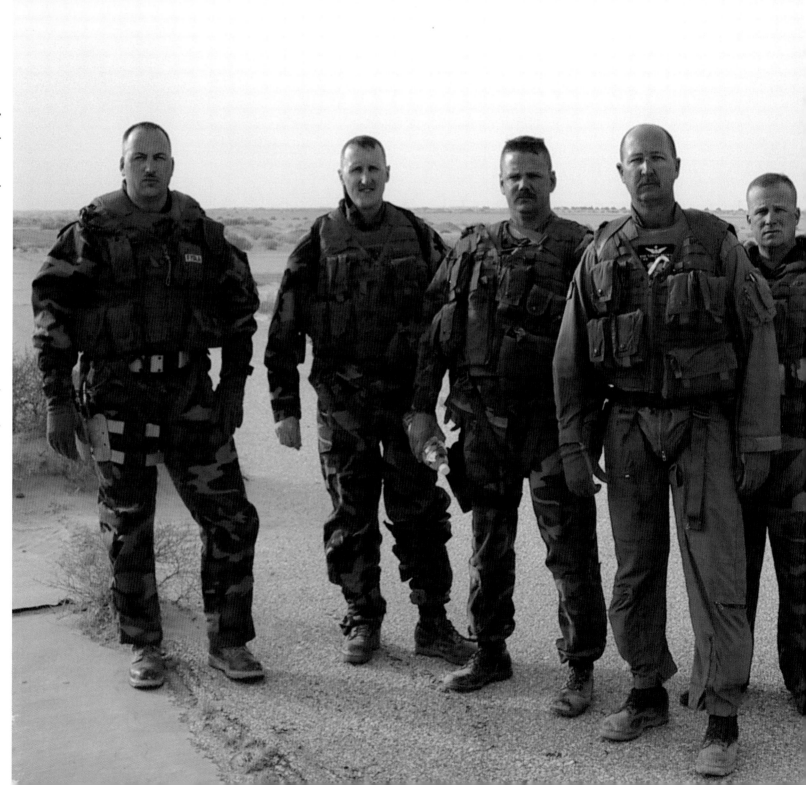

**03.20.2003**
**PHOTOGRAPHER**
**UNKNOWN**
**Tallil Air Base**
Pilots with the 507th Medical Company out of Fort Hood, Texas, at the Tallil airfield in southern Iraq. The 507th was historically one of the busiest medevac teams in the army. With its seventeen Black Hawks, it was responsible for transporting casualties from the battlefield to the nearest combat-support hospital. Working twelve-hour shifts, one team could ferry up to six litter patients or eight ambulatory casualties at a time. The 507th was recently deactivated after seventy-three years of service. Photo submitted by Chief Warrant Officer Brent McKinney.

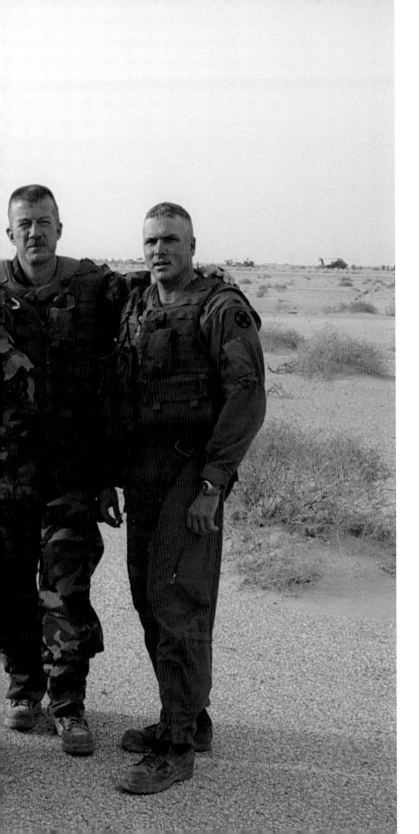

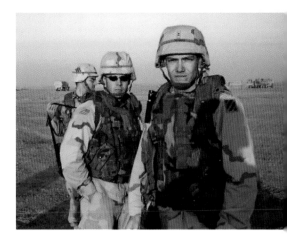

**03.2003**
**SERGEANT FIRST CLASS**
**CHRISTOPHER**
**GRISHAM, U.S. ARMY**
**Northwest Kuwait**
From left, Sergeant
Denis Higginbotham and
Chief Warrant Officers
Steve Walker and Willis
Young gear up for a day
of drills in 100-degree heat
near the Iraqi border. As
interrogators, they are
training up on simple Arabic
phrases and Iraqi customs.
"Getting a feel for the
culture was an important
aspect of our training,"
says the photographer.
"Later, I couldn't figure
out why the Iraqis would
snicker when I introduced
them to Nick, our unit's
interpreter. I later
learned that *nick* is
the Iraqi word for 'fuck.'"

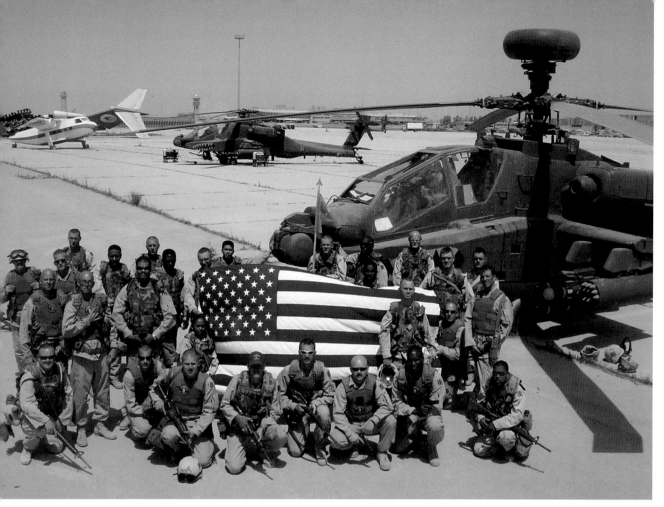

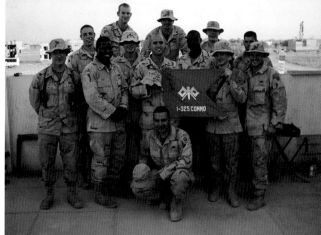

Signal Officers for the 82nd Airborne Division

"Team Sexy" of the 1st Battalion, 25th Aviation Regiment

Pilots and crew chiefs of the 1st Battalion, 3rd Aviation Regiment

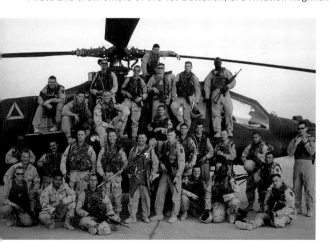

Alpha Company, 1st Infantry Division, 1st Aviation Brigade

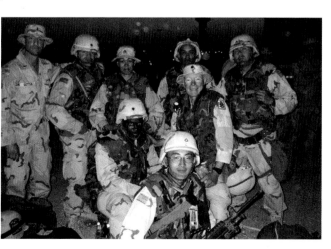

Medics of the 310th Military Police Battalion

3rd Maintenance Support Battalion's "Dragon Squad"

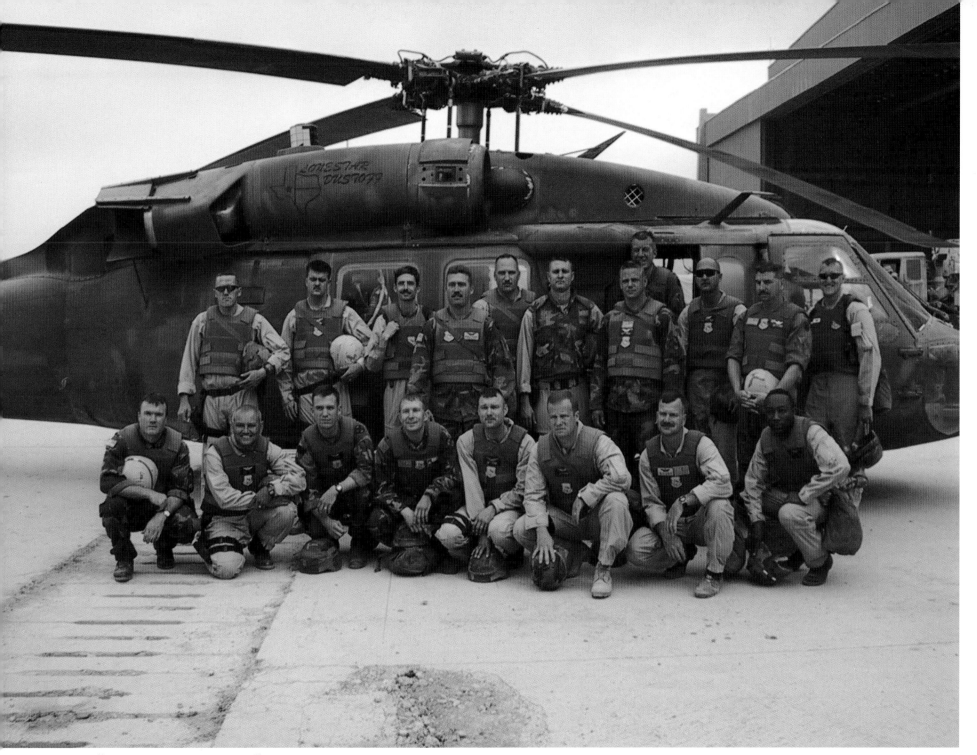

**04.2003**//**PHOTOGRAPHER UNKNOWN**//**Baghdad International Airport**
Pilots with the 507th Air Ambulance Company. The unit ran its operations out of one of two airplane hangars formerly used by Saddam Hussein to store his Boeing 747s. Photo contributed by Brent McKinney.

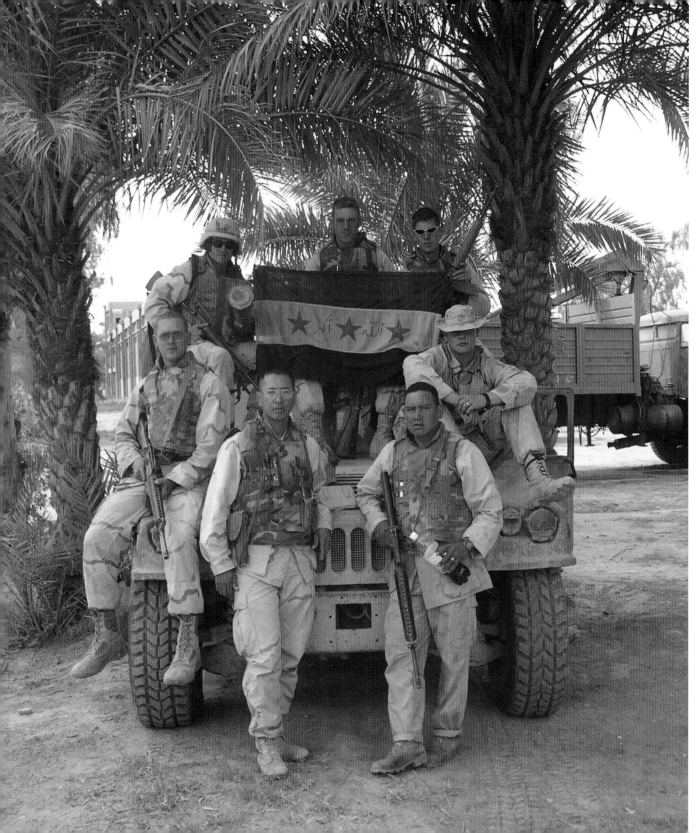

**04.09.2003**
**PHOTOGRAPHER UNKNOWN**
**Baghdad**

Sergeant James Kimmerle (top left) poses with the rest of his team on the banks of the Tigris River. As a refueler, Kimmerle helped build a pipeline from Kuwait to An Nasiriyah to facilitate the American assault. But on this particular day, Kimmerle and his team provided security for a convoy delivering fuel to a water-treatment plant that, once running, could deliver clean drinking water to nearly a third of the city of Baghdad. "It was a humanitarian thing we were trying to do," says Kimmerle. The Iraqi flag in the photo now hangs in his garage, in Watauga, Texas, signed by the members of his platoon.

**03.2003**
**LANCE CORPORAL COLIN SMITH,**
**U.S. MARINE CORPS**
**Camp Coyote, Kuwait**

"There was a lot of boredom while waiting in Kuwait," says the photographer. Still thirty miles from the Iraq border and the war that would follow in a matter of days, Marines liked to exercise—push-ups, sit-ups, the occasional free-weight session—to keep busy. Here, after a workout, Lance Corporal Artist Marshall stands in front of the Humvee he manned as a gunner. "Because of the heat and stress, everyone lost ten to fifteen pounds of water weight," Smith says. "But you did end up looking a lot more cut."

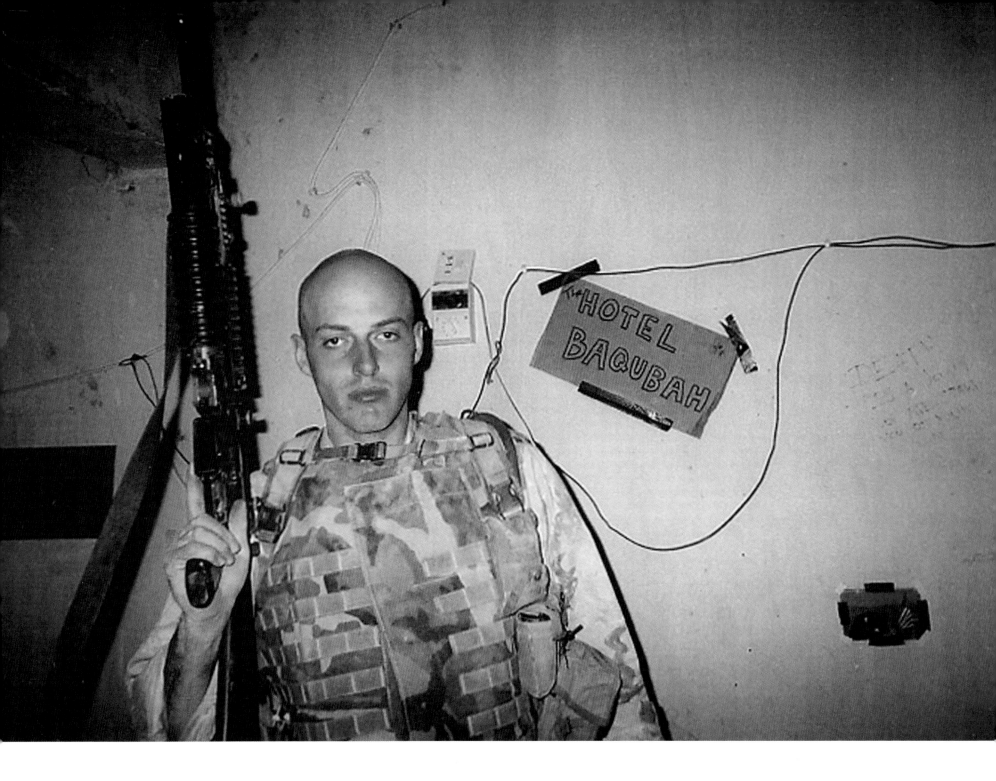

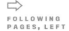

FOLLOWING
PAGES, LEFT

FOLLOWING
PAGES, RIGHT

**04.2003
STAFF SERGEANT
CIRCIAO AYALA,
U.S. MARINE CORPS
An Nasiriyah**
"Staff Sergeant
Ayala took that photo
using my camera,"
says Sergeant Tori
L. Porter. "That girl
was a Marine in my
unit. I'm still not sure
of her name. People
come in and out of your
life in the military."

**03.22.2003
PETTY OFFICER
FIRST CLASS
AARON ANSAROV,
U.S. NAVY
Southern Iraq**
On the third full
day of the war,
Stormi Young and
Joe Elm, friends
from separate
units within Naval
Mobile Construction
Battalion 74, take
a moment to relax.

**07.2003//PHOTOGRAPHER UNKNOWN//Ba'qubah**
Specialist Eric Bigham's mom, Judi, used to pay him twenty-five cents for every sparrow he
shot on their Ohio farm, and from that money, he had to buy his ammo. So it was no surprise when
he was assigned to a two-man sniper team in Iraq, despite never having gone through training.

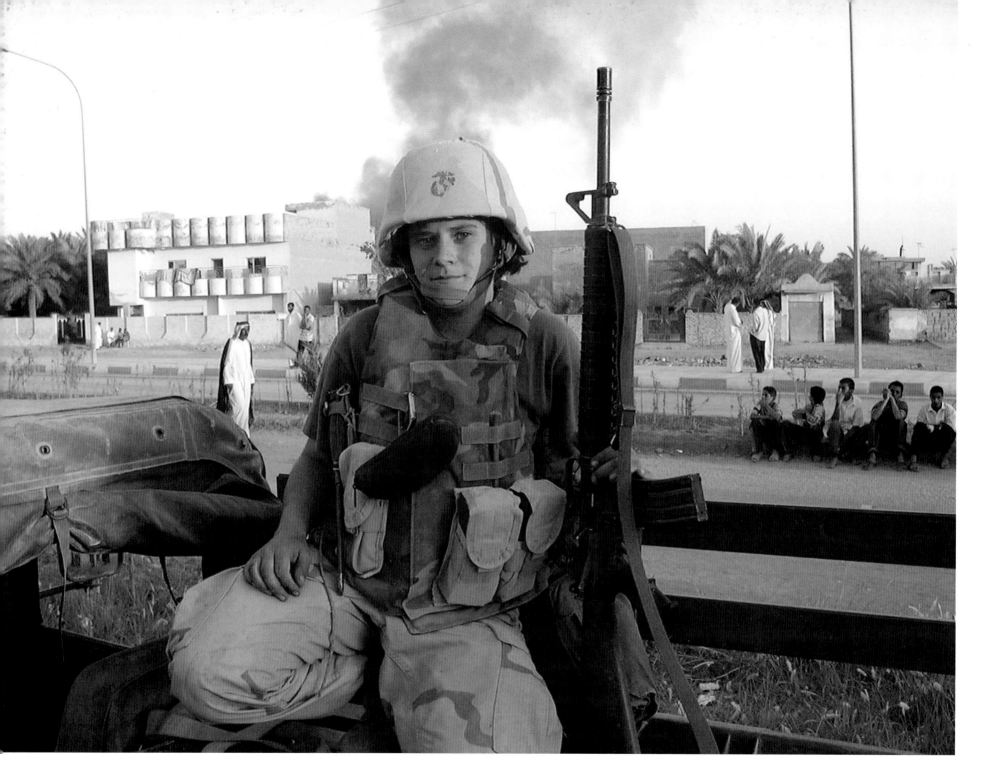

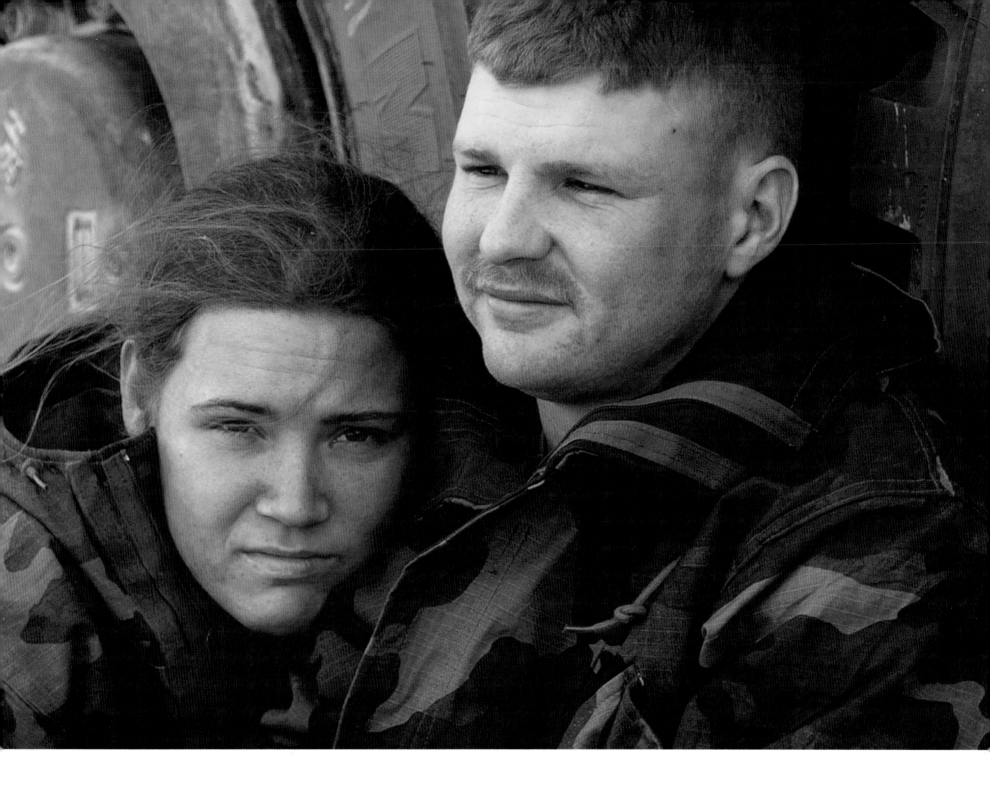

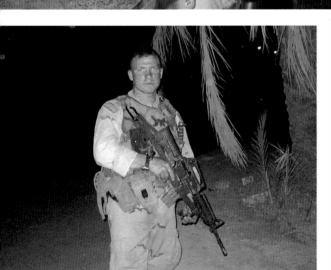

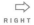
RIGHT

**10.18.2004//AIRMAN FIRST CLASS
CRYSTAL F. JAMES, U.S. AIR FORCE
Baghdad International Airport**
Senior Airman Quentin J. Hightower brandishes
an SA80. He spent the latter half of 2004 near
the airport, processing soldiers for R&R or
emergency leave, or sending them home for good.

CLOCKWISE, FROM LEFT

**07.2004
PHOTOGRAPHER UNKNOWN
Outside An Nasiriyah**

**04.05.2003
PHOTO BY LIEUTENANT
JEFF NELSON,
U.S. ARMY
North of Karbala**

**08.2004
PHOTO BY SERGEANT
JAMES BAUMGARDNER,
U.S. ARMY
Kirkuk**

**12.12.2003
PHOTOGRAPHER UNKNOWN
Baghdad**

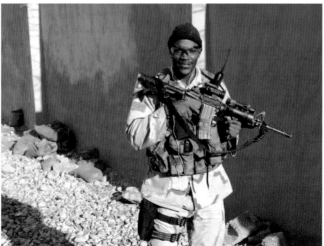

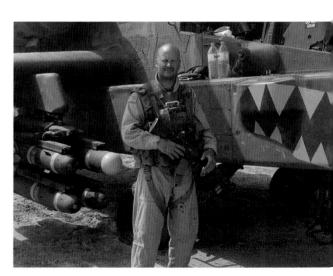

↑

THIS PAGE, FROM LEFT

**12.2004**
**PHOTO BY FIRST LIEUTENANT**
**SETH MOULTON,**
**U.S. MARINE CORPS**
**An Najaf**

**02.11.2003**
**PHOTO BY PETTY OFFICER FIRST CLASS**
**BRIEN AHO,**
**U.S. NAVY**
**Iraq-Kuwait border**

OPPOSITE PAGE, LEFT, FROM TOP

**09.11.2003**
**PHOTOGRAPHER UNKNOWN**
**Al Asad Air Base**

**09.2004**
**PHOTO BY FIRST SERGEANT**
**BOB WEIBLER,**
**U.S. ARMY**
**Camp Cooke, near Taji**

**08.2003**
**PHOTO BY SERGEANT FIRST CLASS**
**CHRISTOPHER GRISHAM,**
**U.S. ARMY**
**Near Fallujah**

OPPOSITE PAGE, UPPER RIGHT

**09.2004**
**PHOTOGRAPHER UNKNOWN**
**Taji**

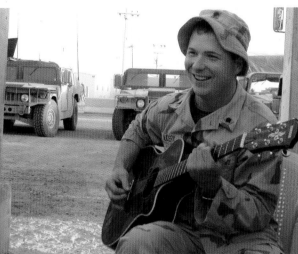

**06.01.2004//CORPORAL SAMUEL VALLIERE, U.S. MARINE CORPS//West of Baghdad**
The photographer, a public-affairs officer in the Marines, poses for a self-portrait on a rooftop at Camp Taqaddum. "It was just a picture to send my wife," he says. "I wanted her to know how I was feeling. I missed her, and it wasn't the easiest time in my life." He hadn't seen his wife, also a Marine, since they'd celebrated their wedding anniversary at Camp Fallujah two months before.

**08.2004**
**LANCE CORPORAL**
**COLIN SMITH,**
**U.S. MARINE CORPS**
**Camp Duke, An Najaf**
Lance Corporal Adam
Schumacher, who
orchestrates landing
support for his Marine
battalion, holds aloft an IV
unit. The photographer,
a gunner, has just
inserted its needle into
Schumacher's arm during
a training exercise run by
navy corpsmen. These
corpsmen were embedded
to teach Marines how to
perform medical
procedures in the event
that professional
medics weren't around.

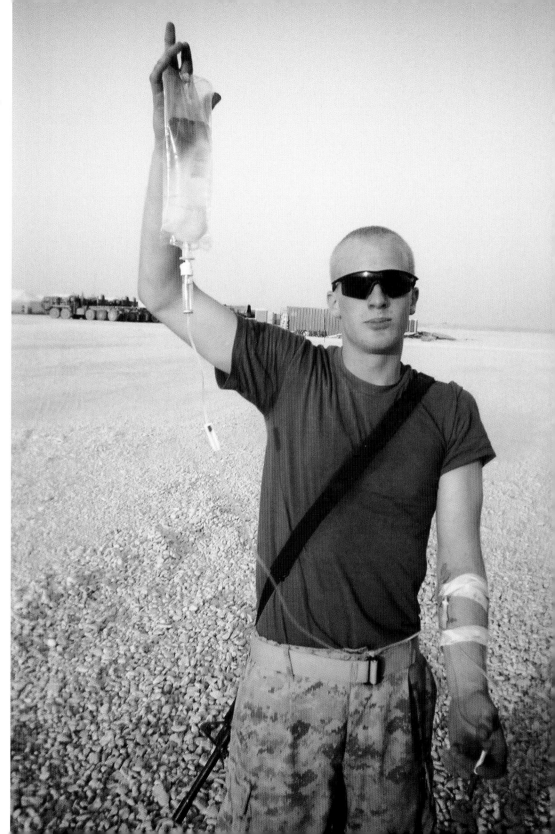

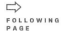
**FOLLOWING
PAGE**

**04.2003**
**PHOTOGRAPHER**
**UNKNOWN**
**Baghdad**
Colonel Curtis Potts,
Commander of the 3rd
Infantry Division's
4th Brigade,
stands in front of
an abandoned Iraqi
tank. Iraqis often
camouflaged their
outdated Soviet-built
T-52 tanks in
vegetation and hid
them in palm trees in
an attempt to level
the playing field
against the more
modern American
M1s. Although Iraqi
forces were quick
to engage American
troops, they were
also quick to abandon
their tanks. "When
one gets blown up
right next to you, you
lose the will to fight
pretty quickly," says
Brent McKinney, who
contributed the photo.

**03.26.2003**
**PHOTOGRAPHER**
**UNKNOWN**
**Southern Iraq**
During the first week
of war, pilots in
Chief Warrant Officer
Michael S. Madura's
unit used Jalibah Air
Base as an operations
center for missions
into An Nasiriyah.
Madura models a broken
pair of U.S. Army
glasses that probably
had been left
during the Persian
Gulf War, when American
troops first captured
the air base. "It's
different now," he
says, "but back in the
early '90s, whenever
you got a prescription
in the army, those are
the glasses they would
give you. We call them
birth-control glasses."

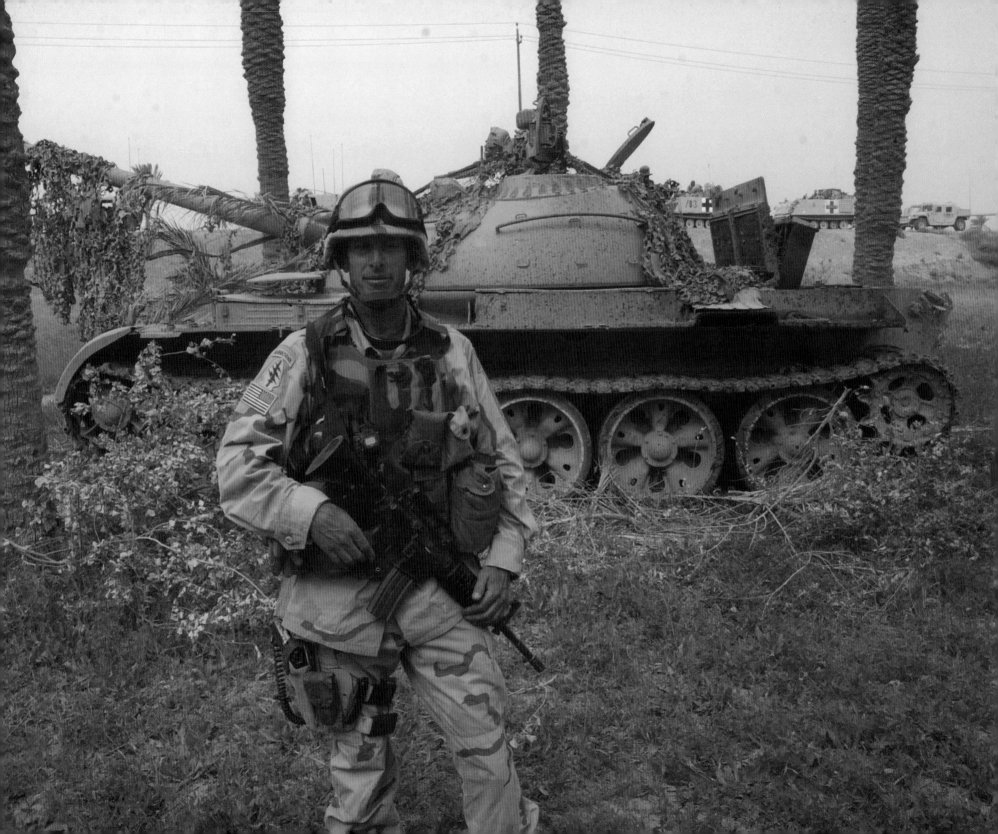

⬇

"IF I SIT DOWN TO THINK ABOUT IT, THE BIGGEST THING IS, I CAN STILL SMELL THAT DAY—THE BURNING FLESH, THE BURNT HAIR, THE EXPLOSIVES IN THE AIR. IT'S NOTHING YOU REALLY EVER GET USED TO."
— STAFF SERGEANT HARRY J. DeLAUTER, U.S. ARMY

# 3. THE BATTLEFIELD

**04.2003**
**SPECIALIST**
**ADAM NUELKEN,**
**U.S. ARMY**
**Baghdad**
After fighting their
way out of an ambush
a few days before,
the 2nd Battalion,
69th Armor Regiment,
took control of an
abandoned airfield in
Baghdad. Amid constant
nearby gunfire, the
photographer climbed
into the control
tower and snapped
this picture of an
Iraqi vehicle burning
in the distance.

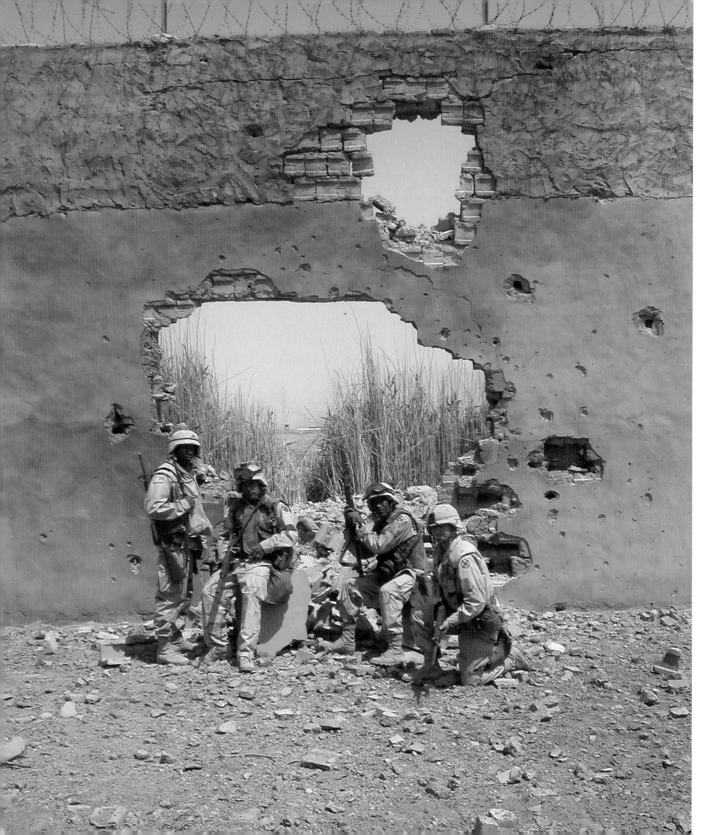

**SUMMER 2003**
**SPECIALIST**
**EDOUARD H. R. GLUCK,**
**U.S. ARMY**
**Ramadi**
A staircase inside
one of Uday Hussein's
palaces is covered
in debris, after having
been hit in the U.S.
air campaign. This
palace was situated
near a tributary of the
Euphrates, and the
compound served
as a game preserve.
"There were thirty- or
forty-pound carp
swimming around in
the water there," says
the photographer.
"The palace has been
bulldozed now.
It was kind of neat,
because the army
used Iraqi contractors
to do the job."

**03.2003**
**PHOTOGRAPHER**
**UNKNOWN**
**Baghdad**
Soldiers from the
13th COSCOM
(a support unit
whose tasks ranged
from providing ground
transportation to
securing food services)
pose next to a blast
hole made by an
M1 tank outside
Baghdad International
Airport. "It used
to be called Saddam
International Airport,
until our tanks came,"
says Brent McKinney,
who contributed
the photo.

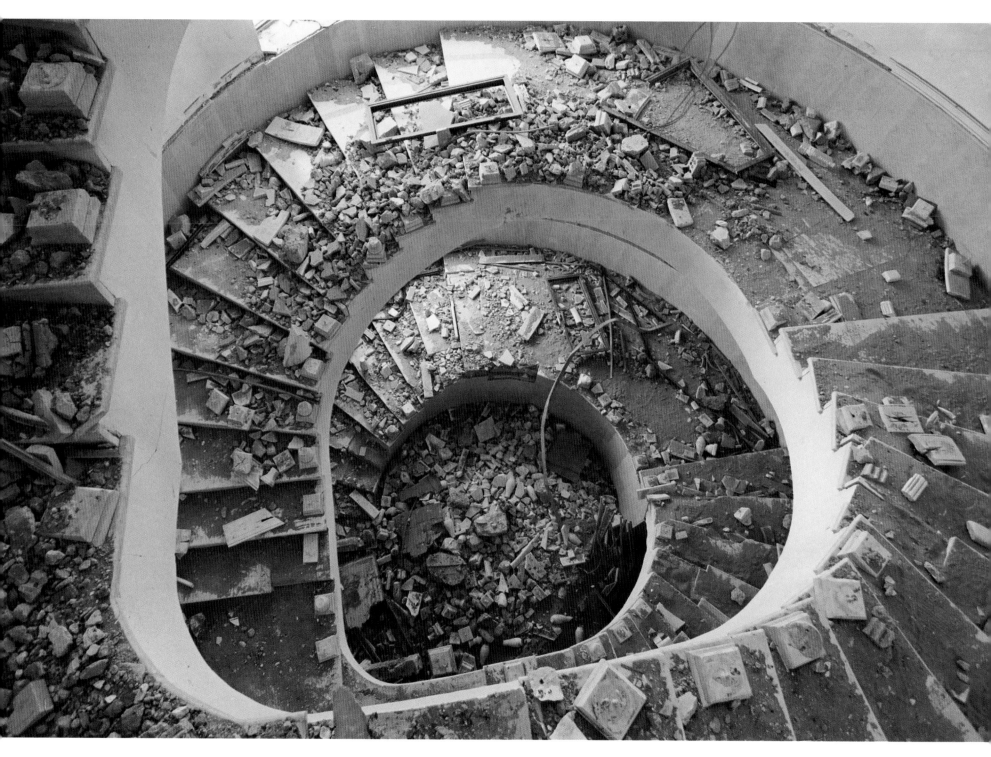

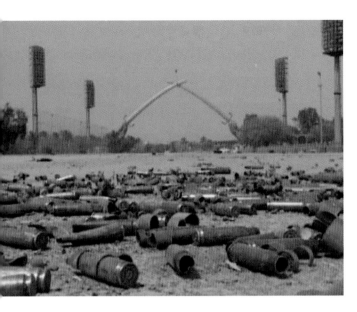

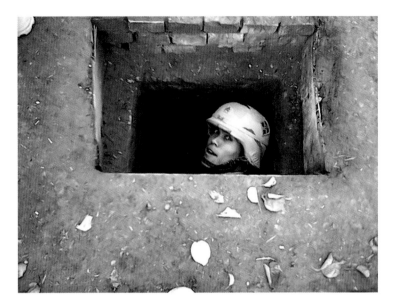

**07.2004**
**SERGEANT**
**JAMES BAUMGARDNER,**
**U.S. ARMY**
**Baghdad**
During his six months of
continuous travel around
Iraq, Baumgardner
encountered many of the
country's most famous sights.
Here, American ammunition
covers the ground of the long,
empty concourse leading to
the crossed swords (officially
called Hands of Victory),
a famous Iraqi war memorial.
Baumgardner's platoon had
stopped for a security check
just long enough for him to
take this picture. Then they
moved out again.

**12.2003**
**PHOTOGRAPHER**
**UNKNOWN**
**Tikrit**
Staff Sergeant Blue poses
inside the spider hole
where Saddam Hussein was
captured. Blue, an army
career counselor, brought
truckloads of soldiers to the
site as part of a reenlistment
effort: "We signed up about
twenty or thirty people at the
hole before it got too dangerous.
We thought it would be a
good idea, because soldiers
can say, 'Hey, I was part
of the brigade that supported
the capture of Saddam, and
I was able to reenlist at the
place where he was hiding out.'"

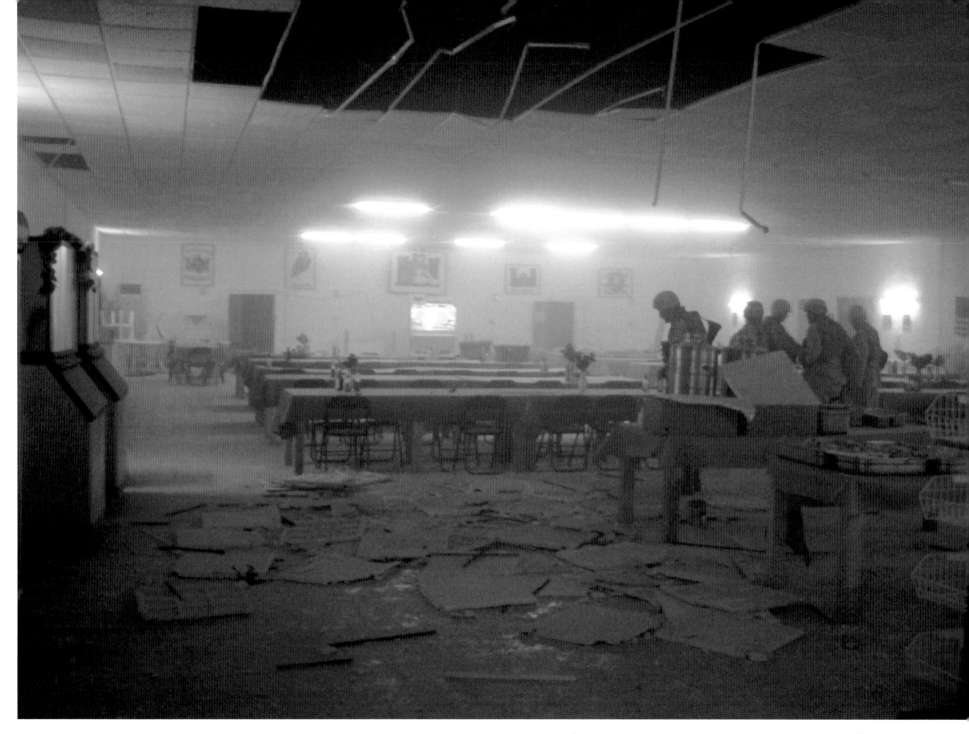

**10.2004**//**STAFF SERGEANT HARRY J. DeLAUTER, U.S. ARMY**//**Ba'qubah**
When a mortar round hit this mess hall at FOB (forward operating base) Gabe, "we had soldiers in there watching *Monday Night Football*," says the photographer. "That bright spot on the wall—that's a big-screen TV." Within minutes, these soldiers were already discussing how to clean up. "Nobody got hurt, surprisingly. The round exploded on the roof. If it'd exploded inside, it would have been a different story."

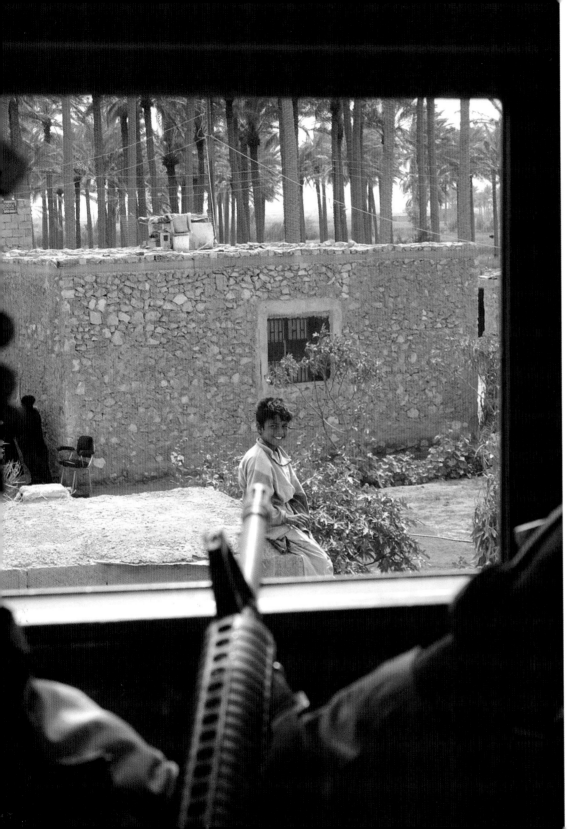

**04.2003**
**CHIEF WARRANT**
**OFFICER**
**BRENT McKINNEY,**
**U.S. ARMY**
**Baghdad**
An M16 belonging
to a member of the
photographer's unit is
trained on an Iraqi boy
during the first weeks
of the war. "This is
one of my favorite
photographs," says
the photographer's
wife. "The weapon is
pointed at the boy.
That's not an accident.
If the boy moves the
wrong way, he's not
going to smile anymore."

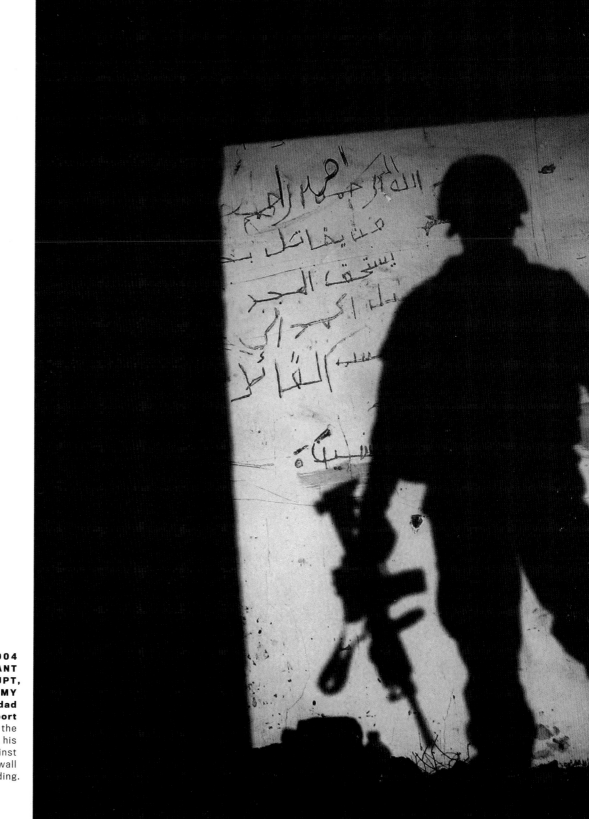

**08.17.2004**
**SERGEANT**
**BRIAN MOCKENHAUPT,**
**U.S. ARMY**
**South of Baghdad**
**International Airport**
While on patrol, the
photographer catches his
shadow cast against
a graffiti-covered wall
in an abandoned building.

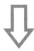

# "YOUR FRUSTRATION IS OUT THE WINDOW. IT'S PRETTY MUCH, 'LET ME MAKE IT THROUGH THE NEXT FIVE MINUTES AND THE NEXT FIVE MINUTES AFTER THAT.'"
— PETTY OFFICER FIRST CLASS AARON ANSAROV, U.S. NAVY

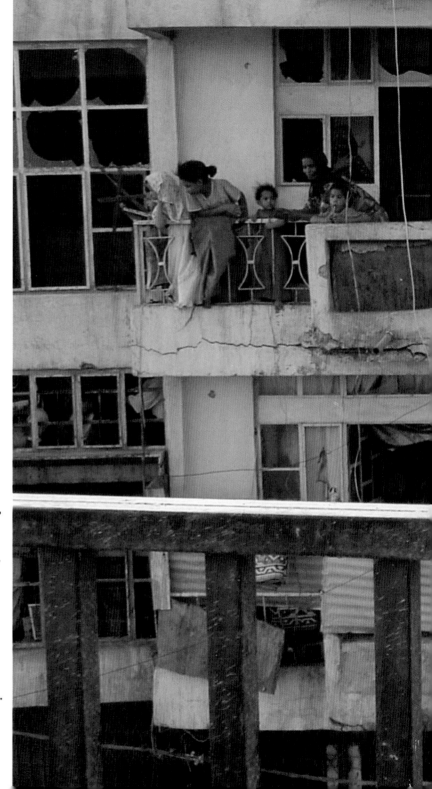

**07.2003**
**SPECIALIST**
**EDOUARD H. R. GLUCK,**
**U.S. ARMY**
**Ramadi**
A member of Charlie Company, 1st Battalion, 124th Infantry, keeps watch on an overpass in downtown Ramadi after an IED explosion in the area. "If you look at the family on the balcony, you can see the broken glass in the windows above them," says the photographer. "That was from the IED blast."

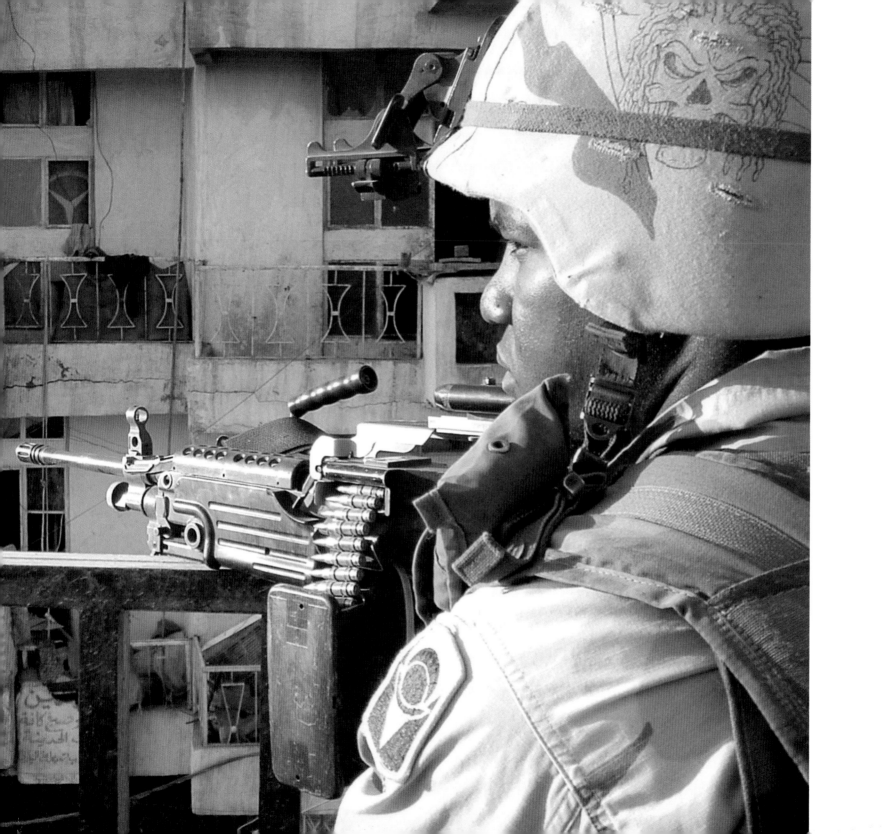

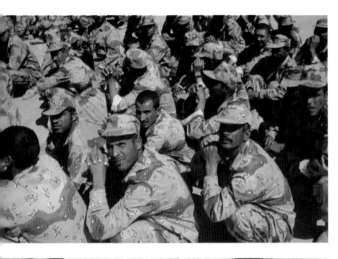

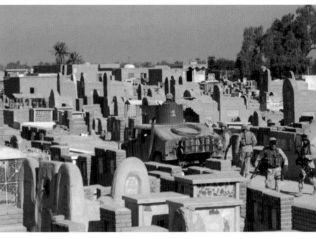

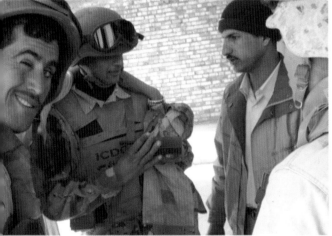

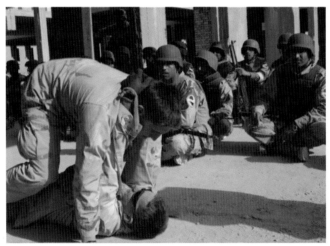

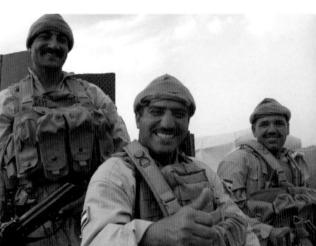

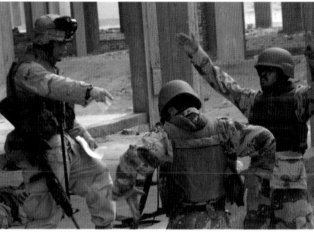
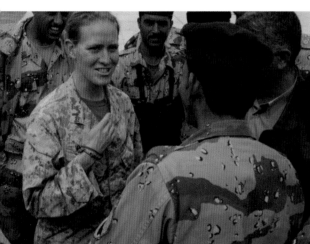
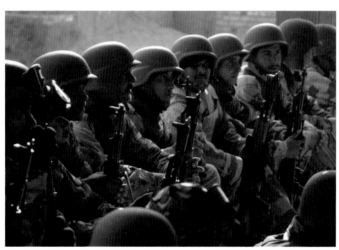

**05.2004-08.2005//FIRST LIEUTENANT SETH MOULTON, U.S. MARINE CORPS//Iraq**
The photographer took these pictures during his second deployment to Iraq. He worked as a platoon
commander with the 1st Battalion, 4th Marines, training and operating with the Iraqi army, until he
was asked to become a special assistant to David Petraeus, the general in charge of training all Iraqi
security forces. "We would do everything with the Iraqis," explains the photographer: "physical
training, shooting, room clearing, running convoys." His work puts him in the center of a crucial and
difficult transition: "Building an army and police force from scratch is incredibly challenging. But
no matter what happens in the long term, I'm honored to be a part of it."

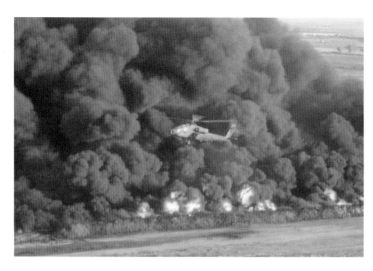

**07.13.2004**
**PHOTOGRAPHER**
**UNKNOWN**
**Tikrit**
"I can't tell you how
many mornings I would
get up and see the oil
lines on fire," says
Sergeant Frankie Davis,
who contributed this
photo, taken after
insurgents blew up an
oil pipeline near his
unit's base. Davis was a
crew chief in charge of
maintenance for Apache
helicopters. In this
instance, his unit's
helicopters were
providing security for
the infantry as they
tried to put out the fire.

**03.2003**
**SERGEANT FIRST CLASS**
**DAVID K. DISMUKES,**
**U.S. ARMY**
**Southern Iraq**
"The first thing the Iraqis
did was try to light
those oil fields," the
photographer says.
He took this picture of
Specialist Joshua Earl,
a military policeman
guarding the Rumaila
oil fields, while he was
escorting a group of
journalists reporting on
the fires. He says
infantry duty (his job in
Desert Storm) may be
safer than working with
reporters, who crave the
front lines. "Actually,"
he says, "that's what
puts you in all the heat."

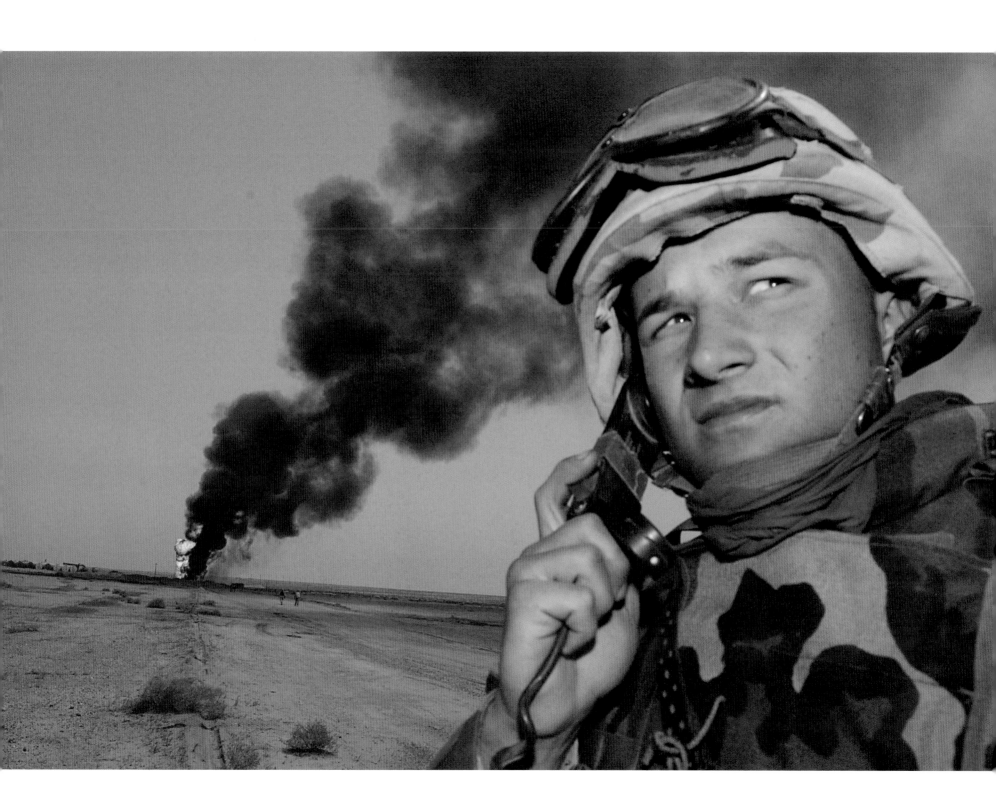

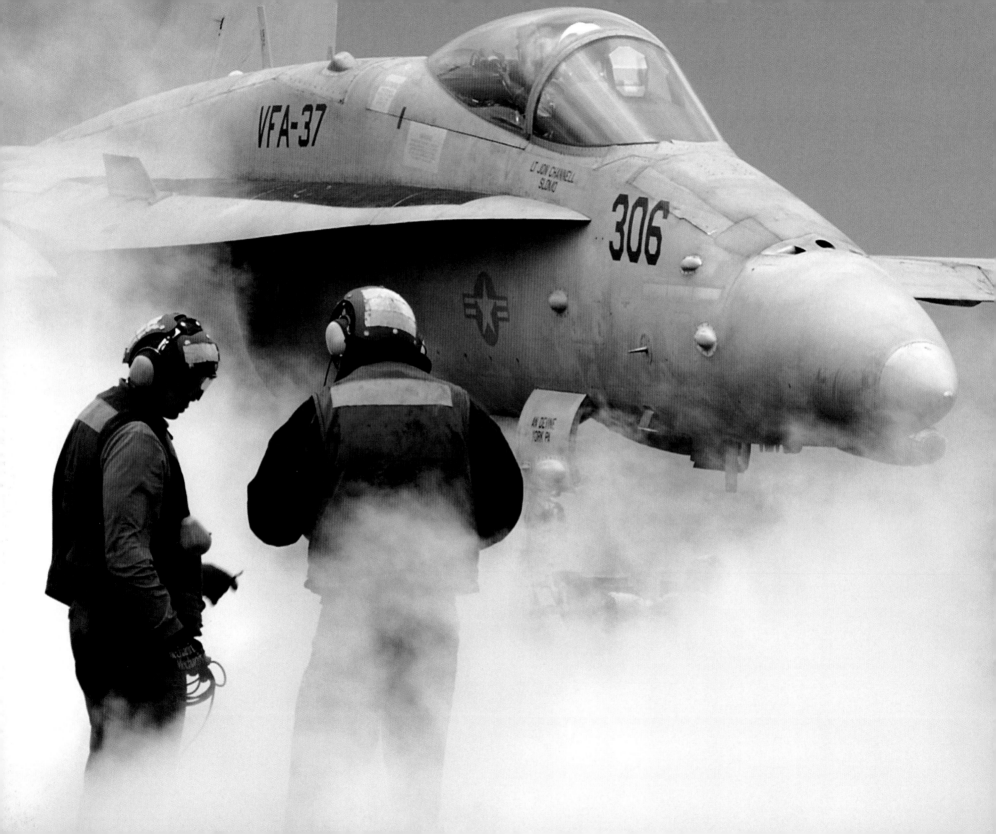

**12.01.2004**
**PETTY OFFICER**
**THIRD CLASS**
**KRISTOPHER WILSON,**
**U.S. NAVY**
**USS *Harry S. Truman*,**
**Persian Gulf**
"On the ground, they're
not that pretty," says
the photographer,
describing life up close
to jets like this F-18
Hornet waiting its
turn on the carrier's
steam-powered launch
catapult. "They leak.
They don't even look like
they could run, because
of all the oil pans
and stuff underneath
them." But in the air, he
says, "the sleek lines,
curves, everything–it's
ridiculously sexy."

**01.28.2005**
**PETTY OFFICER**
**THIRD CLASS**
**KRISTOPHER WILSON,**
**U.S. NAVY**
**USS *Harry S. Truman*,**
**Persian Gulf**
"You can always tell a
Tomcat pilot," says the
photographer. "All of
them have a little bit of
swagger in their step.
It's such an iconic
aircraft, with *Top Gun*
and stuff like that.
I mean, shit, they've
got the job that most of
us dreamed we'd have
when we were little
kids. If I was doing that,
I'd be the same way."

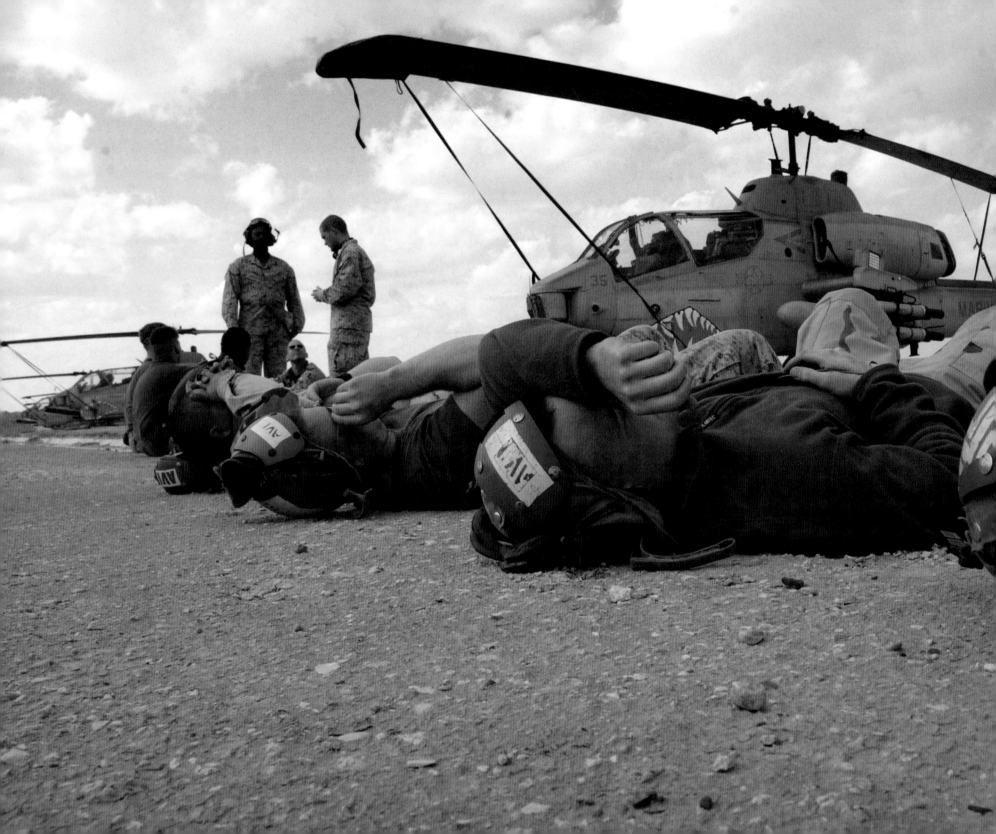

**02.21.2004**//**SPECIALIST EDOUARD H. R. GLUCK, U.S. ARMY**//**Al Asad Air Base**
Members of Helicopter Marine Light Attack Squadron 167 are visibly exhausted after a day and a half of flying back
and forth between Kuwait and Iraq. "This is literally their first day in Iraq, and they are just smoked," explains
the photographer. "The stresses of flying those missions are tremendous. We had already lost half a dozen helicopters
by that point. For these guys, they're flying in a moving target." But the unit was not unprepared for the mission, Gluck explains:
"These guys are part of a unit that's just legendary. They're definitely the hot-shit helicopter unit in the Marines."

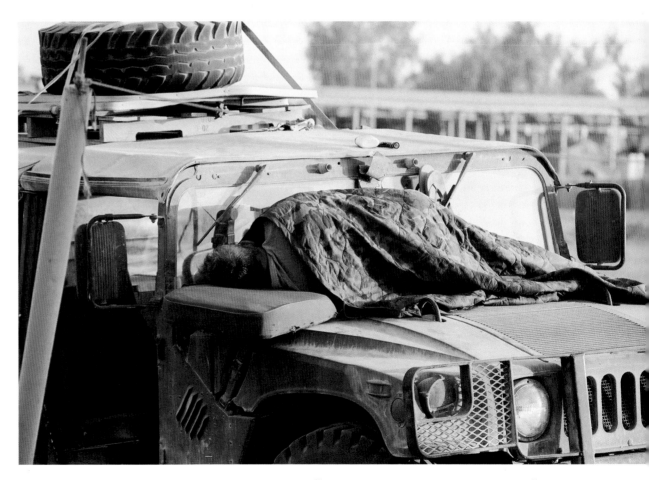

**07.2003**//**CAPTAIN LARRY E. LaROE, U.S. ARMY**//**Near Balad**
Until air-conditioned tents were set up at LSA (logistical support area) Anaconda, LaRoe's unit
slept outside. "When you're used to like 120 degrees during the day, at eight-thirty at night it's a nice
cool 100," he says. "It gets down to 90 degrees, you need a blanket." Most guys slept on cots,
but not First Sergeant Terry Cox, who favored a Humvee hood. "He wouldn't sleep anywhere else."

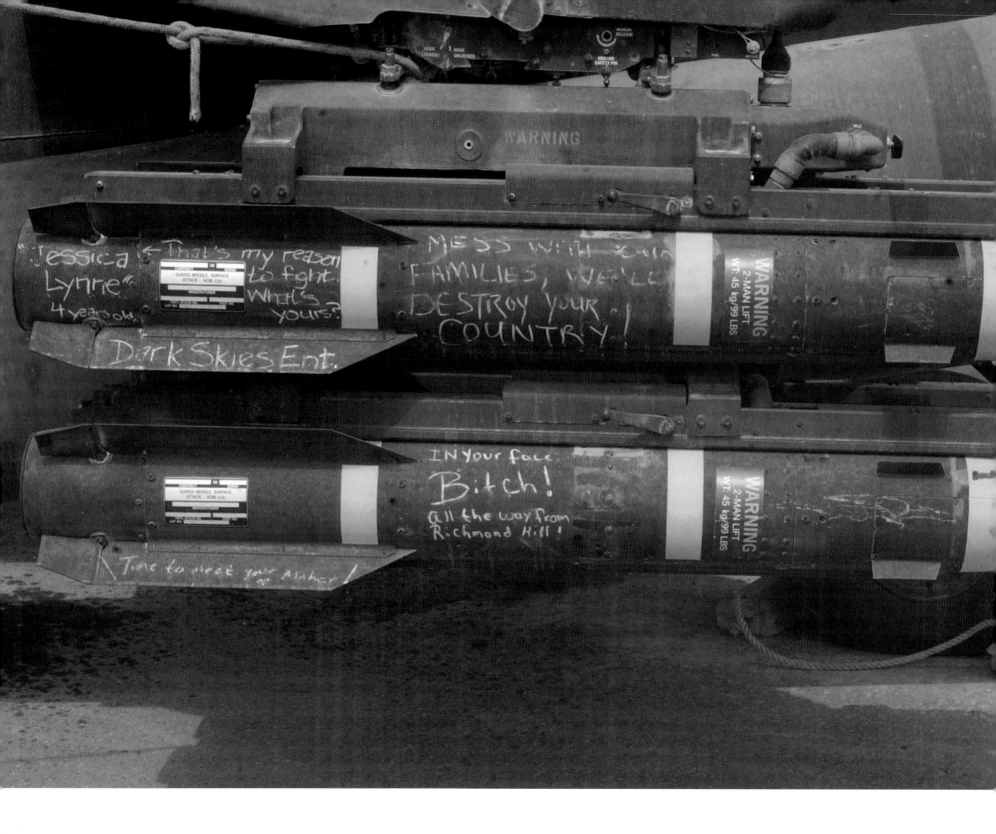

**03.2003**
**PHOTOGRAPHER**
**UNKNOWN**
**Kuwait**
Two Hellfire missiles
have been tagged by
the pilots and crew of
an AH-64 Apache.
Now that the ordnance
has been officially
christened, it is ready
to leave Kuwait for use
in a mission into
Iraq. "This type of
personalized writing is
pretty common throughout
the military," says
Brent McKinney, who
contributed the photo.

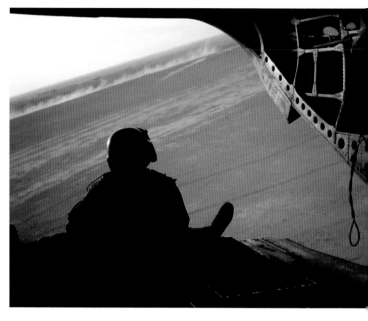

**10.2003**
**FIRST LIEUTENANT**
**RYAN KELLY,**
**U.S. ARMY**
**Over the desert**
**west of Mosul**
The photographer
snapped this picture
from the back
of a helicopter en
route to a raid in the
western part of Iraq.
The mission was
intended to disrupt
the influx of foreign
fighters crossing the
border from Syria.

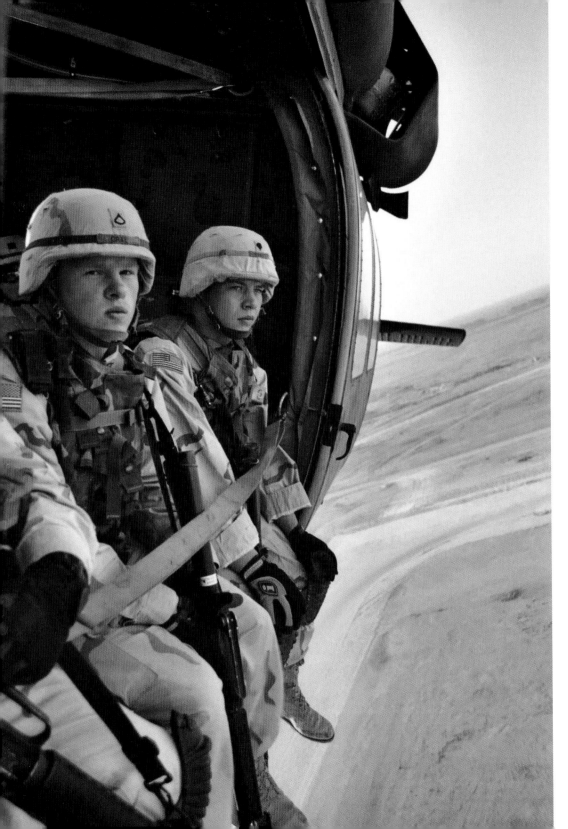

**11.2003**
**SPECIALIST**
**EDOUARD H. R. GLUCK,**
**U.S. ARMY**
**Over Al Asad**
**Air Base, Ramadi**
The photographer took
these photos while flying
with soldiers from an
elite immediate-action
rescue team during a
mock evacuation
mission. Developed after
the infamous downing of
a Black Hawk helicopter
in Mogadishu, Somalia,
teams like this one were
designed to assist
downed aviators when
other rescue teams were
unable to reach the
scene in time. "I shot
this picture [left] from
outside the helicopter
with a monkey harness
on," says the photographer.
For these soldiers, a
single strap across the
chest is all that protects
them from falling out
of the craft. "This was no
doors, no seats—you
better hold on." A member
of this unit, Specialist
Michael A. Diraimondo,
was killed several months
after this photograph
was taken, when his
medevac helicopter was
shot down over Fallujah.

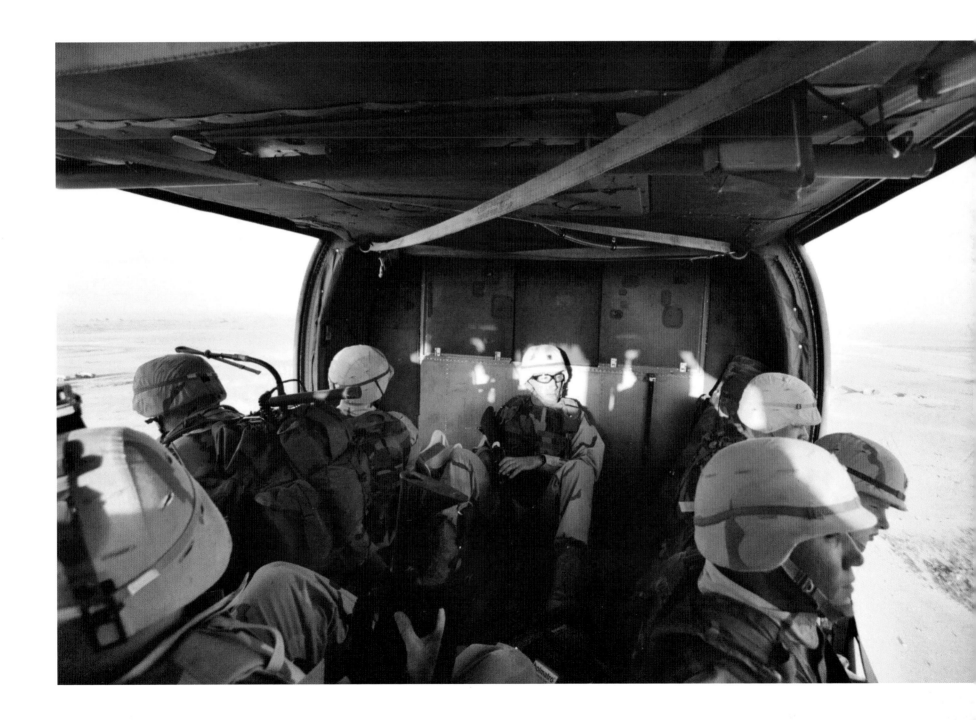

**11.2003//SPECIALIST EDOUARD H. R. GLUCK, U.S. ARMY//Al Asad Air Base, Ramadi**
Soldiers from the immediate-action team (previous page) continue their mock evacuation on the grounds of the airfield.

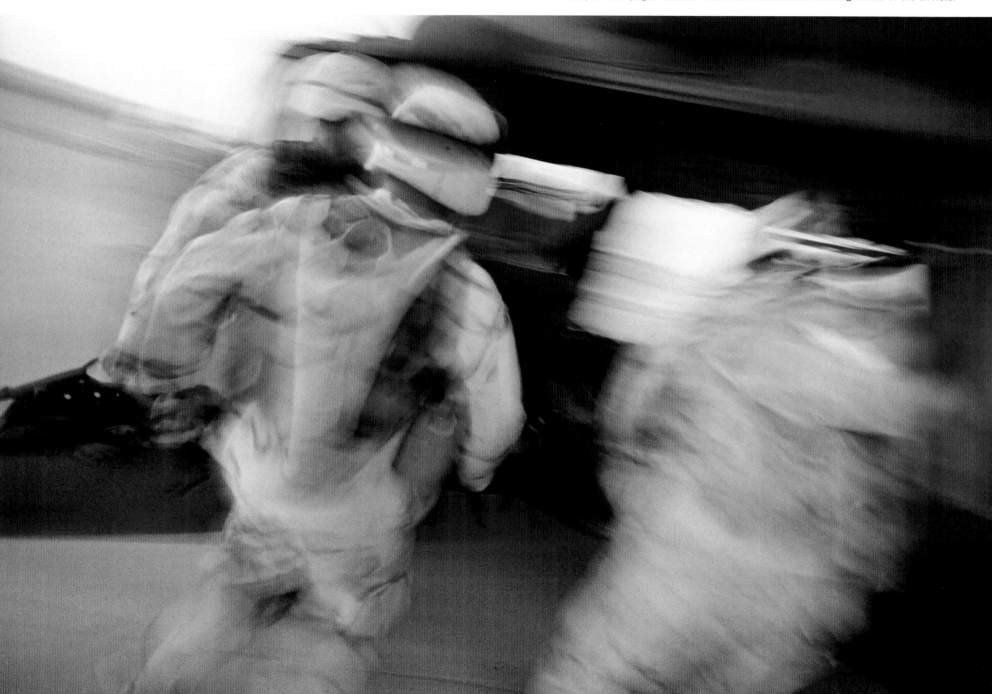

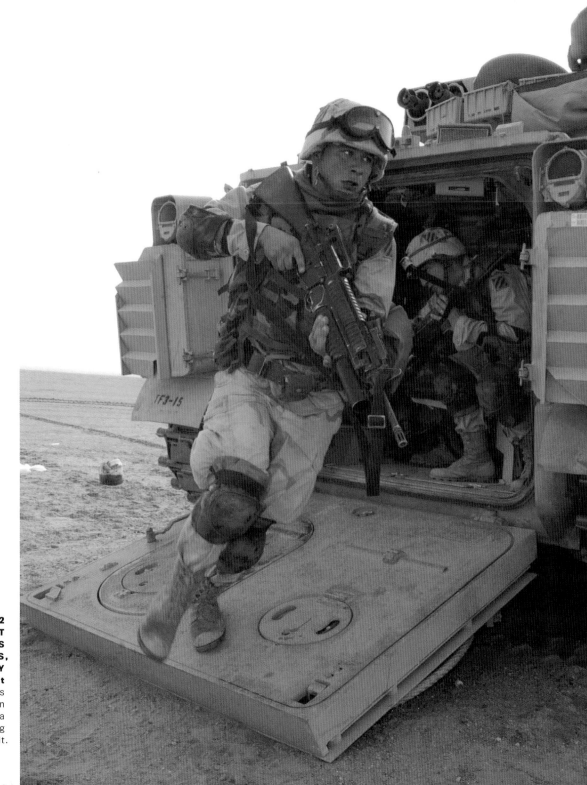

**12.09.2002
SERGEANT
FIRST CLASS
DAVID K. DISMUKES,
U.S. ARMY
Udairi Range, Kuwait**
Private Second Class
Christopher Nauman
strides out of a
Bradley fighting
vehicle in Kuwait.

02.08.2003
PETTY OFFICER
FIRST CLASS
BRIEN AHO,
U.S. NAVY
Kuwait, near
the Iraqi border
Builder Second Class
Nathan Waite eats an
MRE (meal ready to
eat). The meals come
inside vacuum-sealed
bags ("so they can last
forever," says Aho),
are available in
twenty-four varieties
(including BBQ pork
rib, Cajun rice with
sausage, and sloppy
joe), and are warmed in
water using flameless
chemical heaters.

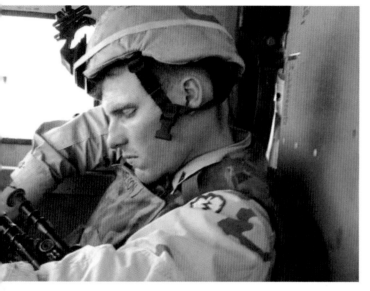

04.05.2003
SERGEANT
JAMES BAUMGARDNER,
U.S. ARMY
An Najaf
The photographer was part of
a quick-reach reaction force
in Iraq—which meant he and the
men in his unit were rovers, going
anywhere in the country they were
needed. Traveling so much, he
never knew when or where he'd
be able to sleep. Here, another
man in his unit, Sergeant Shawn
Nelson, takes a break from securing
the surrounding area to nap in
the cab of a Humvee.

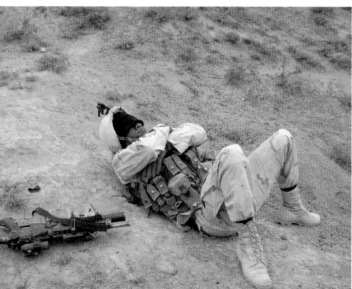

09.2004
SERGEANT
JAMES BAUMGARDNER,
U.S. ARMY
Samarra
After three nearly sleepless days of
combat to secure the city of Samarra,
Specialist Michael Gholston rests
on the desert floor. Men in the
photographer's unit sometimes had
hallucinations from sleep deprivation.
"That was interesting," says
Baumgardner. "We would do our thing
all night long and secure a building.
In the morning, anti-Coalition forces
get up, and they find American forces
all around them, so guess what—
they start shooting. So then you go
through the cycle again."

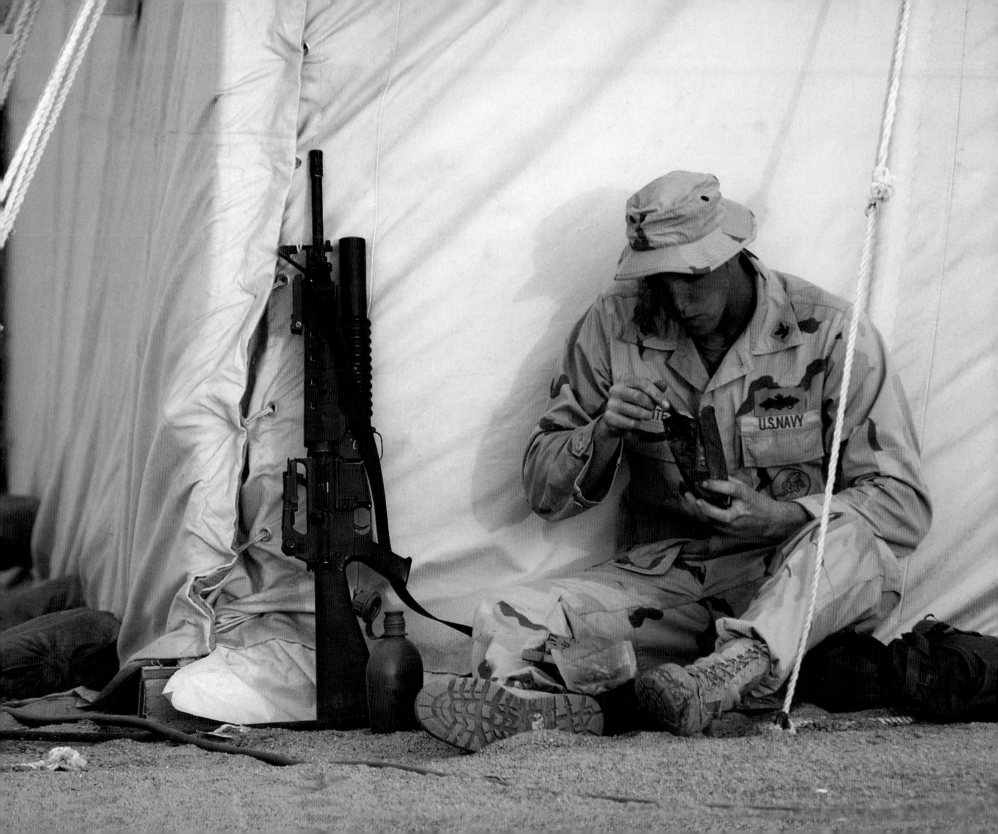

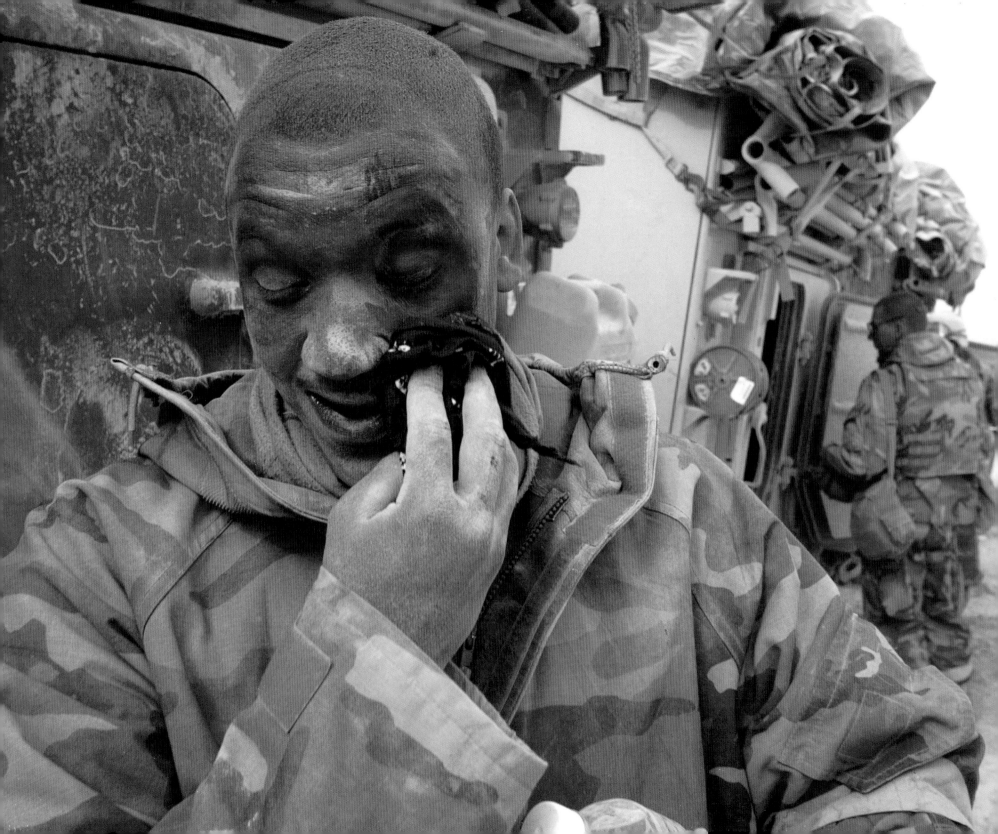

# "THE SAND BLOWS SIDEWAYS IN IRAQ, FROM THE BOTTOM, FROM THE TOP, FROM ANYWHERE."
— PETTY OFFICER FIRST CLASS KEVIN H. TIERNEY, U.S. NAVY

**03.24.2003**//**FIRST LIEUTENANT TRAVIS HOWELL, U.S. ARMY**//**Near An Najaf**
Advancing on Baghdad, drivers with the 70th Armor Regiment were constantly exposed to the wind, sand, and storms of the desert. "Scraping this amount of crud from your face was pretty routine," says the photographer.

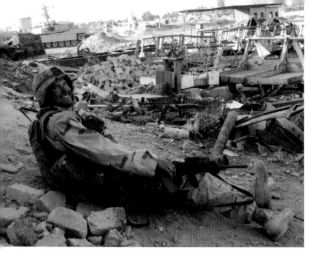

### THE PHOTOGRAPHERS
First Lieutenant Seth Moulton

Seth Moulton has spent most of the last three years in Iraq, taking hundreds of photographs along the way. "During my first tour, I just took pictures to record what I had been through," he says. "But on my second deployment, it really became a hobby for me."

Moulton joined the Marines after graduating from Harvard in 2001. He says most people assume he enlisted in the military because of September 11, but that isn't the case: "I've always thought that military service is important, and the September 11 attacks only reinforced my decision to serve."

When the war began, Moulton participated in the initial invasion, moving up the eastern flank of Baghdad with the 1st Marine Division while the army attacked from the west: "I was a platoon commander, so I wasn't there to take pictures. My camera only came out when things were pretty quiet."

After the battle for An Najaf in August 2004, during his second deployment, Moulton and his unit turned their focus to training Iraqi security forces. "While I was home, I bought a better camera with the money I had saved up," says Moulton. "And we had a freelance photojournalist attached to our company during our second deployment. I bugged him for tips all the time. It was basically a free nighttime photography class." Moulton's most recent assignment has been working as a special assistant to General David Petraeus, who led the effort to train security forces in Iraq. Working closely with these Iraqi units, Moulton was able to witness the difficulties and successes of a culture in flux. "If we ever want to go home, the ticket out is these Iraqi security forces. Whether I agree with why we came here or not, that's the bottom line."

03.2003
**FIRST LIEUTENANT
SETH MOULTON,
U.S. MARINE CORPS
En route to Baghdad**
A Marine in the photographer's unit pauses to clean his rifle before settling in for the night in a trench during the first days of the war. "The famous trenches from World War I were impressive because soldiers were in the same position for a long time, so they could make their ditches deeper and more interconnected," says the photographer. "But we were often only in a position for one night. You would dig a hole big enough for your body to be just below the surface, to protect you from mortars. And sometimes we wouldn't even have time to do that—we'd just sleep on the ground."

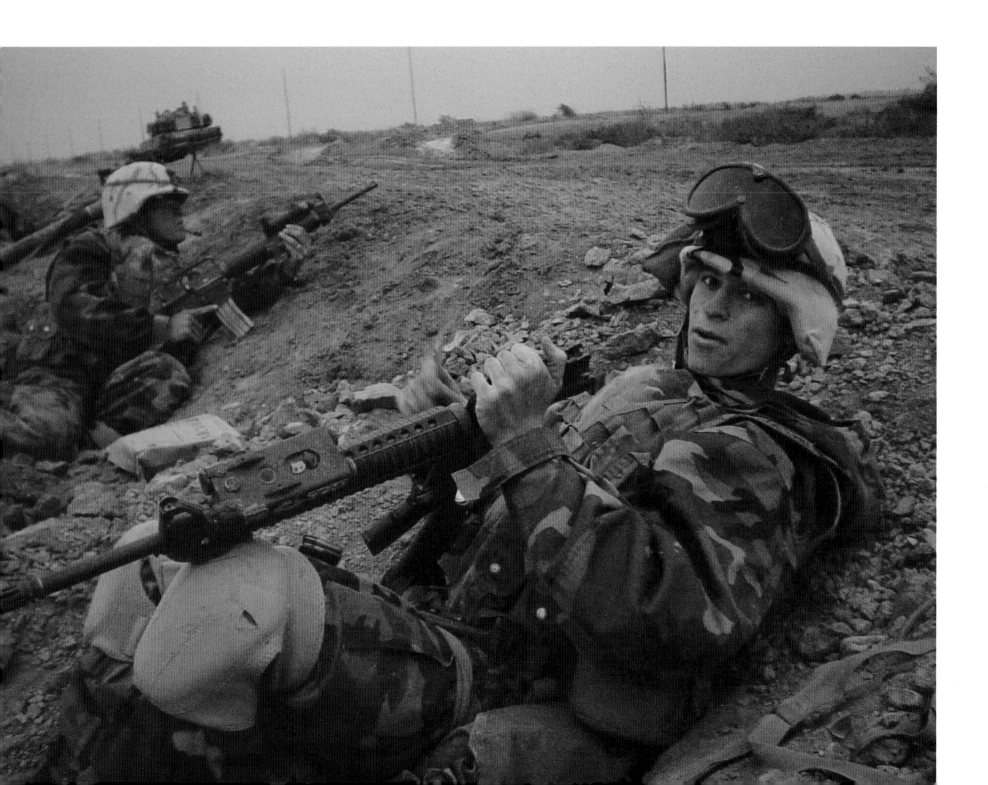

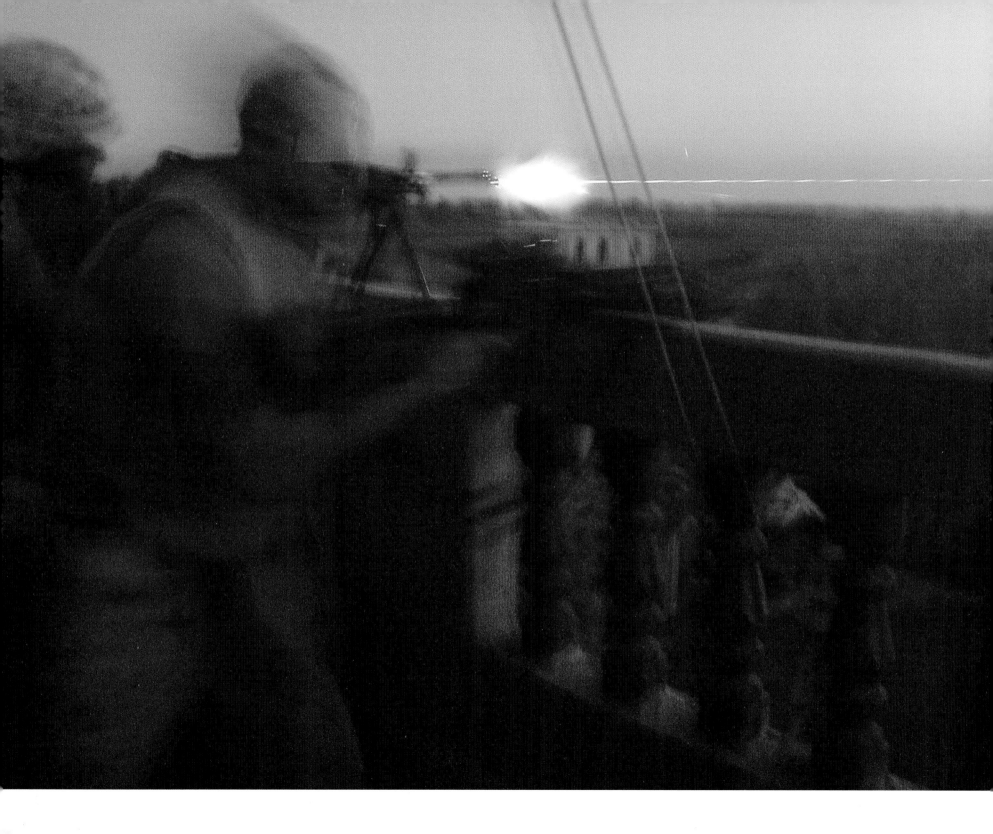

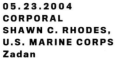

**05.23.2004**
**CORPORAL**
**SHAWN C. RHODES,**
**U.S. MARINE CORPS**
**Zadan**
Insurgents often strike at dusk, when light is low enough to make them difficult to spot but before darkness gives U.S. troops equipped with night-vision goggles the advantage. It's when these Marines, a sniper and a gunner from 2nd Division, came under rocket attack. The tracer fire from a SAW (squad automatic weapon), coupled with a shutter speed accidentally set too slow, creates the blurred effect. "We were all laying down rounds on the bastards who shot at us," says the photographer. "There's a feeling of anger that these people would try to keep you from getting home. That's all the motivation you need."

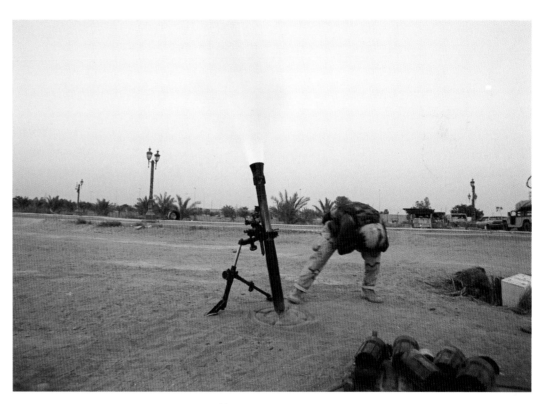

**07.2003//SPECIALIST EDOUARD H. R. GLUCK, U.S. ARMY//Ramadi**
A Florida National Guardsman ducks after firing a mortar at an island in a lake on the other side of Ramadi. The photographer explains: "After the invasion, all these Iraqi military men had surrendered, but that didn't mean they lost their skills. These Iraqi mortar men would set up what we called 'hip-shoot' mortar attacks, and they would fire on our base at dinnertime, so guys would be scared to eat." The battalion's commander— "He was definitely the Wyatt Earp of Iraq," says the photographer—ordered that for every mortar that landed near the Americans, they would send two back. "It worked. It totally curbed the mortar attacks."

**06.2004**
**SERGEANT JAMES BAUMGARDNER,**
**U.S. ARMY**
**Between Baghdad and Kirkuk**
Sometimes even American weapons, in this
instance a cache of ammunition, are targets
in Iraq. Here, a rocket fired by insurgents, or
what the army terms AIF (anti-Iraqi forces), hits
an American holding area, detonating stocks
of U.S. ammo and lighting up the early-morning
desert. "That was just some bad guy who got
a lucky shot," says the photographer.

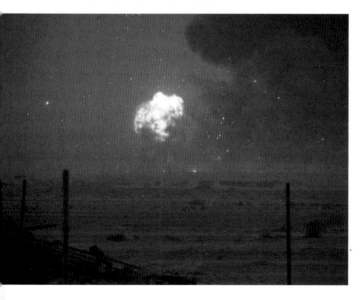

**10.2004**
**FIRST LIEUTENANT**
**SETH MOULTON,**
**U.S. MARINE CORPS**
**An Najaf**
As Marines in
his unit wait in
line for chow,
the photographer
captures a rare
thunderstorm in
the desert.

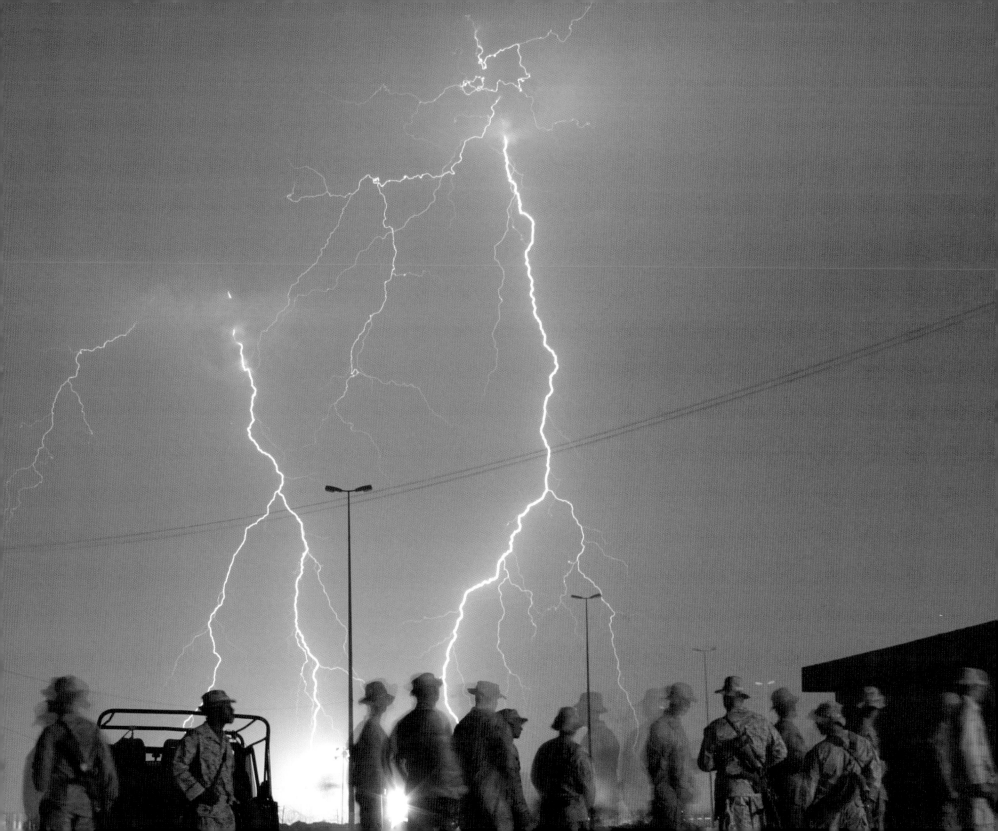

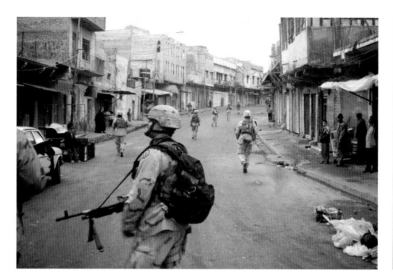

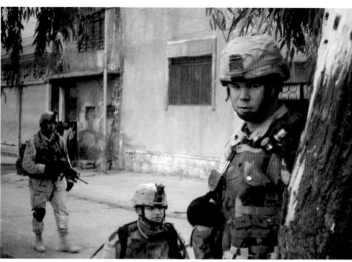

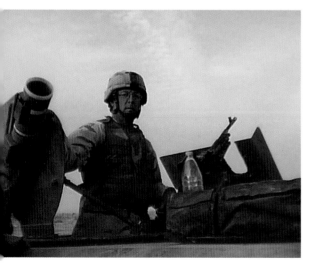

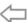

## THE PHOTOGRAPHERS
Sergeant James Baumgardner

  James Baumgardner was pulled out of college in 1990 when, as a 21-year-old reservist, he was called up to fight in the first Gulf War. He didn't take many pictures during the seven months he was deployed in Desert Storm. "I didn't want nothing back from that place," said Baumgardner, who was leaving behind a 4-year-old son, David. "I didn't want to be there." In January 2004, having now made the military a career, he departed for Kuwait in advance of the war, and this time he brought his camera and a notebook. "When I went over, because of my kids and stuff like that, I thought: 'I need to bring something back.'" He had become a father of four.

  In Iraq, Baumgardner was a member of the 1st Battalion, 14th Infantry Regiment, and was assigned to a quick-reaction force, which took him on missions all over Iraq. And while he traveled widely and frequently through the country, he took pictures and kept a journal. "From the beginning, the men I was with and I just bonded," said the photographer, who took nearly as many pictures of his fellow soldiers as he did of combat and desert vistas. When Baumgardner returned home on February 8, 2005, he had almost 3,000 pictures and videos to show his wife, Elizabeth, his daughter Devon, and young sons Lance and Drake. David, his oldest, had become a member of the army's 82nd Airborne Division.

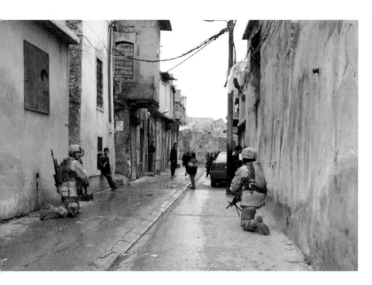

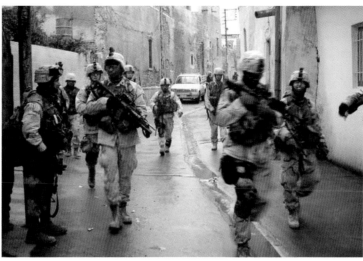

**01.2004**//**SERGEANT JAMES BAUMGARDNER, U.S. ARMY**//**Mosul**
After securing the area for upcoming elections, soldiers walk through
the streets of Mosul, interacting with the citizens. These operations are called
presence patrols, and they represent a stark difference between this war and
the Gulf War of 1991.

"There was no interaction with the local population in the first war,"
says the photographer, who served in both conflicts. "None. We were there
to push Iraqis out of a country. This time, you're walking down the streets
of Baghdad, you're talking to kids, you're talking to old men, women. You're
buying  stuff from their shops."

Presence patrols can also be dangerous because troops expose themselves
to insurgent attacks. During the patrol pictured here, a sniper fired a grenade
at troops passing through the street below. The round clipped the heel of a
patrolling soldier and bounced several times, but did not explode. "It makes you
nervous," Baumgardner says, laughing. "But you've got all these other crazy
guys on your side who are next to you, so that gives you some sense of security."

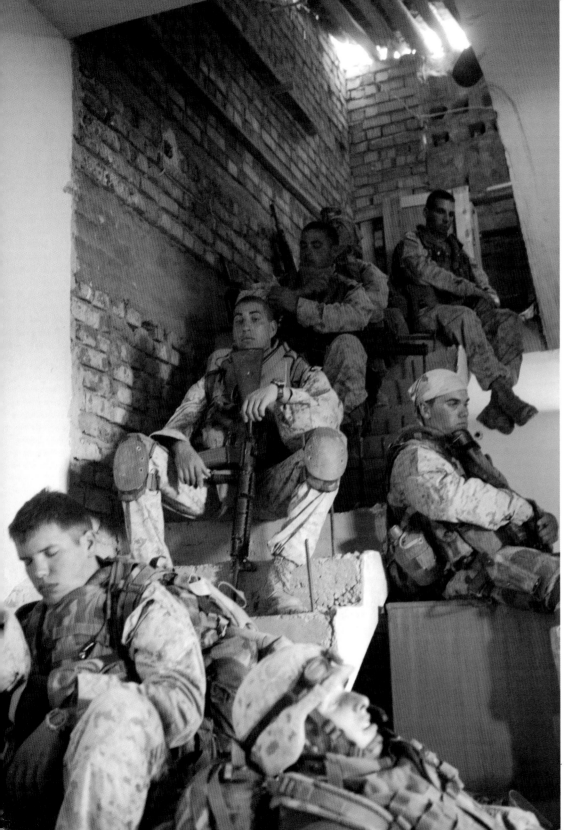

**11.13.2004**
**SERGEANT**
**LUIS R. AGOSTINI,**
**U.S. MARINE CORPS**
**Fallujah**
Agostini and his Marine unit spent November 2004's Fallujah offensive jumping from rooftop to rooftop, sometimes with one hundred pounds of gear on their backs. "As soon as you sit down, you start saying, 'These houses are filthy' or 'I'm tired' or 'I can't wait till this is over,'" he says. After a twenty-minute breather, they were back out in the streets, kicking down doors.

**11.10.2004**
**SERGEANT**
**LUIS R. AGOSTINI,**
**U.S. MARINE CORPS**
**Fallujah**
Marines from the 3rd Battalion, 5th Marine Regiment, during the Fallujah offensive in November 2004. "We entered the city at night," says Agostini. "It was clearing houses, clearing houses, clearing houses. You can clear a hundred of them and find nothing–but there would be that one where you have insurgents holed up, hiding."

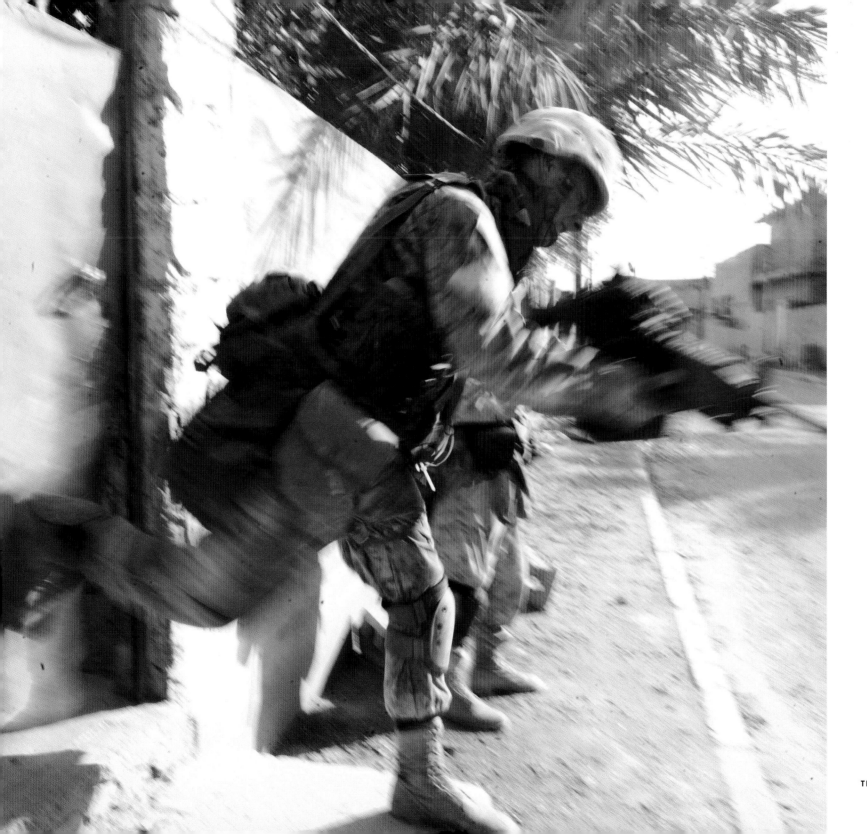

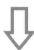

# "YOU HAVE TO REMEMBER SOMETHING ABOUT BEING DETAINED IN IRAQ. UP UNTIL WE GOT THERE, FOR A LOT OF INFRACTIONS, CRIMINALS COULD BE KILLED. SO THESE GUYS WERE SCARED."
— SPECIALIST EDOUARD H. R. GLUCK, U.S. ARMY

**09.2003**//**SPECIALIST EDOUARD H. R. GLUCK, U.S. ARMY**//**Ramadi**
An Iraqi man is detained in the back of an army vehicle as members for the 1st Battalion, 124th Infantry, from Florida, conduct a daylight raid in the northwest corner of Ramadi. The photographer says that his unit was one of the few to execute raids during the day: "The people in Ramadi knew that when our battalion rolled out in force, you stayed inside or you were gonna have a problem."

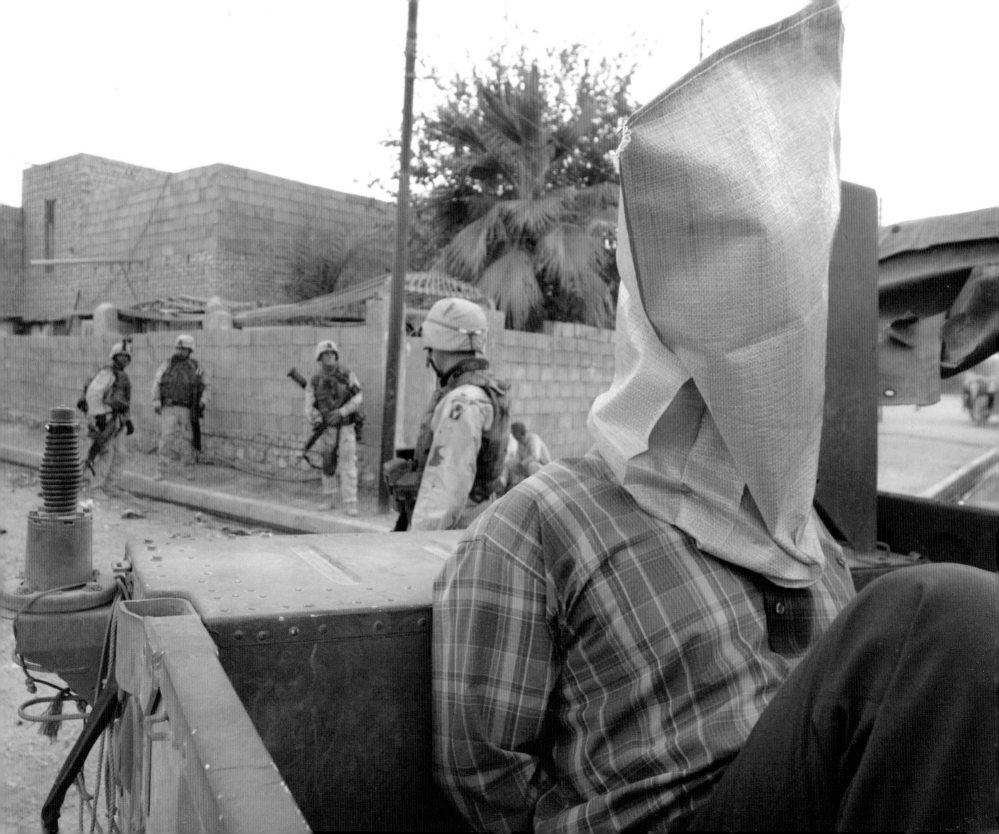

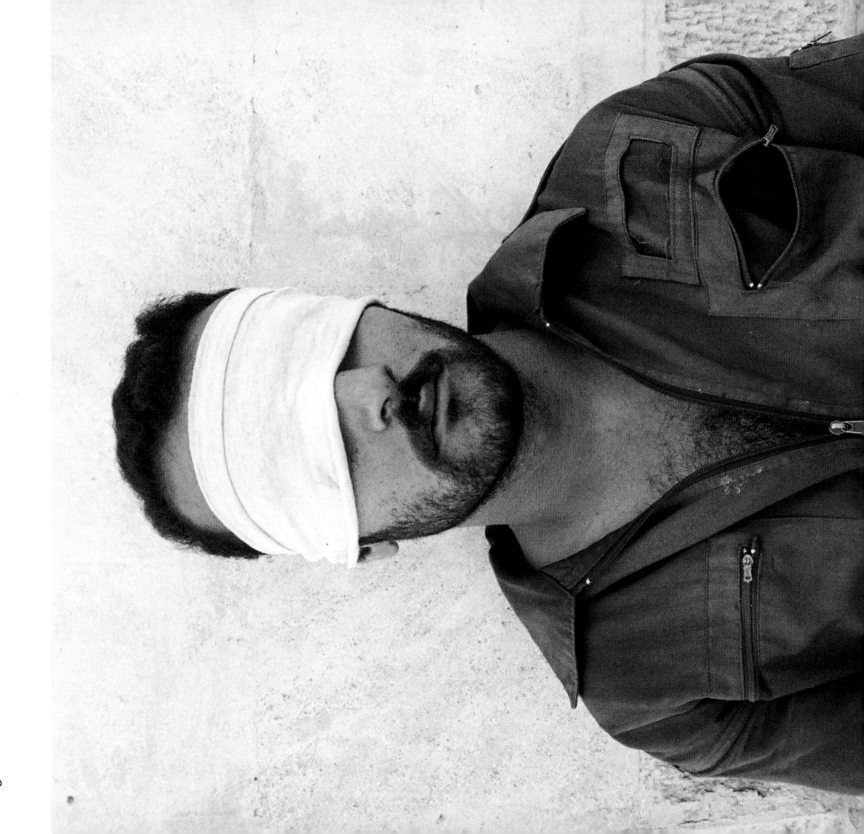

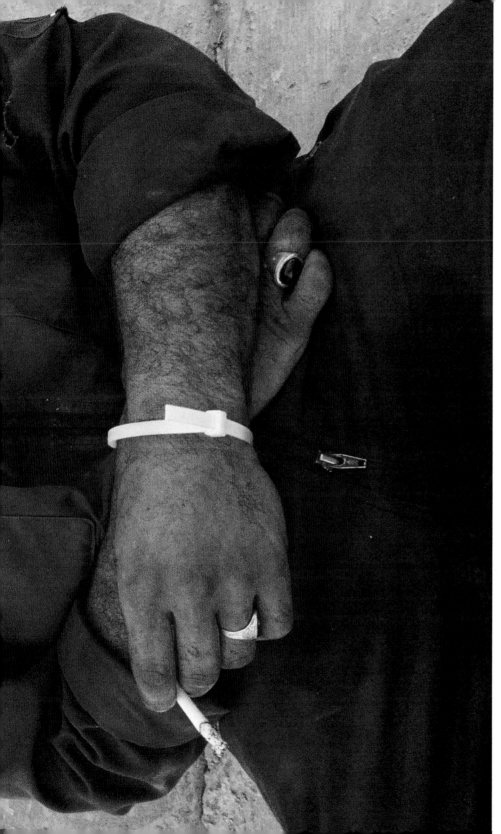

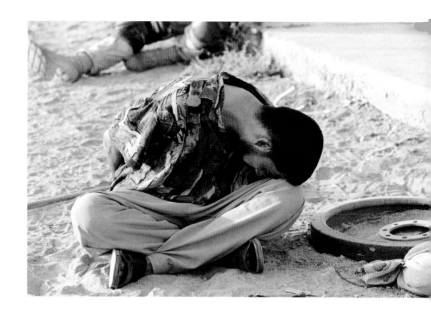

**07.2003**
**SPECIALIST**
**EDOUARD H. R. GLUCK,**
**U.S. ARMY**
**Ramadi**
"I was wondering if he
could see through that
blindfold," says the
photographer of the Iraqi
prisoner pictured here.
"If you look close, you
can see three small
green dots on his hand.
That means he's a member
of Saddam's fedayeen.
These guys were
incredibly violent and
ultra loyal. You don't end
up in our compound for
being a nice guy."

## THE PHOTOGRAPHERS
Chief Warrant Officer Brent McKinney

Brent McKinney, 32, arrived at Camp Doha, Kuwait, from Fort Hood, Texas, in February 2003. He spent the next five months as a pilot for the 507th Medical Company, a helicopter ambulance unit that supported the 3rd Infantry Division. McKinney was the chief pilot of a UH-60 Black Hawk. Along with his four-man crew, he worked twelve-hour shifts transporting casualties from the battlefield to the nearest medical facility. "It was tough but rewarding work," says McKinney. "Being a helicopter pilot, you really end up working in a tight-knit group. Your copilots and crew become your family.

"This was the first war where so many soldiers had digital cameras, and that made it easier to document everything," says McKinney. "Of course, I was doing the old-fashioned thing, sending film back home to have it developed." (Thanks to the army's postal system, McKinney actually made it home before most of what he'd sent to his wife, Debbie.) Many of the other pilots in McKinney's company, however, brought digital cameras with them. Back home McKinney and the 150 other men and women in his unit began exchanging pictures. "We had hundreds and hundreds of photos between us," McKinney says. "Some were better than others, but the best ones really allowed you to reflect on what you went through. When you look at a photo, it sort of triggers a reaction in your mind. They're just electronic snapshots, but to me they're everything—the whole experience." In an effort to show the Fort Hood, Texas, community what the members of the 507th had been through, Debbie McKinney compiled the best photos onto a series of discs, which she later turned into a showcase at a local theater. All the pictures McKinney submitted for *This Is Our War* came from those discs. Now back home in Texas, McKinney works as a system administrator at Fort Hood while taking night classes to complete his degree in chemistry. "I want to be a mission specialist at NASA," he says. "I guess that means you could say I want to be an astronaut."

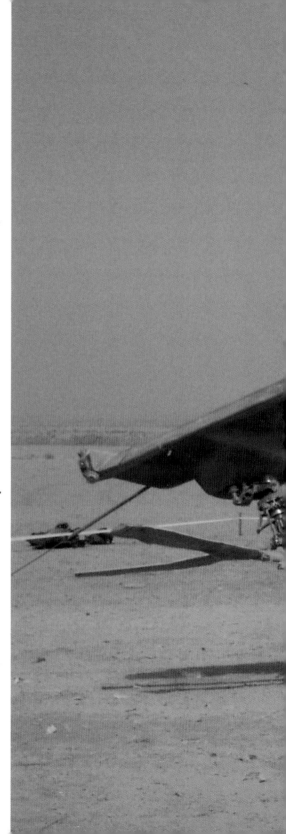

**03.2003
PHOTOGRAPHER
UNKNOWN
West of Fallujah**
An overturned AH-64 Apache is proof of the difficulty involved in takeoffs and landings in the desert. "It was so hot outside, and the chopper was carrying so much weight, that it just couldn't generate the power to lift," says Brent McKinney, who contributed the photo. He was attempting a takeoff in a Black Hawk about a mile away at the time of the crash. The 150-foot plumes of dust generated by the blades don't help matters: "The pilot couldn't see anything, and he couldn't get off the ground, so he started drifting. As soon as I took off, I looked to my right in time to see the chopper clip its wheels on the ground, roll over, and crash." Despite the explosive cargo—eight Hellfire missiles and a number of rockets—everyone walked away unscathed.

**11.15.2003**
**SPECIALIST CHRIS JONES,**
**U.S. ARMY**
**Mosul**

"I took these pictures right after they lifted the Black Hawk off of the house," says the photographer.

The night before, he'd been watching *Monty Python and the Holy Grail* when he received a call about a helicopter crash. He wasn't given any details—just that he should be there in the morning.

He knew that a Black Hawk had been shot down the week before, killing six soldiers. And the week before that, a Marine Chinook helicopter had crashed near Baghdad, and sixteen had died. "November was already the worst month—then this happened."

Jones arrived at 6 a.m. "It was kind of a shock," he says, "because I hadn't seen anything like this." Two Black Hawks had collided, and seventeen soldiers were dead. One helicopter had crashed onto a house, and Specialist Jones was told to get up on the roof and take pictures of the wreckage to document the incident for army public affairs.

"I didn't say a word the whole time I was there, about two hours. I felt like I was dreaming." Nobody was talking, he says, except "the guy whose house the chopper dropped on. He was asking about how the army was going to pay for the damage. It was as if he was totally oblivious to the fact that eight or nine dead bodies were on top of his house.

"But then again, he was probably scared," Jones says. "You spend your whole life getting that house—that's your life right there."

Jones has been back at Fort Campbell, Kentucky, for over a year, but he still thinks about the crash. "When anything happens in the news, I kind of wonder, 'Hey, who's taking pictures there? What are they thinking?' I think about cops, ambulance drivers. They see carnage every day—really bad stuff. I couldn't imagine getting used to that."

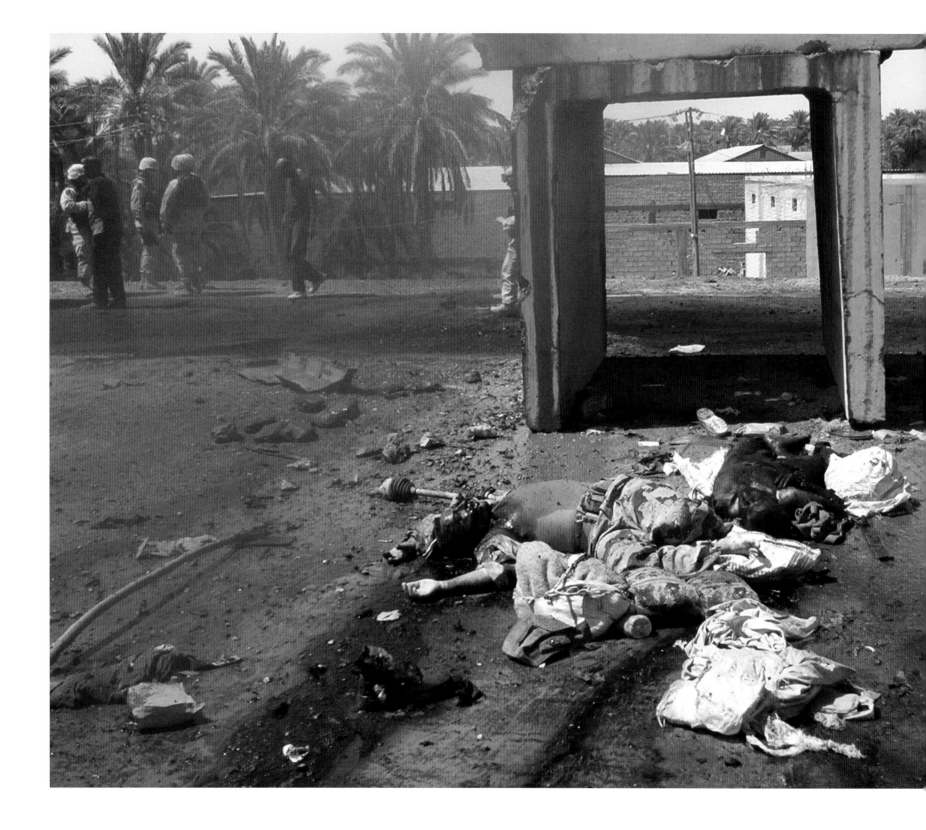

**07.16.2004
STAFF SERGEANT
HARRY J. DeLAUTER,
U.S. ARMY
Near Ba'qubah**
"The biggest part that's
left of the truck is sitting
there, that axle," says
the photographer,
describing the power of
the explosion at a
checkpoint that killed
four Iraqi National
Guardsmen (two of whom
are pictured here).
"If I sit down to think
about it, the biggest
thing is, I can still smell
that day—the burning
flesh, the burnt hair,
the explosives in the air.
It's nothing you really
ever get used to."

**THE PHOTOGRAPHERS**
Sergeant First Class David K. Dismukes

David K. Dismukes, 43, from Alabama, has been taking photos since age 19 and war photographs since Desert Storm. "Off we went to war, and I took my little FM2," he says. "I shot a lot of death and destruction—bloody bodies, people that were mangled. And when I came back, every time I looked at those photos, I had nightmares. Those are the images of the war that I remember, even today.

"This time when I went over, I didn't want to shoot that. The story I wanted to tell was what the people had gone through, not the blood and guts. I remember looking out of a window in Baghdad, and this lady's just crying, screaming, like she needed something. I was up on the third floor, so I got a big lens and took a picture, even though I didn't know what she was crying for. That's what I wanted to photograph—things that affect you."

Dismukes was a public-affairs officer who spent most of his time escorting and briefing civilian journalists as an aide to General David McKiernan, then commander of the allied ground forces in Iraq. Meanwhile he'd take photos, often in places civilians were not permitted. One of Dismukes's photos from Iraq ("I must have taken thousands") was used for the book jacket of General Tommy Franks's memoir, *American Soldier*. After a twenty-year army career that took him all over Europe, the Middle East, East Asia, and the United States, Dismukes returned to his hometown of Opelika, Alabama. He now works in the public-affairs office at nearby Fort Benning, Georgia. He keeps active by shooting supercross racing and his beloved Auburn Tigers football team. "The hundred, two hundred dollars you make," he says, "it's only for beer money."

**12.04.2002
SERGEANT
FIRST CLASS
DAVID K. DISMUKES
U.S. ARMY
Udairi Range, Kuwait**
Soldiers prepare for evacuating casualties in a training exercise in Kuwait. "My son is getting ready to go to Afghanistan," Dismukes says. "He's 19, and I've had five combat tours. He asked me, 'What is it like?' All I could say was, 'You do what you've practiced, what you've trained to do.'"

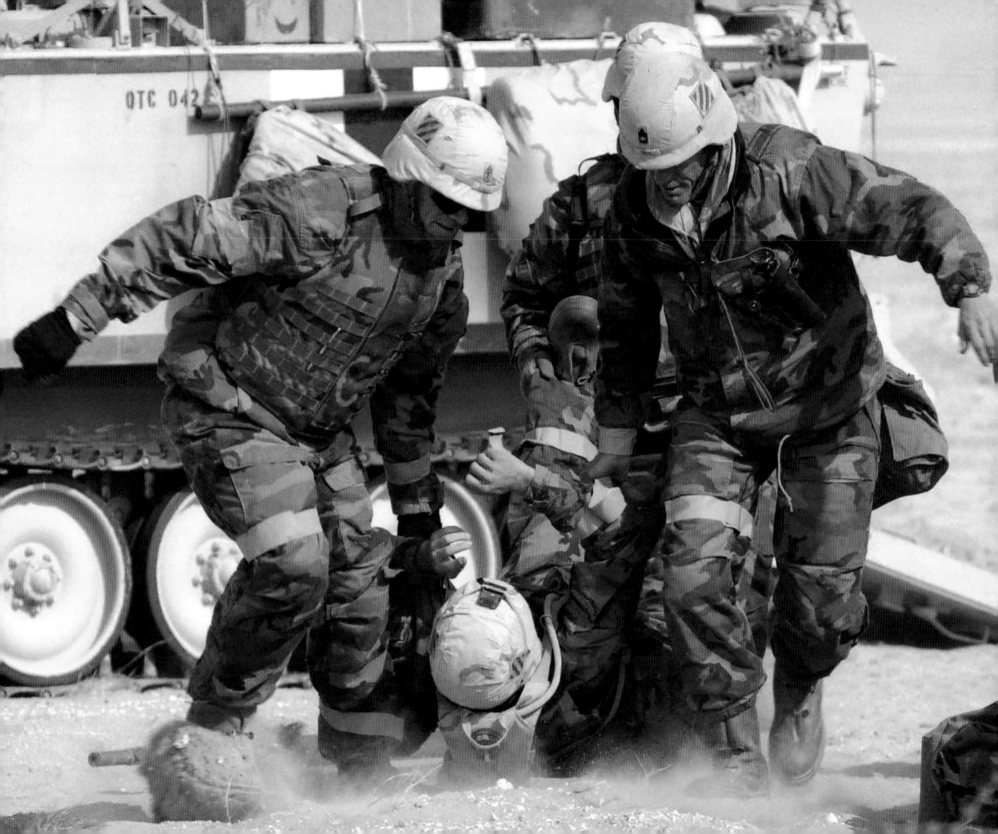

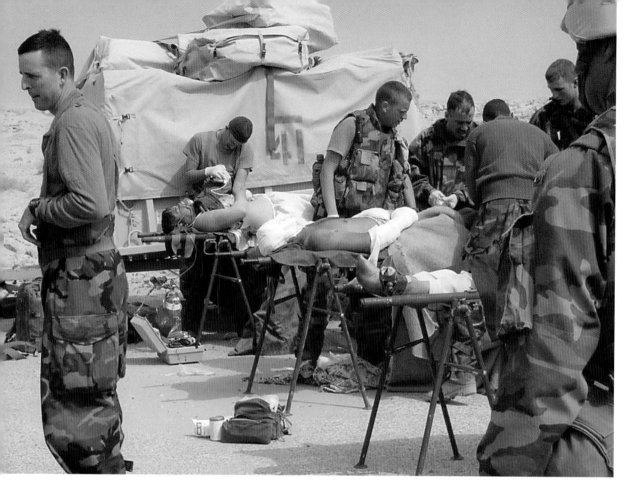

**03.24.2003**
**PHOTOGRAPHER**
**UNKOWN**
**Jalibah**
The 3rd Aviation Regiment's medical personnel work on injured Iraqi POWs at a battalion aid station at Jalibah Airfield, southwest of An Nasiriyah. The abandoned airfield became the battalion's first stop in Iraq on its two-week trek from Kuwait to Baghdad. Medics treated up to twenty-four casualities on a busy day, attending to everything from gunshot wounds and burns to missing limbs. Photo contributed by Chief Warrant Officer Michael S. Madura.

# "EVERYBODY IN OUR UNIT CAME HOME. ONE GUY GOT SHRAPNEL IN HIS HAND, ONE GUY GOT SHOT IN THE PINKIE, AND ONE GUY GOT CLIPPED WITH AN RPG IN THE FOOT. WE WERE EXTRAORDINARILY LUCKY."

— SERGEANT JAMES BAUMGARDNER, U.S. ARMY

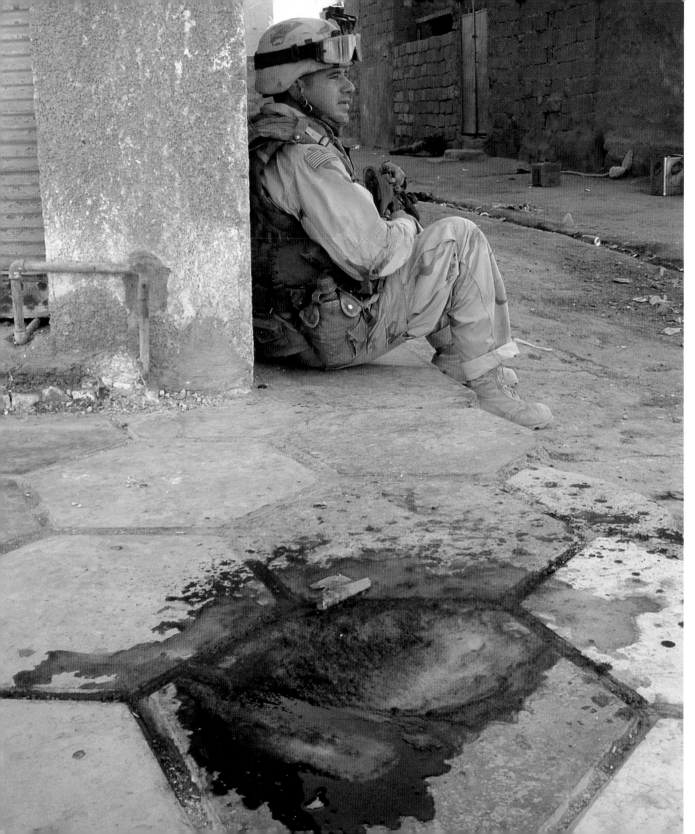

**07.2003**
**SPECIALIST**
**EDOUARD H. R. GLUCK,**
**U.S. ARMY**
**Ramadi**
A member of the
photographer's unit,
Specialist Perez Cross,
takes a break after
a raid. Earlier
that morning, troops
swept the city for
a transmitter that
insurgents had used
to detonate an
IED. The bloodstain
next to Cross marks the
spot where a fellow
soldier sliced
his arm open breaking
through a plate-glass
window during a
security sweep.

**08.29.2003//SPECIALIST EDOUARD H. R. GLUCK, U.S. ARMY//Ramadi**
This series of pictures captures the rescue, treatment, and evacuation of Staff Sergeant John Adams, a member of Gluck's battalion who was wounded during a routine patrol; he and his team were doing a morning sweep to check for roadside bombs when their vehicle was struck by one. "We had this conversation," says the photographer, "and Adams said, 'If I get hit, I want you to do the photos.' Guys say that, but they never think they're really gonna get hit. Adams did, just five days later."

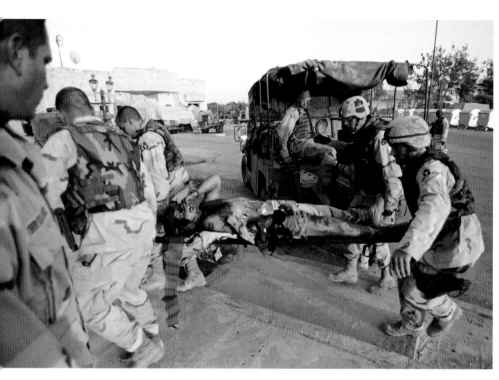

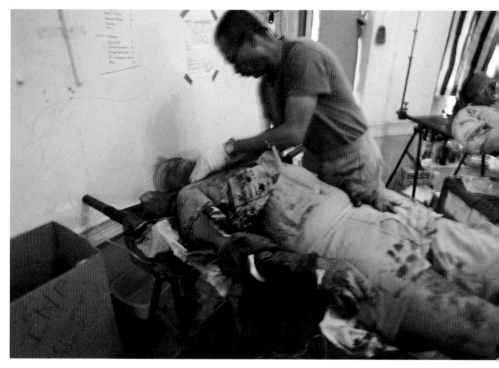

Medics at Hurricane Point, the battalion's headquarters, transport Adams from a vehicle to their field hospital. "You can see a lot of the clothing is ripped from the blast," explains Gluck, "and there is a guy behind him, Specialist Will Riddle, who got wounded in the face and almost lost his eye."

Adams is treated in triage at Hurricane Point. "There's a piece of paper hanging above his head on the wall—that's the Glasgow coma scale. It helps the medics know what to look for in terms of motor response." Gluck remembers: "At that point, they were losing him."

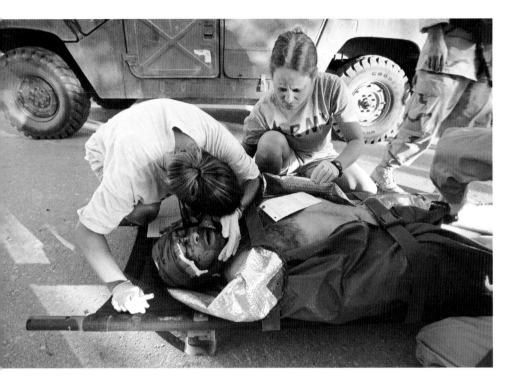

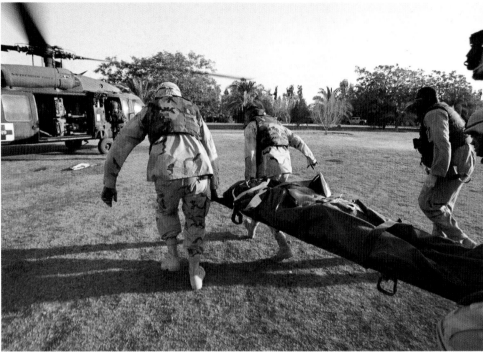

Lieutenant Connie Welch and Staff Sergeant Jeannie Diflauro, both nurses with the 3rd Armored Cavalry, continue to treat Adams as he waits to be evacuated by helicopter. "They could not get motor function from him, and he had already lost a lot of blood," says Gluck. The card resting on Adams's chest is a casualty feeder report, a form that identifies how soldiers are killed or wounded.

Adams is loaded onto a medevac helicopter, which will fly him to the 21st Support Hospital in Balad. From there he will be sent to Landstuhl hospital in Germany, where he will start a long process of recovery from the brain injury he suffered from shrapnel. Adams is currently living in Florida with his wife, Summer.

**06.21.2003**
**STAFF SERGEANT**
**STACY PEARSALL,**
**U.S. AIR FORCE**
**Baghdad International Airport**
The crew of this cargo plane
planned to take off before
daybreak, when rocket attacks
are more difficult. They
scrapped their deadline
to wait for a badly wounded
soldier who needed to
be evacuated immediately.

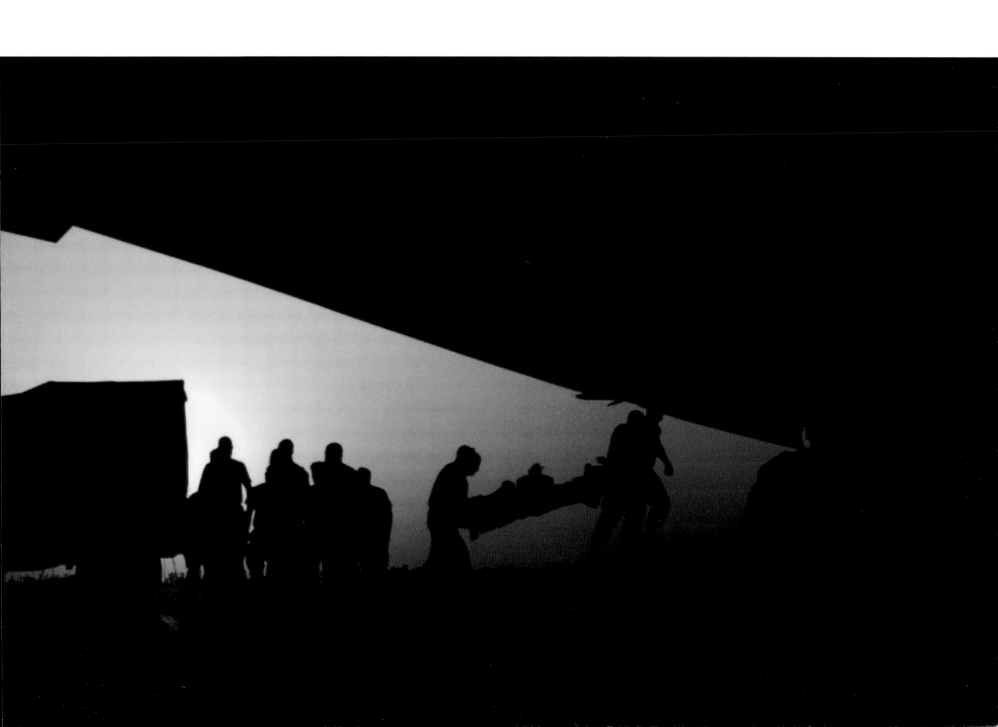

## A Soldier's Story
# THE HIGHEST HONOR

**Sergeant First Class Paul R. Smith** was posthumously awarded the Medal of Honor on April 4, 2005. He is the only American serviceman to have been given the medal for action taken in the Iraq War.

*Birgit Smith (Paul's wife):* Paul was born in Texas, but he moved to Florida when he was 9. He always had it that he would join the military, so when he came out of technical school, he enlisted in the army. I met him in Germany while he was stationed there, at a bar called the Green Goose. We dated for a while, and one day he took one of those golden rings off a Michelob bottle. He put it on my finger and said, "We're engaged now." We got married and came to the States. I had a daughter from a previous relationship, but soon I got pregnant with David, our son.

*Lieutenant Colonel Thomas Smith (Sergeant Smith's battalion commander):* If you look back over his career, the military was the transformation of Paul's whole life. This is a regular American kid who joins the army out of vocational school in Tampa. You can just track how, in operations like Desert Storm and Kosovo, he internalized the idea that he was going to be accountable for a group of men. He had to make sure that they were ready.

*Birgit:* It was not long after he joined before he got orders to go to Desert Storm. It seemed like he had walked into the war as a boy, and when he came back he was an adult.

*Sergeant Matthew Keller (member of the platoon Sergeant Smith commanded):* Everybody knew that he wanted us to give 100 percent all the time. He was a strict-discipline guy.

*Birgit:* Paul got his name in the army as a bad guy. I mean, I wouldn't want to have been one of Paul's soldiers.

He left for Iraq the day before our eleventh anniversary, January 23. I didn't get to hear too much from him while he was there. First of all, Paul was not a writer. He never wrote long letters or anything. The last email he wrote me was to say that if I didn't hear from him, that meant they were

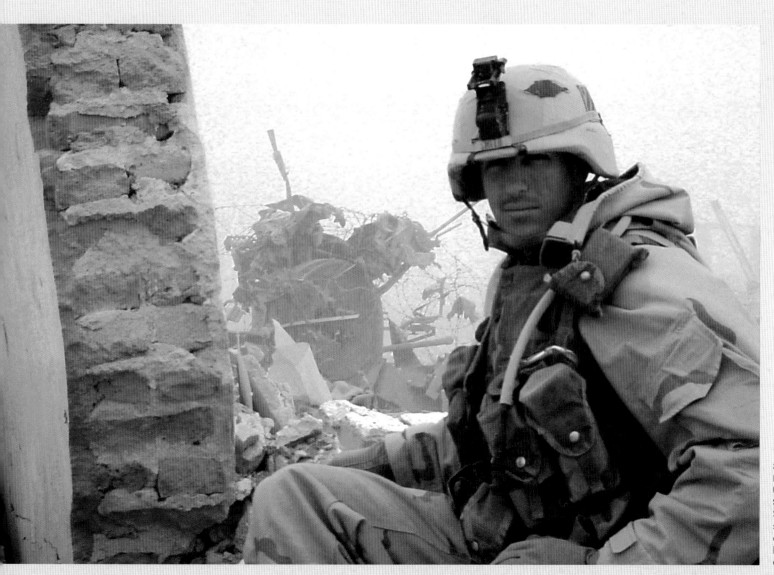

3.30.2005
**PHOTOGRAPHER**
**UNKNOWN**
**Southern Iraq**
Sergeant Smith is
shown here after
crossing the Kuwaiti
border in the opening
days of the war.

moving towards Baghdad. That was around March 15.

*Keller:* Early on the morning of April 4, we pulled into Baghdad International Airport. We were going to build a prisoner-holding area because another unit had detained some Iraqi soldiers. Sergeant Smith had our platoon start to do the construction in this little enclosed courtyard. But while the squad was working, we spotted about a hundred dismounted enemy soldiers moving towards us. Sergeant Smith reacted and called for a Bradley, and it pushed through the gate and went for the enemy. I was going to go around the wall towards the enemy, but Sergeant Smith kind of pushed me aside and said, you know, that he was gonna go first. We had called for another vehicle, an M113, which is an armored personnel carrier. Then, at a certain point, the Bradley was hit with an RPG, and at that same time, a mortar round hit the M113, injuring all three of its crewmen. The scout I was with—I never did find out his name—was wounded, so he and I stayed on the friendly side of the wall, firing grenade rounds over it. I didn't really see what Sergeant Smith was doing, but I know he took charge getting the wounded soldiers out of the area. Then the Bradley started backing up, and I had to jump out of the way so I didn't get run over. Nobody knew why the Bradley was leaving at the time, but it had run out of ammo. At that point, the enemy soldiers increased their firing because they knew the Bradley was our main fire support. When I came back, I saw that Sergeant Smith had climbed onto the M113 and was firing the .50-cal. I knew he was exposed to enemy fire because of how high he was over the wall. He could be seen. I was yelling at him to get down, but he gave me the cutthroat signal, saying no.

*Smith:* When Sergeant Smith was firing at the Iraqis, the other soldiers could advance on the Iraqis that were causing the most problems. I doubt to this day Sergeant Smith knew the effect his firepower had.

*Keller:* I ran to get another Bradley out there, and as I was coming back, my attention got focused on something else. The next time I looked, I saw Sergeant Smith wasn't up there on the M113 anymore. I ran over to it, and it was turned sideways.

I asked where Sergeant Smith was, and Sergeant Kleesner told me he was gone. I was like, "What the hell you mean he's gone?" Then I opened up the door to the vehicle, and he was laying there not moving. I had a feeling he was dead.

*Smith:* I was probably less than a mile away, and my sergeant major came over and told me. I went over to the platoon. Everybody's filthy, and they were leaning up against the tires, sitting there, some of them shaking pretty badly. I remember one of them saying, "Sir, we did everything we could," and that just floored me, because it was as if there was some doubt in my mind that that was the case. There was never any doubt. Never.

*Keller:* When the Bradley pulled out, Sergeant Smith was the only one who had been keeping the Iraqis from coming through the wall. He saved all of our lives.

*Birgit:* It was an awesome thing he did, to make sure they made it home. But for me it was nothing. Because Paul would have done it any day, for anybody. Paul was always there for his soldiers.

*Smith:* People ask me, "Why is he the one guy who got the Medal of Honor? Surely there are soldiers doing heroic things all the time." And I agree with that. But on that day, all of the American systems—all the firepower, and the different electronic equipment, and the aircraft flying overhead—didn't come into play. At that moment, it was just an American platoon with individual weapons firing against Iraqis with individual weapons. And Sergeant Smith puts himself in a position, completely exposed, to engage the enemy until his men are safe and the Iraqis are defeated. He's going to stay up there until that mission is completed, because his men were threatened. And that's where he went above and beyond.

*Birgit:* At first, when they told me that Paul was going to get the Medal of Honor, it didn't mean a lot to me. Because no matter how high the medal is, it doesn't get Paul back. But over time, we learned more about the medal and what a big honor it is. And in D.C., seeing the president in person and having our son David receive the medal for Paul, I really found my closure. Paul's a part of history now.

# 4. TOURISTS IN IRAQ

⇩

"THERE WAS AN IRAQI WOMAN WHO GAVE TOURS OF THE RUINS TO SOLDIERS FOR A DOLLAR. BUT IT'S HARD TO REMEMBER THE DETAILS. SHE DIDN'T SPEAK GREAT ENGLISH."
—CAPTAIN JEROD MADDEN, U.S. ARMY

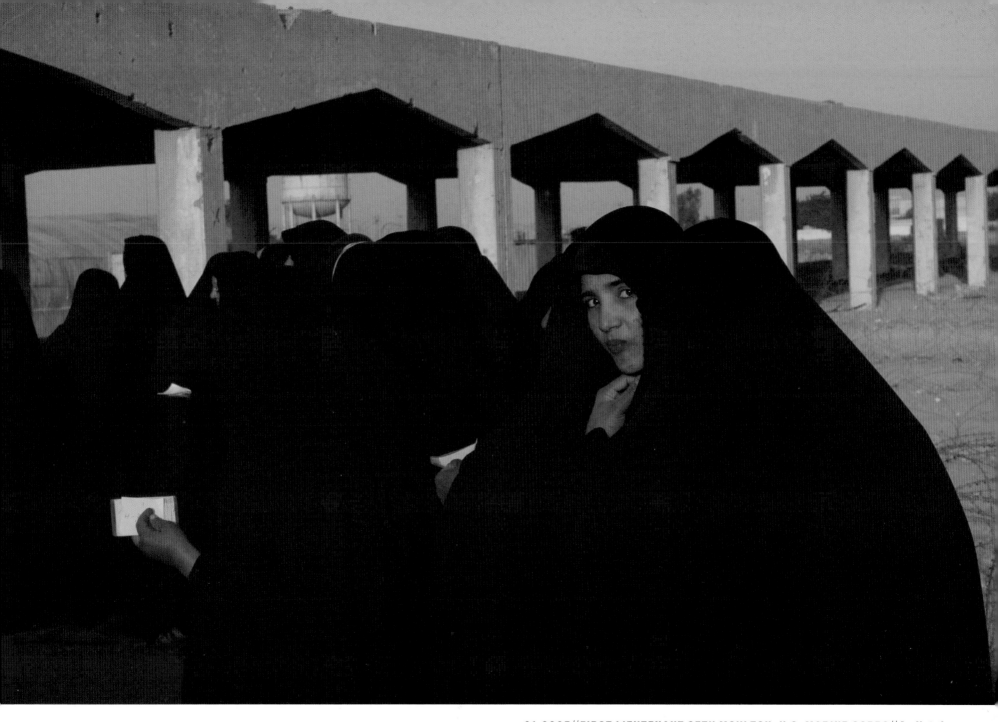

**01.2005//FIRST LIEUTENANT SETH MOULTON, U.S. MARINE CORPS//An Najaf**
After the fighting that broke out in August 2004 in An Najaf, which left parts of the city destroyed, the 11th Marine Expeditionary Unit developed a program
by which Iraqi civilians could receive cash compensation for the damages they'd suffered. Here, a group of Iraqi women wait in line to file their claims.
While many filed claims for property damage, some were there to receive money in exchange for lost loved ones. "It's hard for Americans to understand,
but it is considered acceptable to pay money to compensate for loss of life," says the photographer. "It seems cynical, but there's an acceptable price if you
lose a son versus if you lose a father. A father provides for a whole house, so that means more money. We were trying to give these people a new start."

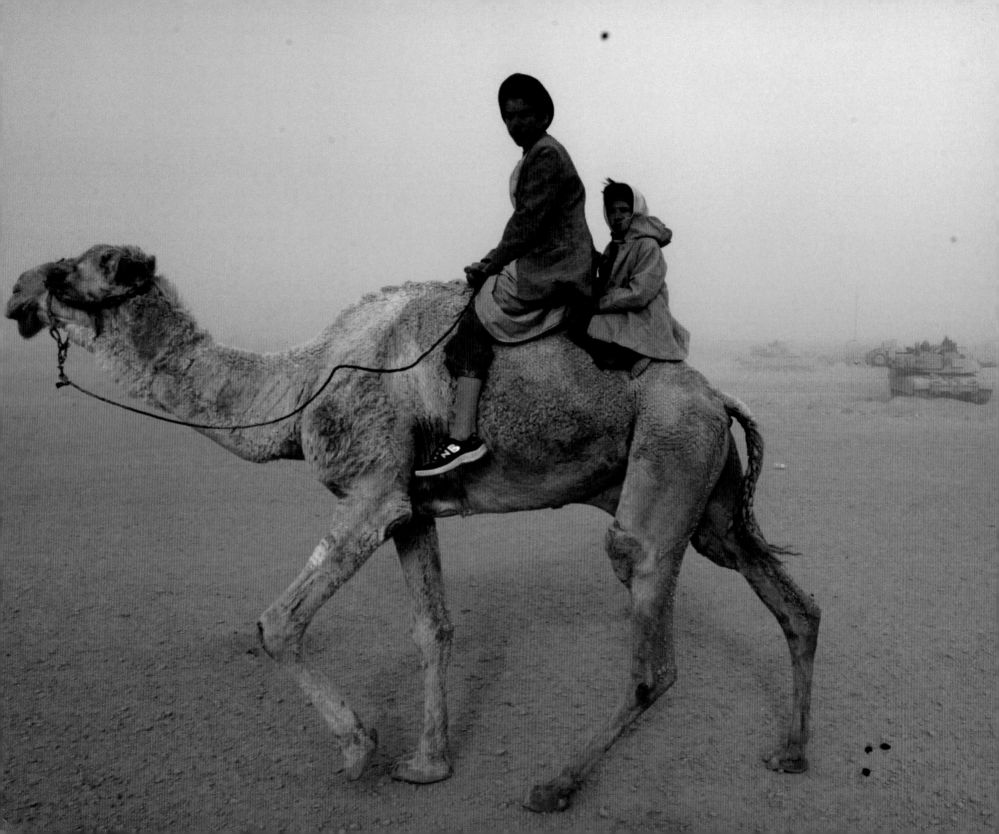

**03.2003**
**FIRST LIEUTENANT**
**TRAVIS HOWELL,**
**U.S. ARMY**
**Southern Iraq**
During the first days
of the invasion, Howell
and the rest of the
70th Armor Regiment
rode their tanks and
support vehicles from
Kuwait into Baghdad.
This picture was taken
between the Kuwait
border and An Nasiriyah.
It was the second or
third of 360 days that
Howell would spend
in Iraq during his first
deployment. "Up to this
point, we had seen
nothing but sand
and camels," says the
photographer. "The
camels were not at all
afraid of the tanks and
the noise they made.
It was actually hard
to get them out of
our way sometimes."

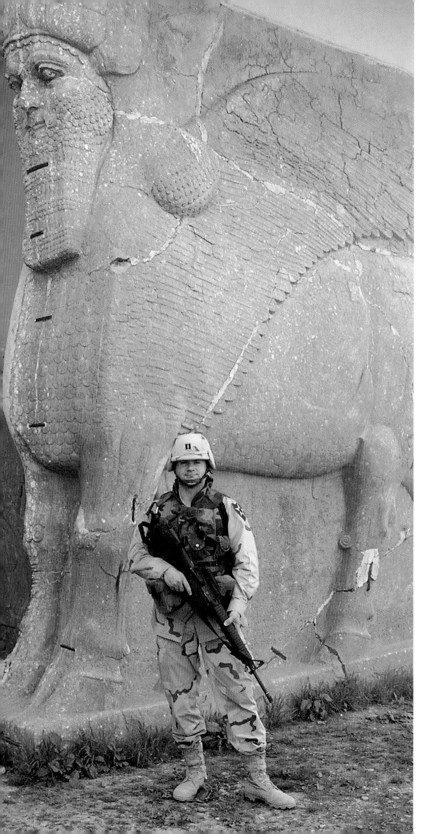

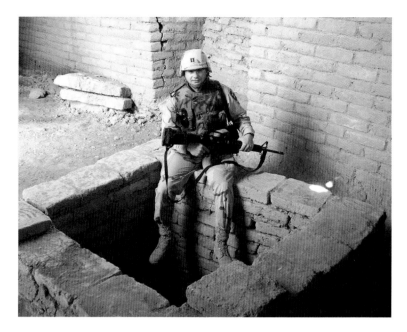

**03.15.2004**
**PHOTOGRAPHER**
**UNKNOWN**
**Outside Mosul**
Captain J. Philip Ludvigson,
a public-affairs
officer, accompanied
a group of U.S. troops
and local Iraqi officials
on a fact-finding mission
to what was once the
ancient Assyrian city
of Nimrud, south of
Mosul. He is shown here
in front of the palace
entrance (left), and by
a royal tomb (above).
The purpose of the tour
was to plan for the area's
preservation. "Because
it was outside the city of
Mosul, its structures had
been neglected," Ludvigson
explains. "We were there
to find ways of keeping
these things from eroding,
preserve the history,
and possibly to increase
tourism someday."

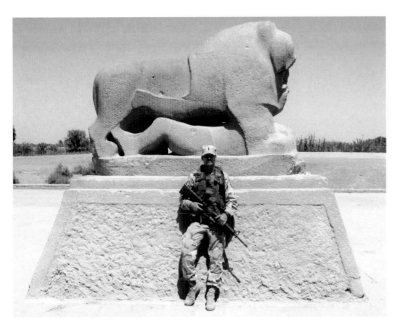

**SUMMER 2003
SERGEANT
TIMOTHY WELLS,
U.S. ARMY
Near Al Hillah**
Captain Jerod Madden,
an executive officer
with the 151st Postal
Company, stands in
front of a statue of
a headless lion in the
ancient city of Babylon.
Madden was stationed
in Baghdad but made
the trip here to scout a
mail-delivery route for
an American base. "As
it turns out, there was
an Iraqi woman who
gave tours of the ruins
to soldiers for a dollar,"
Madden says. "But it's
hard to remember
the details. She didn't
speak great English."

**11.2003
FIRST LIEUTENANT
RYAN KELLY,
U.S. ARMY
North of Qayyarah**
The photographer, a
rifle-platoon leader, saw
this building many times
during patrols with the 1st
Battalion, 327th Infantry.
"I would always wonder
how old it was and what
it was originally built
for," he says. "The day I
took this picture, it was
as beautiful a day as it
can get in Iraq, and the
picture turned out great."

**04.2003
CHIEF WARRANT
OFFICER
BRENT McKINNEY,
U.S. ARMY
Baghdad**
The photographer was
attached to the
3rd Infantry Division
during its march from
Kuwait into Baghdad.
Upon arriving in
the city, he took this
photograph of a soldier
in a carriage rumored
to have been Saddam's.

**09.2003//PHOTOGRAPHER UNKNOWN//North of Baghdad**
During a raid on a foreign ambassador's house, Sergeant First Class Stephen D. McCane (pictured)
and his unit discovered millions of dollars in cash and hundreds of weapons. But the real
surprise was behind a motorized curtain. "We saw this wall-sized mural with all these
naked babes on it," says McCane. "Everybody had their picture taken in front of these boobs."

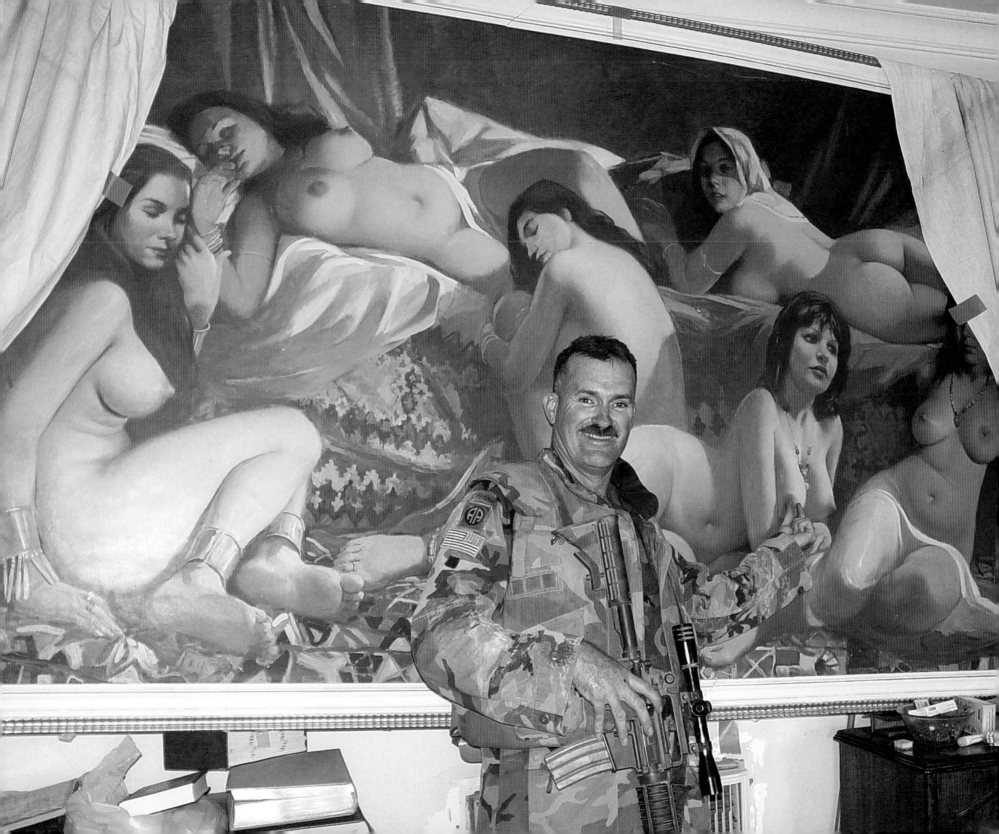

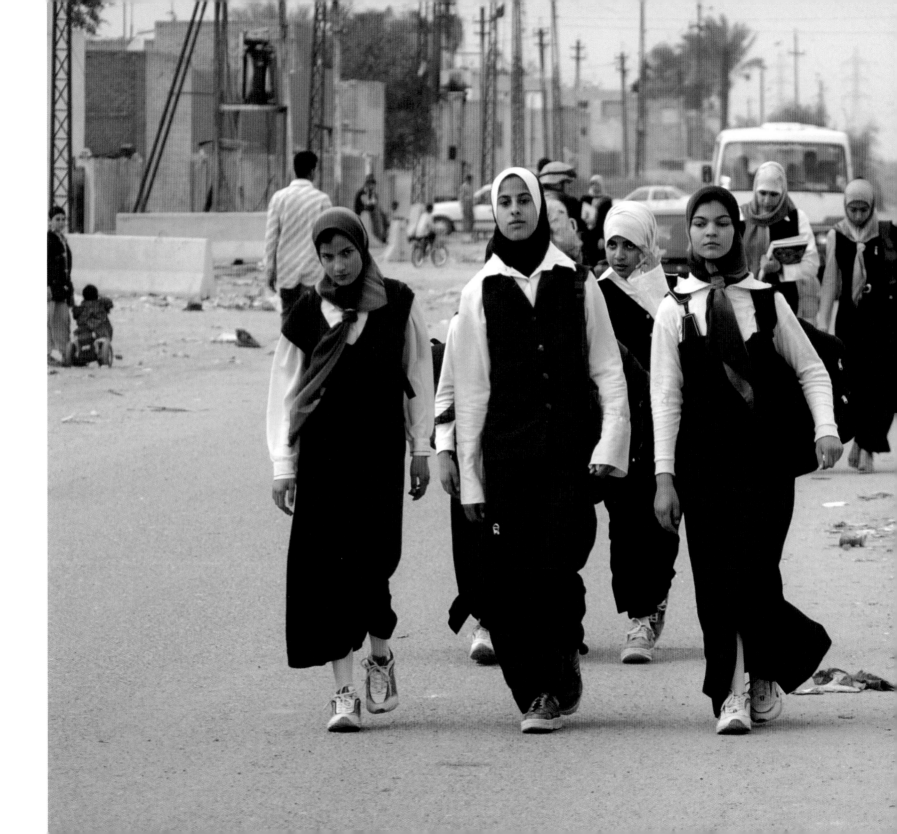

**03.08.2005**
**PETTY OFFICER**
**FIRST CLASS**
**BRIEN AHO,**
**U.S. NAVY**
**Iskandariyah**
In Iraq, soldiers like this
one from a Mississippi
National Guard unit were
told to be careful of local
sensibilities regarding
women and girls while
they were out patrolling.
"We didn't approach them,
we didn't talk to them,"
says the photographer.
"We weren't supposed
to look at them." And for
their part, these girls seem
to have the same idea.
"We weren't supposed to
take many photographs
of them either," admits Aho.

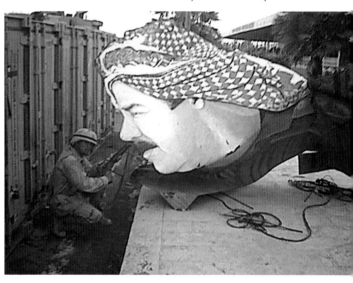

**05.2003**
**STAFF SERGEANT**
**JONATHON BLUE,**
**U.S. ARMY**
**Tikrit**
"There was this big
metal mural," says
the photographer, who
took this self-portrait.
"And I was kind of
saying, 'When we find
you, mission's done.
Time to go home.'
And I was actually
part of the brigade
that caught Saddam,
two days before
my wife's birthday."

**01.2004//LIEUTENANT COLONEL MICHAEL PIERSON, U.S. AIR FORCE**
**Baghdad International Airport**
If you look closely, you can see the words BAD KARMA written across the windows of this Humvee,
which belongs to the 119th Military Police Company out of Warwick, Rhode Island. More visible
is a bobblehead of George W. Bush. "The bobblehead was something unique to this war," the photographer
says. "You wouldn't see one of FDR during World War II or of Johnson during Vietnam. This was us
saying that the Americans have a sense of humor, and here we come."

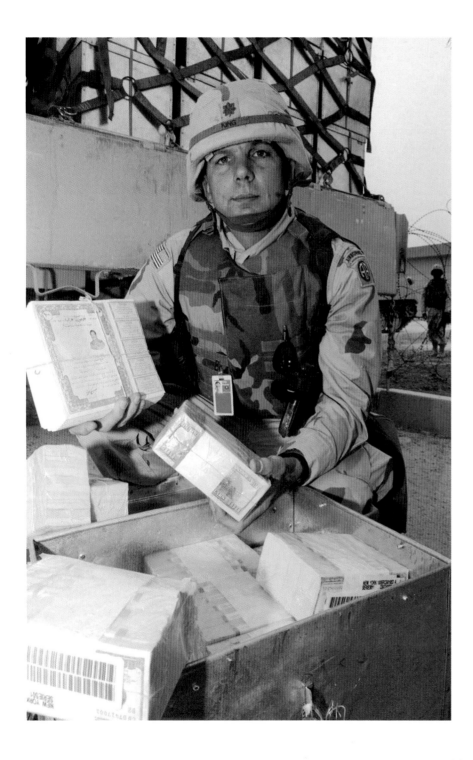

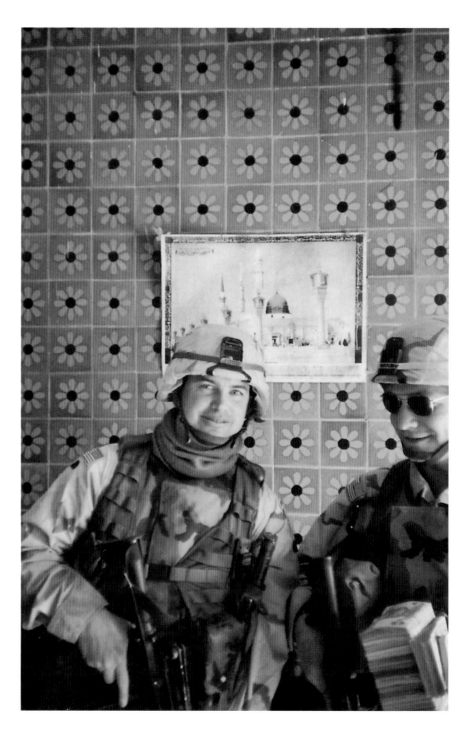

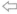
FAR LEFT

**04.19.2003
SERGEANT FIRST CLASS
DAVID K. DISMUKES,
U.S. ARMY
Baghdad**

Major Rodney King, an army finance officer, shows off stacks of bills and bonds that have just been discovered behind a wall in a shed on the grounds of one of Saddam Hussein's palaces. "They found about $650 million that day, supposedly Oil-for-Food Program money," says the photographer. "They loaded it all onto two five-ton trucks, and when they finished, I got to stand on top of a mountain of money— probably the last time I'll ever do that."

LEFT

**01.06.2004
PHOTOGRAPHER
UNKNOWN
Baghdad**

Staff Sergeant Jeffrey Fyderek and First Lieutenant Kelly McCay get their photo taken in an Iraqi telephone station. McCay holds a pile of Iraqi dinars that will pay for telephone services his communications unit was helping set up for the city government. Despite the satisfaction he got from assisting the Iraqis, McCay likes this particular photo for another reason: "The sunflower wallpaper— that's straight-up 1960s. It's like, 'Hey, where's the beanbag chair?'"

**05.2003
LIEUTENANT
JOHNNY V. RODGERS,
U.S. NAVY
Al Kut**

Lieutenant Commander Michael Nick (pictured) and the photographer were walking by a shed when they saw a half-million dollars' worth of recovered Iraqi dinars piled inside, under Marine guard. "We asked the guy in charge if we could play in it," says the photographer. "He said, 'Sure, go ahead.'"

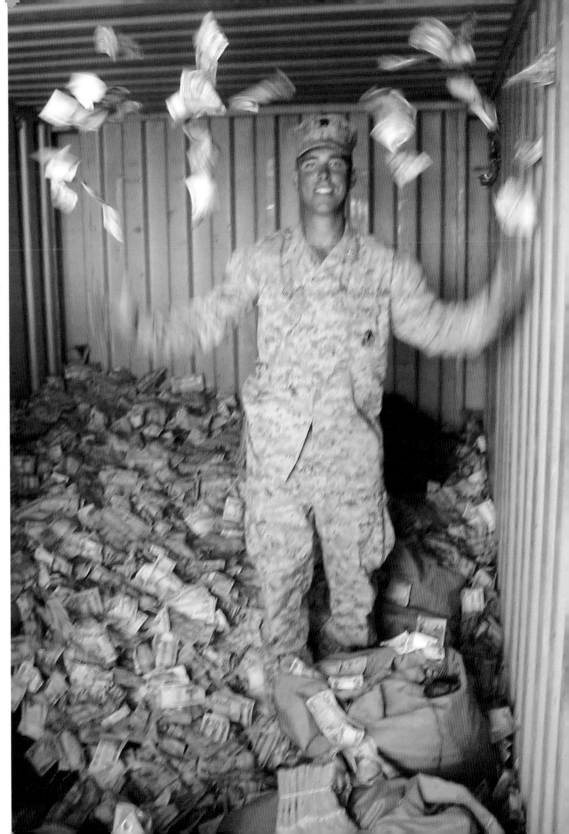

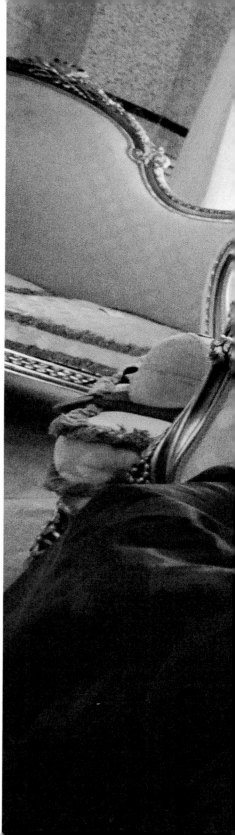

**10.2003**//**SPECIALIST EDOUARD H. R. GLUCK, U.S. ARMY**//**Central Baghdad**
"Soldiers and sleep are a notoriously bad combination," says the photographer. "Soldiers don't sleep."
Here a young enlisted man is caught in a rare moment of slumber—passed out under his poncho liner
on a chair in one of Saddam's more opulent palaces. The building was turned into a Coalition headquarters
and, on this day, the site of High Holidays services for Jewish members of the 1st Armored Division.

**05.2003**//**CAPTAIN JOHN WAYNE PAUL, U.S. ARMY**//**Tikrit**
These medics were stationed near a palace where Saddam had
diverted the Tigris River through his private pool. One 130-degree
day, they decided against orders to have a swim. When their commander
caught them, they explained that they were "taking water samples."

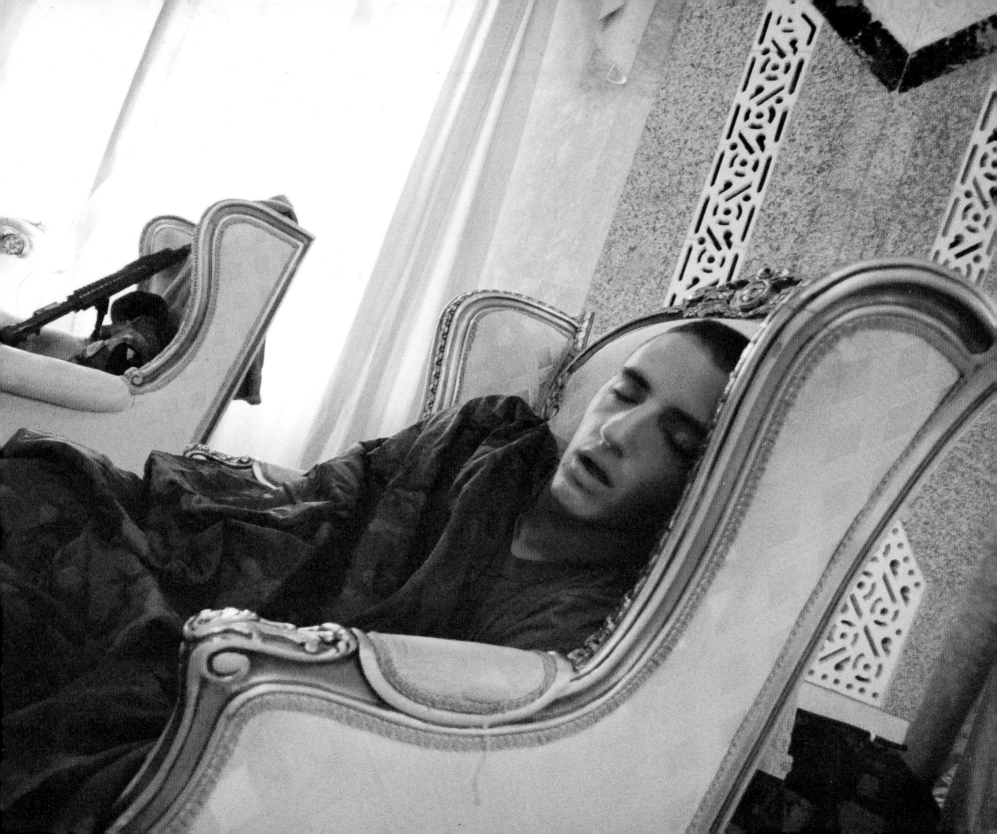

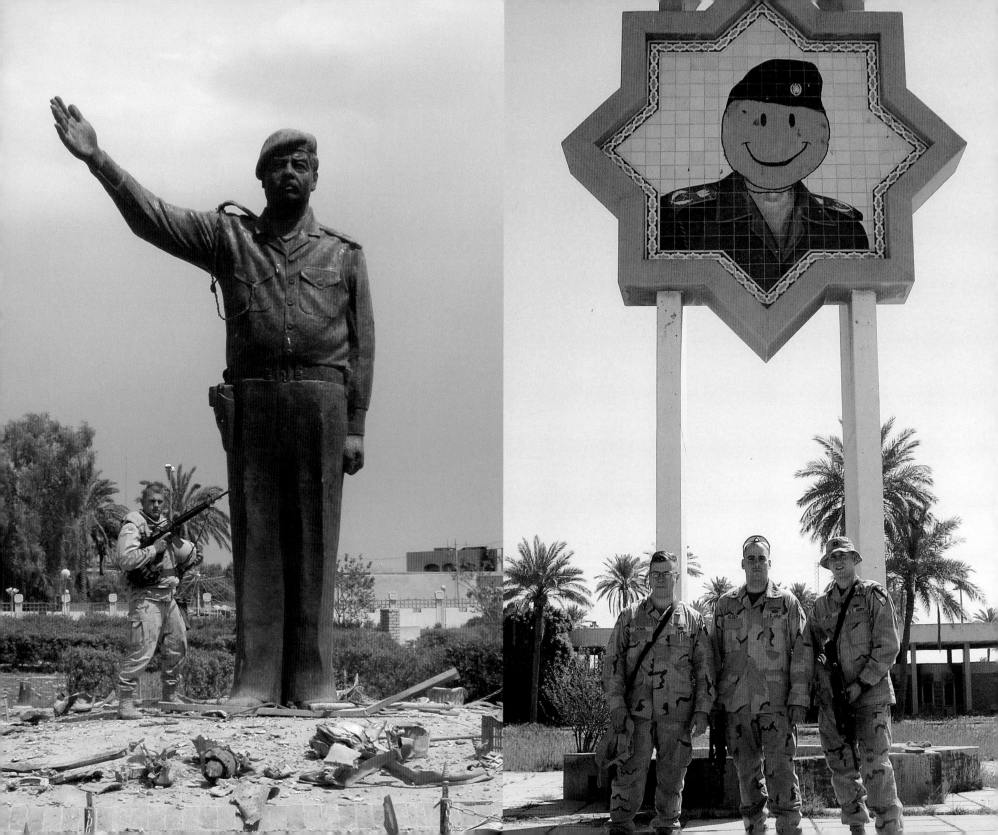

FAR LEFT

**03.2004**
**PHOTOGRAPHER**
**UNKNOWN**
**Baghdad**
**International Airport**
A soldier with the
3rd Infantry Division
brandishes his weapon
next to a statue of
Saddam Hussein.
The building in the
background served
as the Coalition's
aviation headquarters.
Photo contributed by
Brent McKinney.

LEFT

**03.2004**
**CAPTAIN**
**JEFFREY M. GARDNER,**
**U.S. ARMY**
**Baghdad**
Units from the 5th Cavalry
spent seven months
maintaining stability in
the Kadhimiya district,
where three soldiers stand
beneath what had been a
picture of Saddam. "I was
told there was an order
to paint over all Saddam
pictures with a smiley face,"
says the photographer.
"Later they took them all
down. This is probably
one of the last."

**05.2003**
**CAPTAIN**
**JEROD MADDEN,**
**U.S. ARMY**
**Baghdad**
Tim Wells, a supply
sergeant with the
151st Postal Company
from Fort Hood,
Texas, stands atop
the famed crossed
swords monument in
downtown Baghdad
after Coalition forces
took control of the city.
Two massive steel
sabers extend to form
a gigantic arch, marking
the entryway to a
popular parade site
during Saddam's rule.
The hand gripping
the sword is modeled
after Saddam's,
and the helmets
enclosed in the netting
were collected
from Iranian soldiers
killed during Iraq's
eight-year war with its
neighbor in the 1980s.

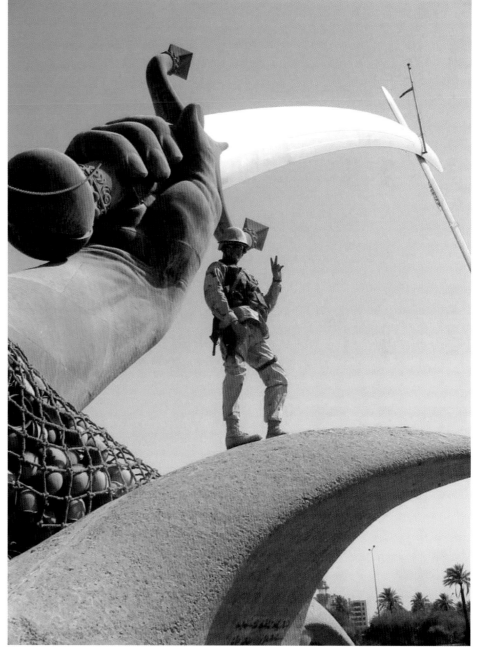

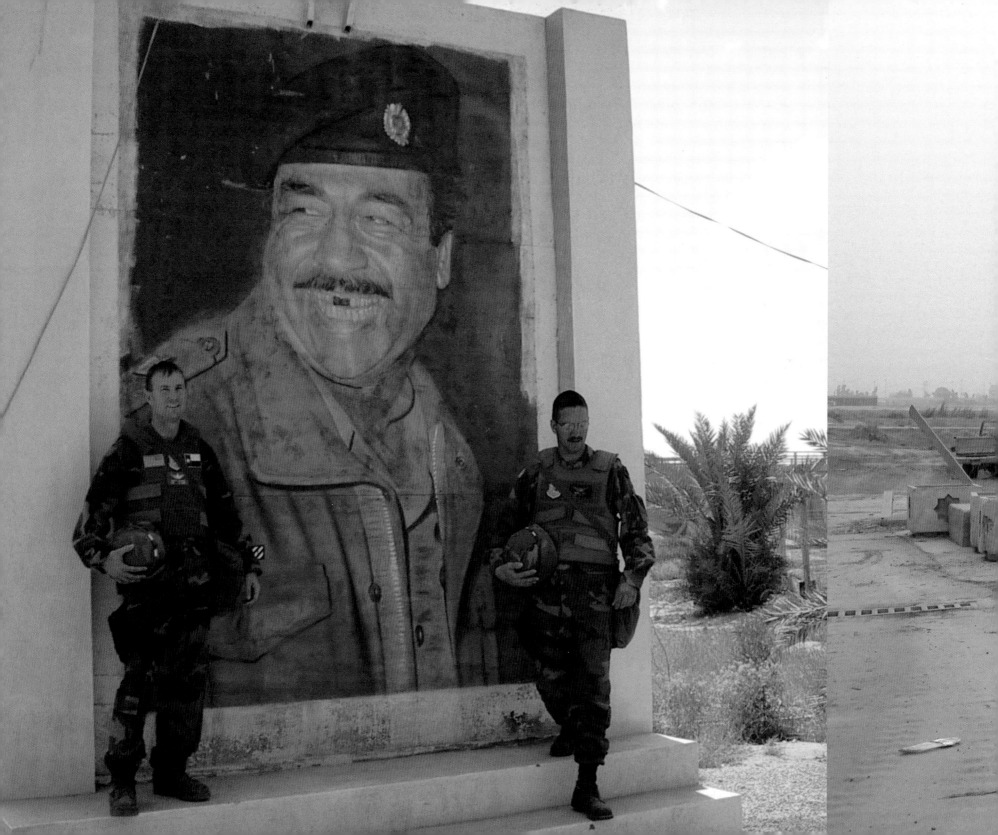

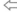

PREVIOUS PAGES, LEFT

**04.2003**
**CHIEF WARRANT OFFICER**
**ROD PETERSON,**
**U.S. ARMY**
**Baghdad International Airport**
Chief Warrant Officer Brent McKinney (left) and
Sergeant Brian Resh from the 507th Medical
Company pose next to a vandalized portrait of
Saddam Hussein outside the airport. "The guy had
pictures of himself everywhere," says McKinney,
who contributed the photo. "He was smart about
this one—it was made out of tile so it wouldn't
weather or fade easily. Guess he didn't want anyone
to forget who was boss."

PREVIOUS PAGES, RIGHT

**03.2003**
**PHOTOGRAPHER UNKNOWN**
**Baghdad International Airport**
Soldiers often used the numerous portraits of Saddam
Hussein around Baghdad as their own canvases.
Here, at an entrance to the airport, a mosaic of
Saddam displays the handiwork of the 101st Airborne
Division (their insignia appears to the right of Saddam's
head and again on his right arm). Not all taggings were
so official, though: The same American unit wrote I
LIKE BOYS down the length of the former president's tie.
Photo contributed by Brent McKinney.

**09.2004//SERGEANT BRIAN MOCKENHAUPT, U.S. ARMY//West of Baghdad**
"The economy isn't really kicking in the area where we were," the
photographer says."So these kids were doing pretty well with their little concession
business. Of course, why they weren't in school is another question."

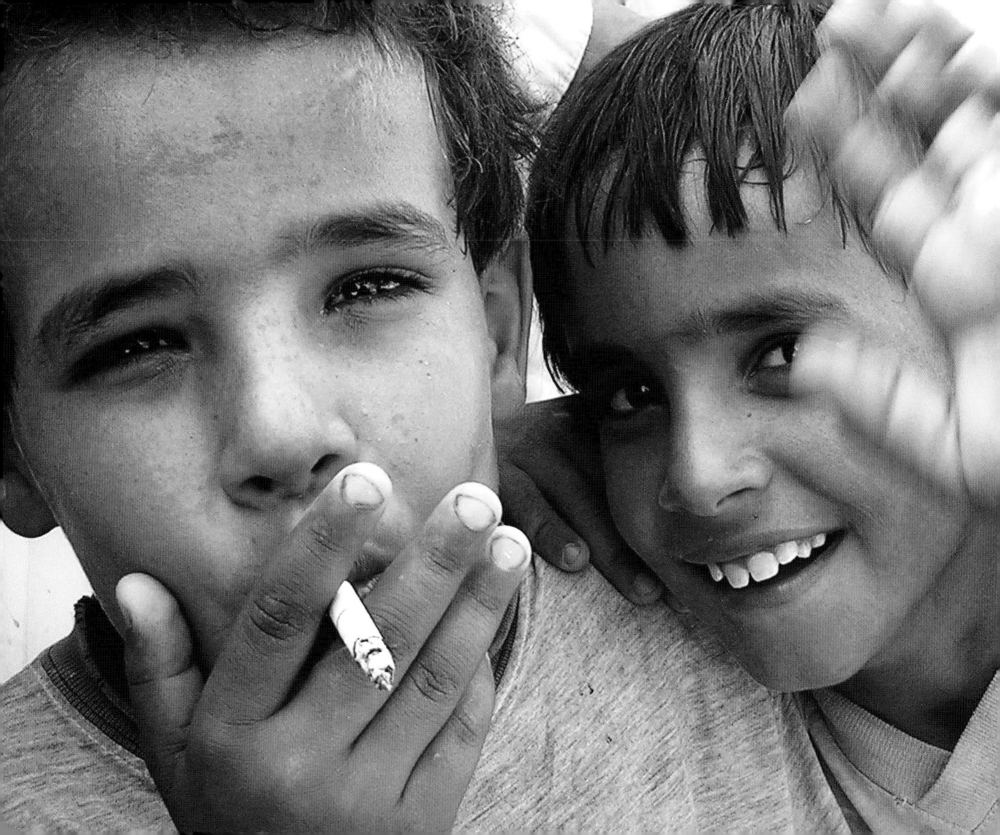

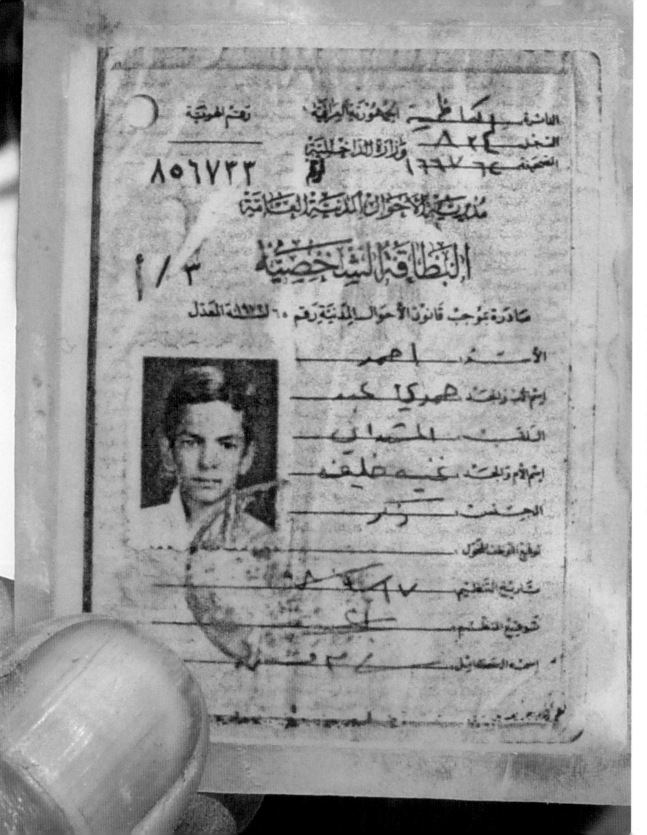

**05.2003
COLONEL
CHARLES IKINS,
U.S. MARINE CORPS
Mahawil**

In 1991, following the Gulf War, Muslim Shia in southern Iraq rose up against the regime, killing local Baath Party officials. The revolt was crushed, and the Shia population was rounded up and executed. At right, victims' relatives make their way along a line of remains recently unearthed with a backhoe, looking for identification. At left, the photographer holds the ID card of a boy who was killed in the massacre. "Everyone knew what had happened and where they were buried," says the photographer, one of five Marines sent to the site to investigate. "They even knew the people who did it, because they used local Baath Party guys to essentially act as executioners." This grave was reported to have held over 10,000 bodies.

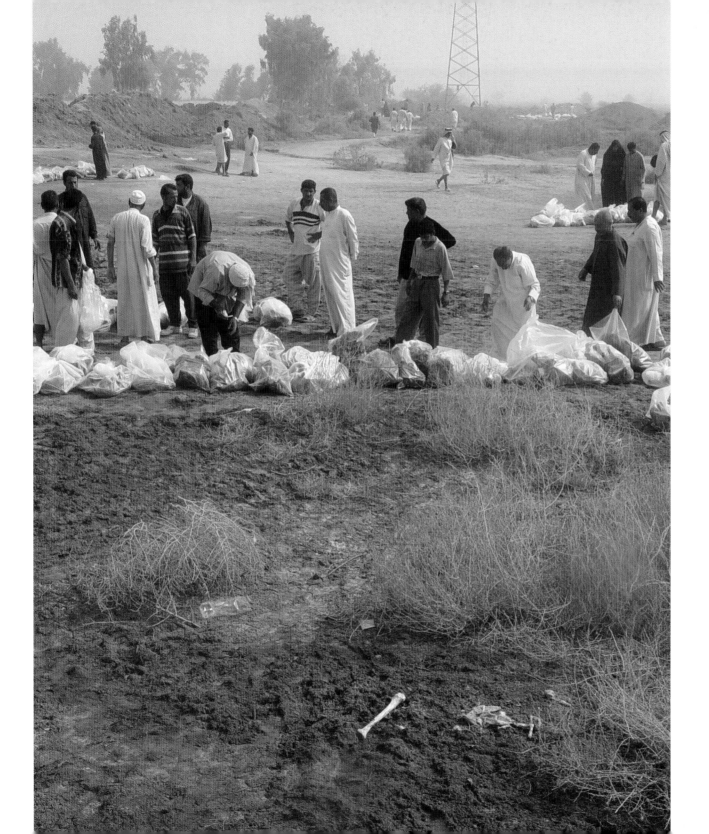

**10.28.2004**//**FIRST SERGEANT BOB WEIBLER, U.S. ARMY**//**East of Taji**
Specialist Joseph Monday, a mechanic with the 3rd Battalion, 153rd Infantry,
rescues a Hummer that had broken down earlier that morning, while an
Iraqi sheepherder looks on. "He showed up five or ten minutes into our little
operation and hung around for quite a while," explains the photographer, whose unit
was tasked with patrolling the area around Taji, twenty miles north of Baghdad.

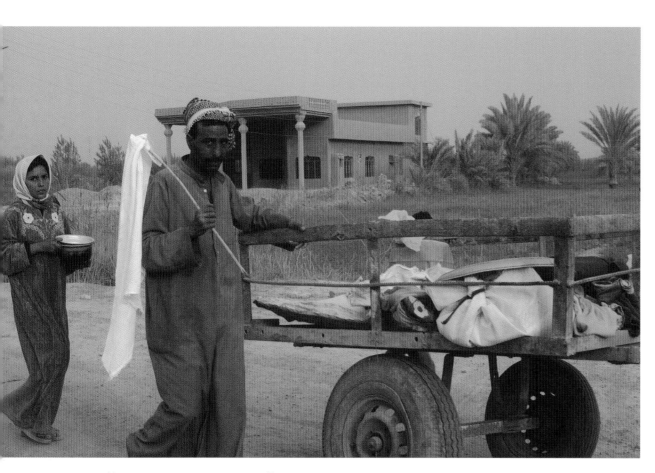

**04.2003**//**PHOTOGRAPHER UNKNOWN**//**Outside Baghdad**
An Iraqi civilian carries a white flag as he makes his way down a rural road. "This was
a pretty common procedure," says Brent McKinney, who contributed the photo. "Though it
wasn't out of the ordinary for guys carrying white flags to drop 'em and open fire."

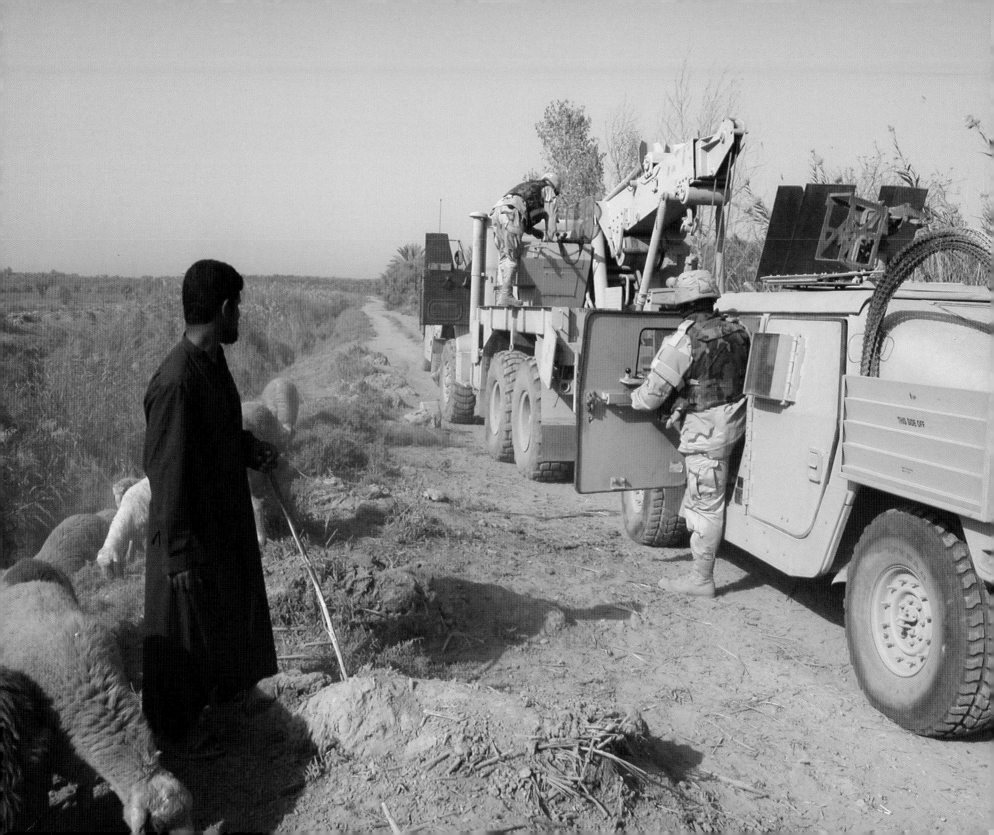

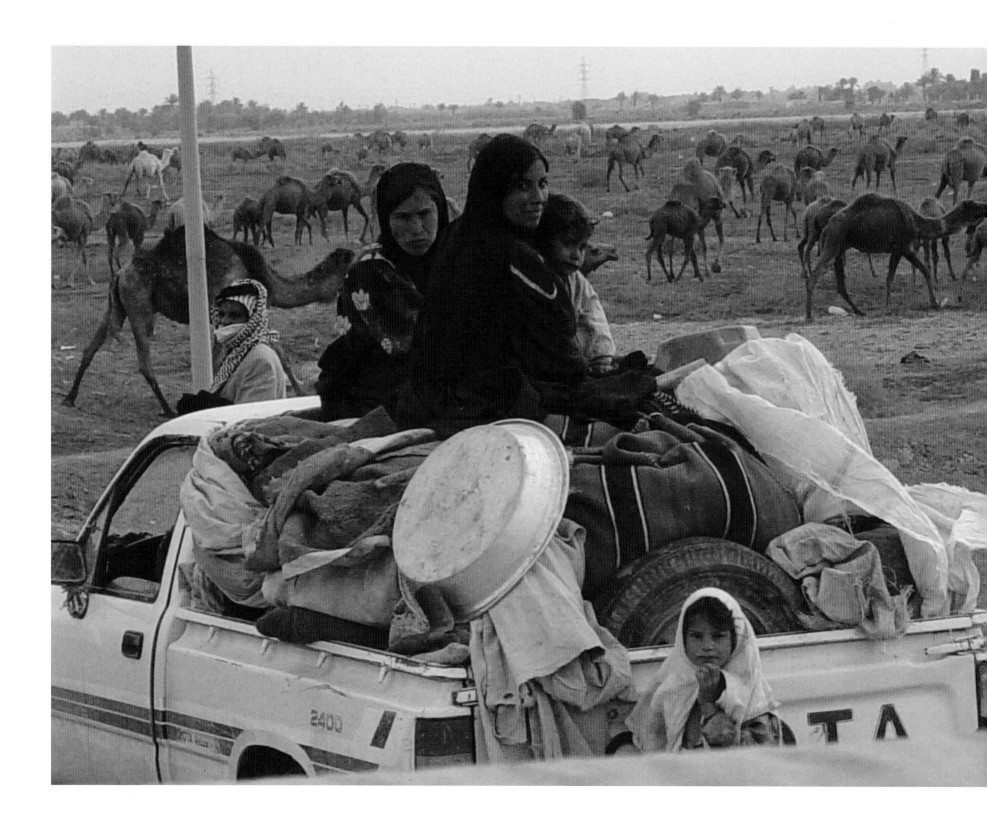

**04.2003**//**COLONEL CHARLES IKINS, U.S. MARINE CORPS**//**En route to Numaniyah**
Nomadic tribes of Bedouins have for centuries lived in the deserts of the Middle East, including Iraq, herding camels, living in tents, and passing freely throughout the region. "The Iraqis don't give them a second look, because they've always been there," says the photographer, who took this picture of a Bedouin family in the bed of a pickup truck, partially because he thought the mother was pretty. "They fly below the radar."

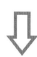

"THERE WAS SO MUCH GENEROSITY, EVEN FROM THE POOREST PEOPLE. YOU'D BE WALKING DOWN THE STREET AND THEY WOULD OFFER YOU TEA. AND THEY HAVE NOTHING. WE WOULD GO ON COMBAT PATROLS AND GO TO PEOPLE'S HOUSES TO CHECK ON THINGS, AND THEY WOULD IMMEDIATELY SEND SOMEBODY OUT FOR A GOAT TO COOK UP RIGHT THERE IN FRONT OF YOU. WE DIDN'T ASK THEM TO—THEY JUST DID IT."
—CAPTAIN J. PHILIP LUDVIGSON, U.S. ARMY

## A Soldier's Story
# ONE INFAMOUS PHOTOGRAPH

Until I was 17 years old, I never knew my father was awarded two Bronze Stars. Senior year in high school, we had to do a report on discrimination, and I did mine on the Vietnam veterans. My father spent twenty-three and a half years in the military, four and a half tours in Vietnam. He retired a Navy SEAL. I was snooping around through his military things, and I found his medals. At the time, I really didn't know what a Bronze Star was. Then, in the winter, I left for basic training, and I found out. You *did* something if you received a Bronze Star—they didn't just hand it to you. You had to put your life on the line. One he got because he went into a minefield and pulled out, I think, fifteen individuals, and I think half of them were already dead. When I came back from basic, for his birthday I had a display box built for both his Bronze Stars, and he now has that in his family room.

I joined the military pretty much out of high school, really to follow in my father's footsteps. I wanted to be like my dad, and I felt that was how I could make him proud of me. I had to lose 60 pounds, get down to 200, before I could sign the contract, and I did that in about a month and a half or two months' time. I really wanted to be an infantry soldier, but my dad told me that was one thing he didn't want me doing. My uncle was killed in Vietnam in 1966, and my dad said he couldn't lose someone else. I became a mechanic.

I was a reservist. We went to drill in November 2002, and the commander said we would most likely not be here for Christmas—we'd be in Kuwait. I went home and told my fiancée. I said, "Do you want to get married now or do you want to wait until I get back?" She said, "Can we find a preacher for next weekend?" Her name is Holly. She graduated from a rival high school. My wedding was a real small one; we actually put it together in a week. We got married November 30, 2002. I was 22 years old.

The first place in Iraq we were posted was Al Hillah, near Babylon. We were in a little compound that used to be a date warehouse. There were 180 of us living in an open-bay building; it was almost like living outside. And we had females right there with us—males and females sleeping beside each other.

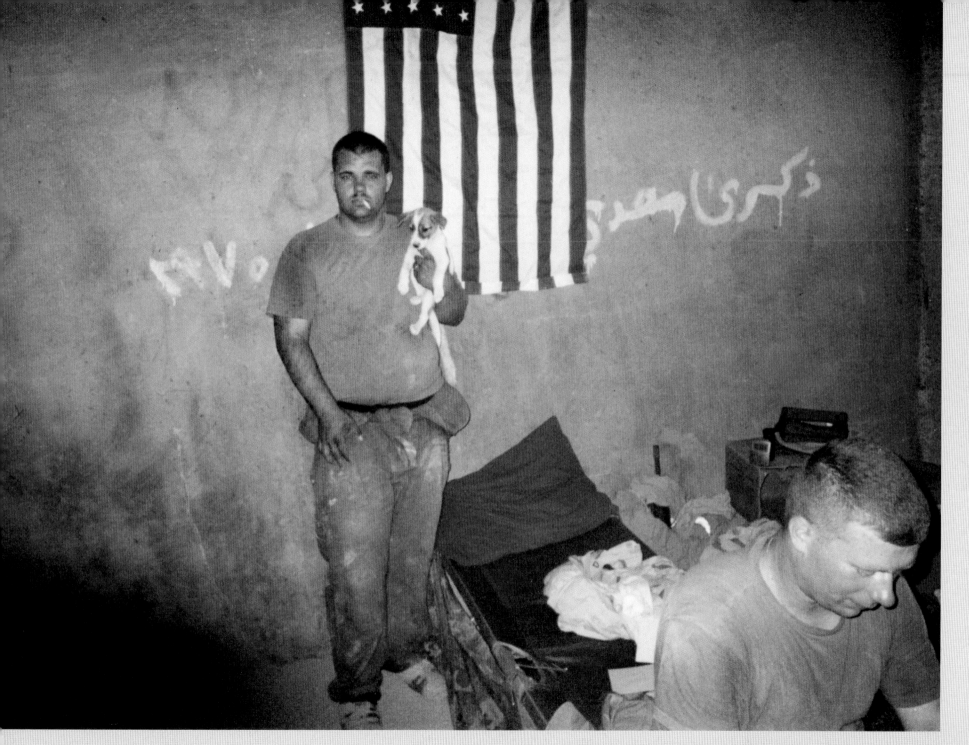

**05.31.2003**//**SPECIALIST BRANDON BROADWATER, U.S. ARMY**//**Al Hillah**
Specialist Jeremy Sivits was a mechanic with the 372nd Military Police Battalion. He appears here with his dog, Justice, which he bought from a local Iraqi boy on his first day in Al Hillah. "When my sergeant found me hiding it, he made me get rid of it," says Sivits. "So I gave it to our interpreter."

We decided we're all adults here, let's act like it and do what we have to do. Our mission was to train Iraqis to become IPs—the Iraqi police force. I pretty much worked in the motor pool, kept our trucks up, things of that nature. From there we got orders to report to Abu Ghraib.

Abu Ghraib was a very, very hard place to be. When we first pulled up, when we come up Highway 1, all we could see was a fifteen-foot concrete wall and guard towers. When we got inside, it was nothing but dust. And the stench was bad. Human stench. Inside the prison, it was actually dark; there wasn't solid lighting set up at that time. Even during the day, it'd be real dark inside. It was weird to be there, a weird feel, because it was where Saddam used to torture and kill people. It almost felt to me like I shouldn't even be here, like it was disrespectful.

We lived in old cells—that was our living area. I roomed with a 19-year-old kid, fresh out of basic training, who volunteered to go with us. He and I became really good friends. I was told that the prisoners were general ones, picked up for robbing or stealing fruit or whatever. I was told there were prisoners that tried to help enemy combatants. I wasn't told like, "This person was part of the Baath Party" or something of that nature. From what I saw, the prisoners who were in the tents had it harder, because they were outside. But I couldn't tell you about living conditions, because I didn't know. I worked in the motor pool, and I wasn't in the prison day to day seeing how they were being treated.

Of the mechanics, one man per night would go over to our company area to make sure the generators were kept with fuel. And it just so happened that that night it was my turn. This was early November 2003. I went over there about 1800 hours. And I really didn't have anything to do. I was sitting there talking to Staff Sergeant [Ivan L. "Chip"] Frederick, and he got a call on the radio that they had some detainees they had to in-process. He said, "Why don't you walk down with me? When I get done in-processing these guys, we'll go back to shooting the shit." I said, "Okay, no problem."

We went to the holding area. I'd never seen in-processing before. There were seven detainees and three or four MPs there.

The prisoners were a little scared because they were blindfolded. I asked Staff Sergeant Frederick, "Freddy, you want me to grab"— not "grab" but "escort"—"one of these detainees?" He said, "Yeah." So I led one down, and when I got into the tier where the cells are, that's when all hell broke loose.

When I walked in, I saw a pile of detainees lying on the floor. I put my detainee in the pile with the others. They were just lying on the floor, not really stacked but just jumbled. I didn't really think anything. I thought they were going to have them there and then start getting them ready to go in their cells. Like, that's where you want them, that's where I'll put them.

Corporal [Charles A.] Graner, a guy from my company, was yelling stuff in Arabic. I knew a little bit of Arabic, but I only knew "thank you," "hello," things like that. But Graner and some of the people were around the prisoners so much they actually knew how to talk. Corporal Graner wasn't the highest rank there, but he was giving most of the orders.

Graner would have them strip all their clothes off. They had them in the pyramid, the famous pyramid picture. There were people that were laughing and things of that nature. I was kind of a little disgusted, but not really knowing what was going on, and surprised because I didn't know people I knew could do stuff like that. But I was more or less going with what was happening. I was told by someone that we were doing what we were told. And I thought, okay, if you guys were told to do this, this is what you guys are doing.

That night there was a total of seven of us that were in there. The whole company, all us guys, were local; we were from a hundred miles of each other, pretty much. Our company is military-police officers working as prison guards. And we got that mission because we had law-enforcement people in our unit, state cops and deputies and prison guards.

When you're deployed a lot, people do take cameras with them and take a lot of pictures, because you're going somewhere new that you've never been. Almost every soldier that goes to Iraq has a camera with him—so you can remember things and show people where you were. I had a camera I didn't use that often, an

old Kodak that took film. I have pictures from, like, when we went out to eat at local restaurants. I have some pictures of things that we saw in Al Hillah. I took one picture at the prison that night, but it was with Graner's camera, a digital camera he had with him. He asked me to take it. The picture I took was of Graner. He was cradling a prisoner in a headlock position, and he had his hand drawn back like he was going to strike the detainee. I'm not sure if that one was published or not, to be honest with you. I don't have it. I don't have any of those pictures. And honestly, I don't want any of them.

I was probably at the tier for a total of a half hour. Things were still happening, but I just left. Two other guys were leaving, and I decided to leave with them. When my lawyer showed me pictures later, I was like, What in the world is that? More stuff happened after I left, and I would say it probably went further than that night. I really don't know, because I wasn't there that much. But I didn't get the idea that this was just something they were trying out for the first time.

I have no idea how the pictures got out. I think they were on *48 Hours* or something. All's I knew was that Specialist [Joseph M.] Darby [another man from Sivits's company] turned them in to the Criminal Investigation Division. When the pictures broke to the media, I was ashamed. I mean, I was disgusted. I felt that I'd let my family down, I'd betrayed my country, everything. I wish I could go back. I should have said something. I should have stopped it. But I didn't want anybody to get in trouble, because that's the kind of person I am. Those pictures being shown to the world—that was not a good thing. It heightened a lot of violence over there. It showed some people acting very stupid, including myself, and it showed things that really weren't the U.S. way. I know that I'm still respected by people in my own unit and by people in my hometown. But all those people out there who saw those pictures . . . It's hard for me to swallow.

I was in Iraq thirteen months before I was court-martialed. I got my first helicopter ride the day of my court-martial, actually. I was charged with dereliction of duty, one charge of conspiracy to maltreat, and a couple other charges—pretty much that I witnessed a crime and I didn't tell on it; I kept it hid; I had a silent agreement that it would not be told.

I was sentenced to twelve months. I did forty-five days in Kuwait, thirty-some days in Germany; then they moved me to Camp Lejeune, North Carolina, and that's where I finished up. I did, like, seven months there. It's not that hard there. I actually left the brig at seven or seven-thirty in the morning, and I didn't have to be back at the brig until three-thirty in the afternoon.

The harder part was telling my father. I called from Iraq and told him that I had got caught up in some stuff and that I was probably going to be in trouble. I didn't tell him exactly what it was, just that it happened when I was at the prison. He told me he'd be behind me a hundred percent. When I got home, it had been arranged that I'd get my first two years at the local VFW completely free; I didn't have to pay dues or things like that. Everyone in town was supporting me.

It really affected my dad. He started to realize a lot of things—that there were a lot of unanswered questions about Vietnam he didn't know. And he was able to come out and talk to me about it for the first time. It brought us closer. He told me that it had been a really tough time, a lot of stuff that he didn't realize had happened, but that he did a lot of good, too. So he knew what it was when I was discriminated against after this.

I'm 25 now. Locally, when people hear my name, they might be like, "Aren't you . . . Didn't you . . . Was that you?" I'm like, "Yeah, that's me." But overall, my name's forgotten. We've moved back in with my wife's father. Hyndman, Pennsylvania, is pretty much a small country town, a very, very tight-knit town. Most of the people work in factories. The only thing around, really, is Hunter Douglas, which makes window blinds, and American Woodmark, which makes cabinetry and stuff like that. But most of all, people move out of town. When they graduate high school, they go to college, and pretty much they don't look back. When I enlisted, at first I wanted to leave, too. But I pretty much like the small-town environment now. I realize how nice it is.

—FROM A CONVERSATION WITH FORMER SPECIALIST JEREMY SIVITS

⬇

"I HAD A NEWBORN. THE WAY YOU HANDLED IT, OR THE WAY I DID ANYWAYS, WAS TO PUT YOUR PERSONAL LIFE—I HATE TO SAY IT, BUT YOU PUT IT ON THE BACK BURNER. IT'S HARD TO DO, AND IT'S A HARD DISTINCTION, BUT THAT'S WHAT I HAD TO DO."

—SERGEANT JAMES BAUMGARDNER, U.S. ARMY

# 5. HOME AWAY FROM HOME

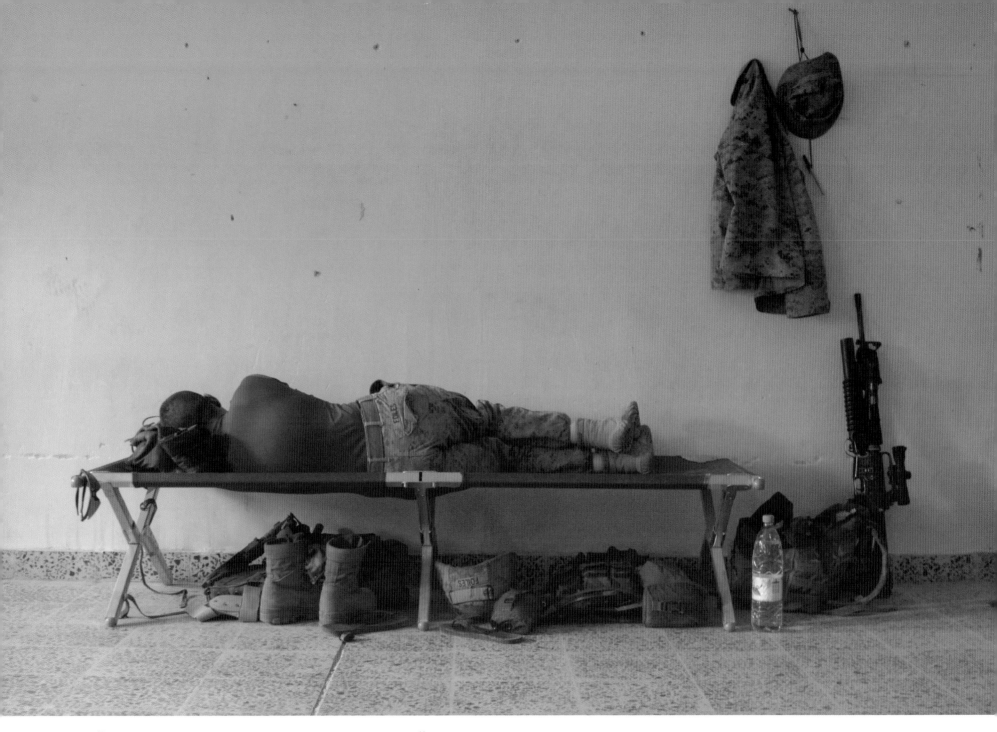

**10.2004//FIRST LIEUTENANT SETH MOULTON, U.S. MARINE CORPS//An Najaf**
Lance Corporal Ryan Foiles takes a nap after a morning of training Iraqi National Guardsmen at Camp Baker with the 1st Battalion, 4th Marines. "You're training them in the midst of a combat environment," explains the photographer, "so these are skills they might very well use that afternoon. It feels important. Our training will likely save some of their lives."

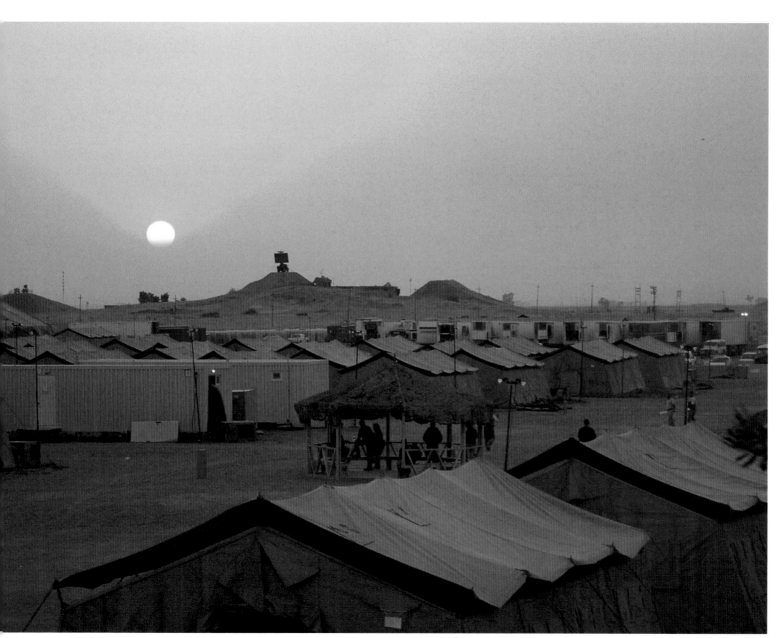

**07.2003**
**STAFF SERGEANT**
**MICHAEL TEEGARDIN,**
**U.S. ARMY**
**Kirkuk**
The photographer, an
intelligence analyst for the
military's Central Command,
captures his unit's base as the
sun sets through a blanketing
dust. Teegardin was part
of a small group that went
to Iraq after the war in order
to determine the effectiveness
of the army's air campaign.
"We looked at buildings and
structures that were targeted
and basically asked, Was
this what we thought it was?
Was bombing it effective?"

# "THESE IRAQI MORTAR MEN WOULD SET UP WHAT WE CALLED 'HIP-SHOOT' MORTAR ATTACKS, AND THEY WOULD FIRE ON OUR BASE AT DINNERTIME, SO GUYS WOULD BE SCARED TO EAT."

—SPECIALIST EDOUARD H. R. GLUCK, U.S. ARMY

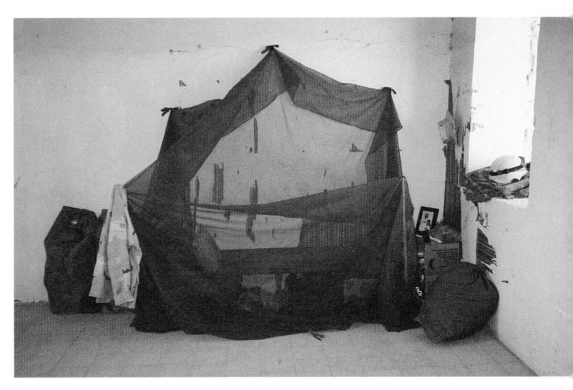

**08.2003**//**SPECIALIST MARK S. SHEPARD II, U.S. ARMY**//**Ramadi**
The photographer threw up a mosquito-net tent in an attempt to escape the sand fleas that infested this abandoned building in Ramadi. "They got through the holes, though," he says. "Within two days, everybody moved onto the roof."

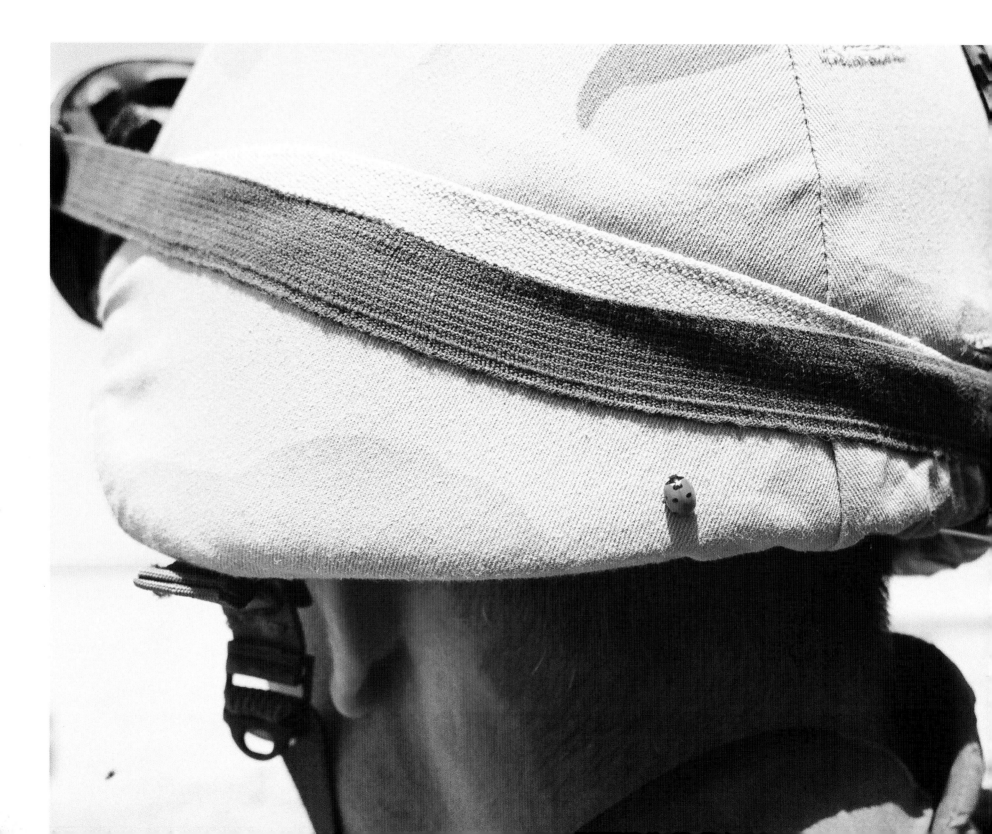

**04.2003
SPECIALIST
EDOUARD H. R. GLUCK,
U.S. ARMY
Jordan**
During a routine firing-range session, while troops from the 1st Battalion of the 124th Infantry were sighting weapons, a soldier is spotted with an unusual visitor on the back rim of his Kevlar helmet. "Nothing lives out there in the desert," says the photographer. "And here was this ladybug. I thought, This will never, ever happen again."

**04.2004
CAPTAIN
J. PHILIP LUDVIGSON,
U.S. ARMY
Mosul**
As violence in Iraq escalated during the spring of 2004, so did the number of baptisms performed by Chaplain Wayne Garcia. Here a female soldier is baptized in one of Saddam's bathtubs.

**04.2004**
**MASTER SERGEANT**
**CORTLAND CARRINGTON,**
**U.S. AIR FORCE**
**Al Udeid Air Base, Qatar**
"I wanted my wife to see
my housing," says the
photographer of this shot
he sent home to his wife,
Rebecca, 8,000 miles
away in Abilene, Texas.
He was living at this base,
which fed troops into
and out of the Iraqi theater.
"What you see in the
photo is housing facilities.
You'd better remember what
building you live in, because
they all look the same."

"EACH ROOM IS TEN FEET DEEP BY TEN FEET WIDE AND SLEEPS TWO TO FOUR PEOPLE, WHICH IS PRETTY SAD WHEN YOU THINK THAT MAXIMUM-SECURITY PRISONERS GET ABOUT THIRTY TO FIFTY SQUARE FEET EACH. MUST BE NICE!"
—MASTER SERGEANT CORTLAND CARRINGTON, U.S. AIR FORCE

**11.16.2003//TECHNICAL SERGEANT LISA ZUNZANYIKA, U.S. AIR FORCE//Baghdad International Airport**
The photographer finds Senior Airman Shari Alicea, a member of a services squadron, in an idle moment at a food-distribution center.
Alicea's unit was responsible for allocating MREs to troops deployed at Baghdad International Airport.

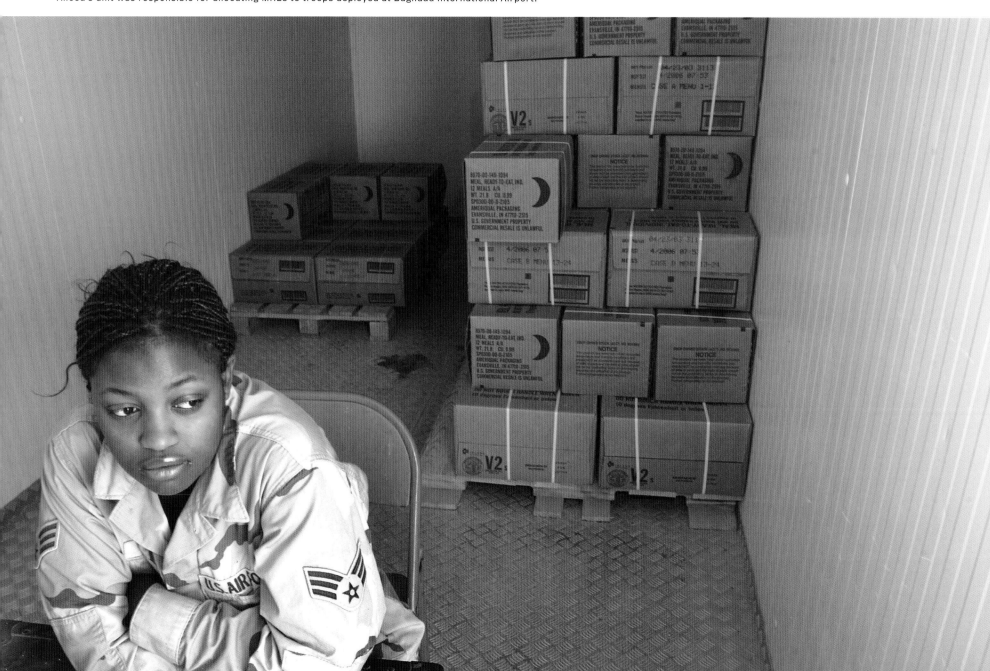

**03.28.2003**
**PETTY OFFICER**
**FIRST CLASS**
**AARON ANSAROV,**
**U.S. NAVY**
**Southern Iraq**
Mess specialists
Jessica Rose Littlefield
(left) and Emily Adine
Sylve were members of
Naval Mobile Construction
Battalion 74. "We were
a bunch of stinky guys
and girls out there," the
photographer says.
"We went a good two
weeks without showers,
and we had a little
downtime, so they took
the opportunity to wash
their hair and comb
some of the knots out."

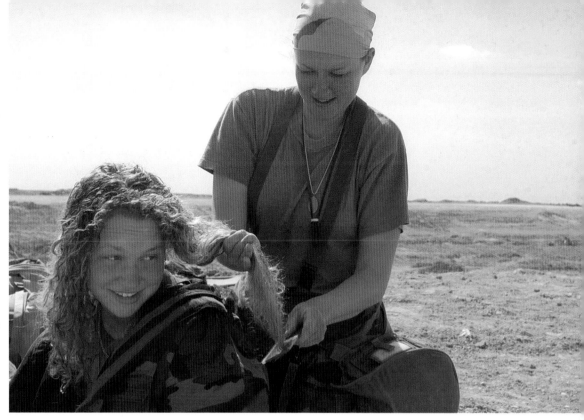

**03.2003**
**FIRST LIEUTENANT**
**TRAVIS HOWELL,**
**U.S. ARMY**
**Near An Najaf**
Using a vehicle battery
to power their clippers,
two soldiers from
the 70th Armor Regiment
participate in what the
photographer describes
as a typical ritual.
"Being our own
barbers was kind of
novel at the beginning,"
he says, "but it lost its
novelty after a while."

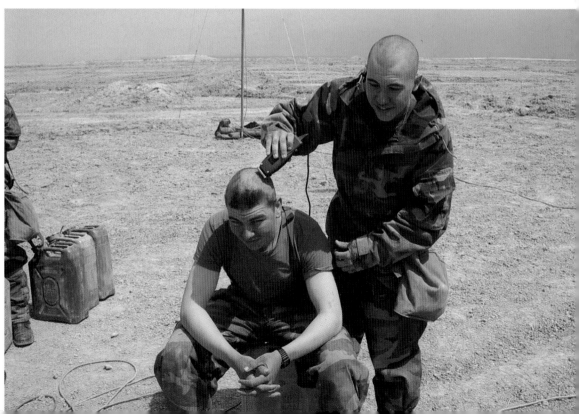

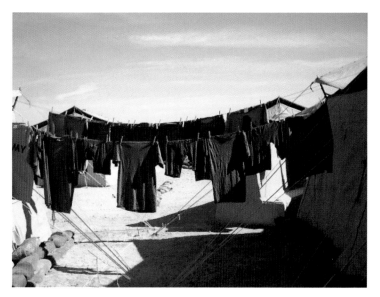

**06.2003
SERGEANT
FIRST CLASS
CHRISTOPHER
GRISHAM,
U.S. ARMY
Near Fallujah**
"You can't get away from the dust in Iraq, and it's really hot," says the photographer, "but you couldn't wash your stuff more than once every ten or twelve days. Putting on a shirt that smelled normal invigorated you for a while, but you had to be careful when you put your wash up, because if it was windy, you'd end up with a shirt that smelled okay but was just as dirty as before."

**DATE UNKNOWN
PHOTOGRAPHER
UNKNOWN
Location Unknown**
A soldier trims a tiny patch of grass outside his tent. Photo contributed by Captain Joe Vargas.

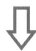

"YOU COULD ARGUE BOREDOM WAS THE HARDEST THING TO DEAL WITH OVER THERE. YOU JUST TRY TO FIND SOMETHING TO DO. TELLING STORIES, WATCHING MOVIES, EVEN DOING LAUNDRY. DIRTY-WATER LAUNDRY, WHICH PROBABLY MADE YOUR CLOTHES DIRTIER. BUT STILL, ANYTHING TO KEEP YOUR MIND OCCUPIED."
—CHIEF WARRANT OFFICER BRENT MCKINNEY, U.S. ARMY

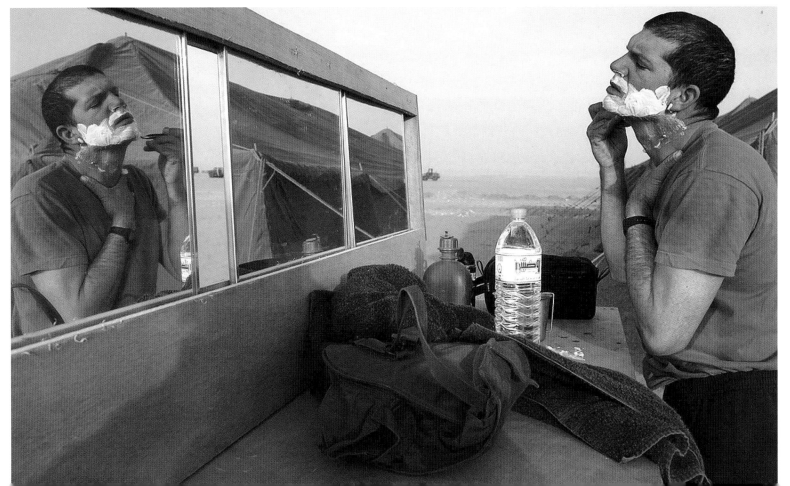

**02.09.2003**
**PETTY OFFICER**
**FIRST CLASS**
**BRIEN AHO,**
**U.S. NAVY**
**Kuwait**
Petty Officer
Second Class
Scott Fabacher
shaves outside
a field-shower
tent in Kuwait.

**01.2005//FIRST LIEUTENANT SETH MOULTON, U.S. MARINE CORPS//An Najaf**

"There's just a couple of guys in our platoon who are good at cutting hair," says the photographer, who captured these images at his unit's outpost in downtown An Najaf. The Marines had taken over a former agriculture department building for two weeks to guard the provincial governor's office. Most of the Marines in this particular platoon were on their second deployment to Iraq, and though the optimism they had at the start of the war was waning, the photographer notes that morale was still good: "We had all that fighting in Najaf in August, and by this point the city was rebuilding and really making progress. So we were in a very optimistic place."

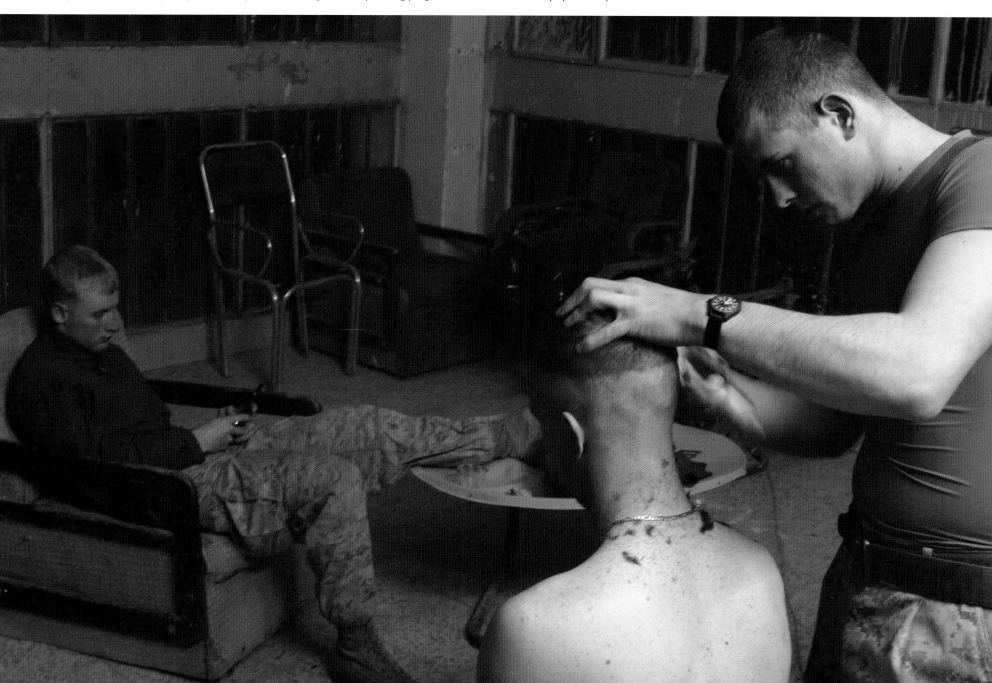

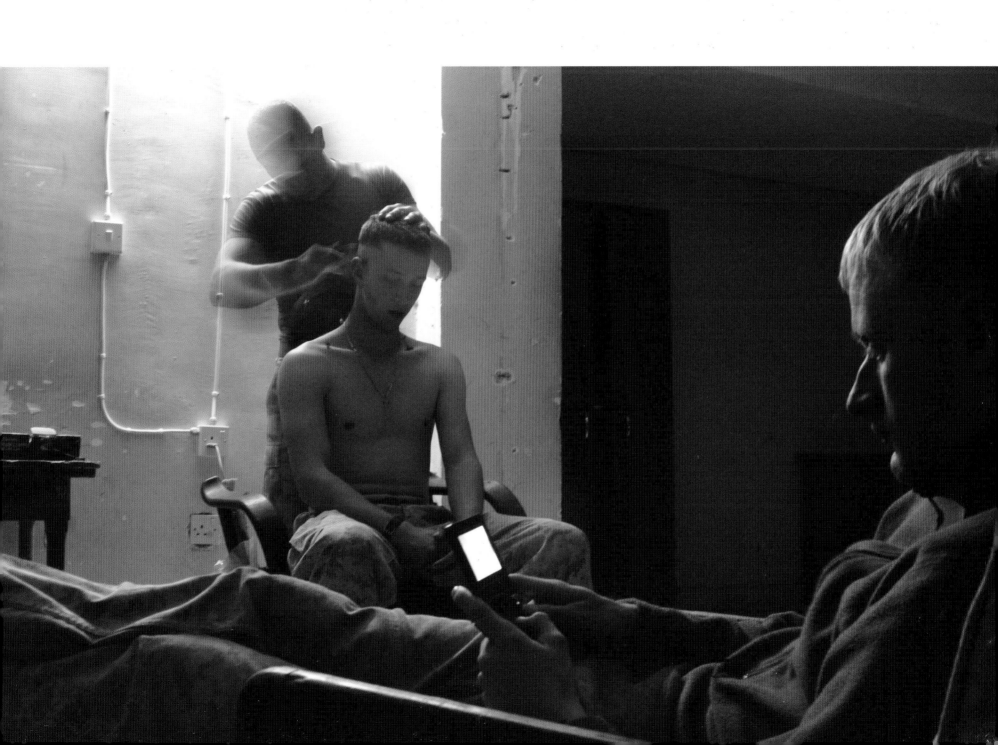

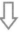

08.2003
**SPECIALIST
EDOUARD H. R. GLUCK,
U.S. ARMY**
**Ramadi**
National Guardsmen
from the 1st Battalion,
124th Infantry, spent
the summer of 2003
sleeping during
the day and conducting
walking patrols at
night. They let locals
know their policy
was "shoot first, ask
questions later."
All 512 men returned
alive—something
no other U.S. infantry
battalion can claim.

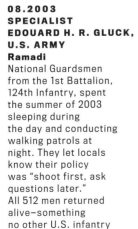

## THE PHOTOGRAPHERS
Specialist Edouard H. R. Gluck

Edouard H. R. Gluck spent ten months in Iraq with the 1st Battalion, 124th Infantry Division, a national guard unit out of Florida. He spent most of his tour working as his battalion commander's driver in Ramadi and taking thousands of photographs of what he saw there, from bound and blindfolded enemy prisoners of war awaiting interrogation, to gatherings of Jewish soldiers on Yom Kippur, to daylight raids in city centers. "I didn't create this situation, and I don't cross that political line," he says. "I just make pictures."

As a civilian, Gluck wanted to become a professional photojournalist but hadn't had much luck: "I had one success with the AP, and it was a photo of a NASCAR race." When he was called to Iraq, Gluck brought along three Nikon cameras. His battalion commander was supportive: "One of the first things he said to me before we left for Iraq was, 'Hey, you have your cameras?'" When one of his troopmates, Staff Sergeant John Adams, was seriously wounded in a roadside bombing, Gluck had the rare opportunity to document the medical evacuation (photos on pages 108–109): "I was getting ready to leave to head up north on another mission when I heard the blast. I remember the truck burning around the corner, and I grabbed my rigs and I just ran out, because I knew something was going to come up."

Gluck's photographs were featured in the *GQ* magazine photo essay that inspired this book. When members of the army's public-affairs team saw his work, they asked him to sign on as a military photojournalist. He recently finished up a year with the 107th Public Affairs Attachment, taking pictures of hurricanes Katrina and Rita.

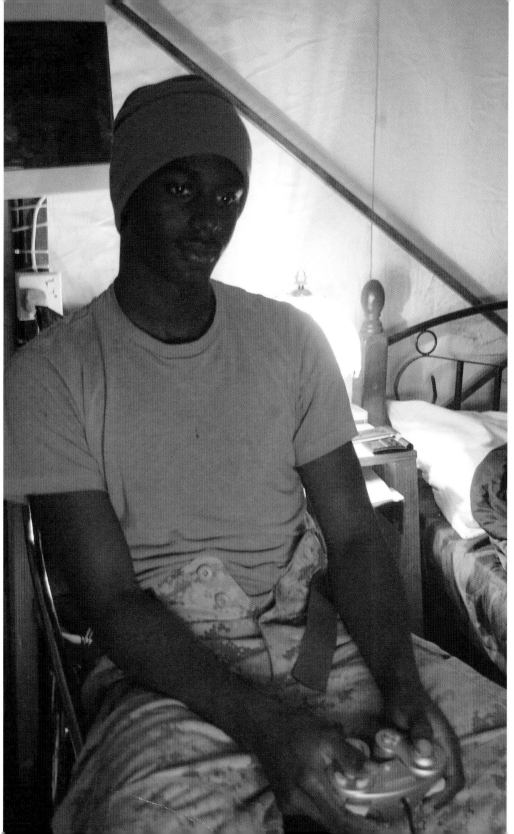

**11.27.2004
CORPORAL
MATTHEW RICHARDS,
U.S. MARINE CORPS
Northwest of An Najaf**
After the fighting in
An Najaf had died down,
relations with the locals
were friendly enough that
Marines allowed them
to open a market on the
base, selling bedframes,
MP3 players, and the
occasional gaming system.
Reconstruction work was
arduous, but the hours were
more regular than during
combat, allowing Corporal
Dave R. Ford and his
tentmates in the 11th
Marine Expeditionary Unit
to enjoy a normal guy's
nightlife, relatively speaking.

**03.14.2003
PETTY OFFICER
FIRST CLASS
AARON ANSAROV,
U.S. NAVY
Kuwait**
Before the start of
war, the men of Naval
Mobile Construction
Force 74 remained
stationed along the
Iraq-Kuwait border.
They would eventually
help build bridges,
airstrips, and roads,
but in the meantime
there was nothing to
do except dip snuff,
watch DVDs, and wait.

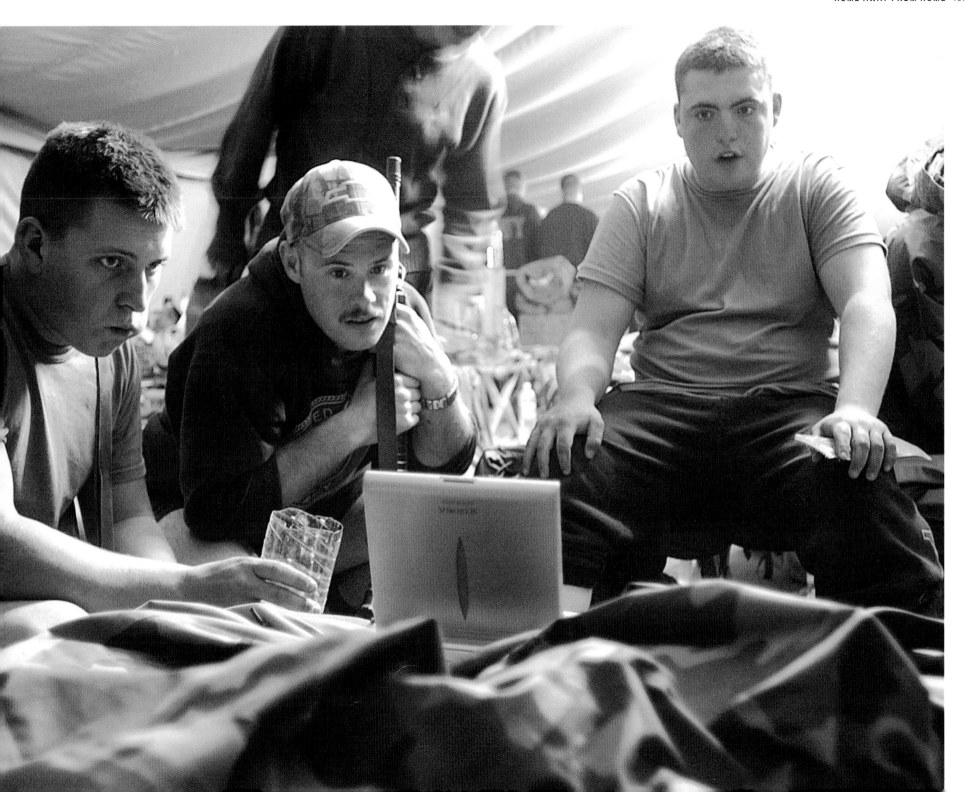

04.2003-04.2004
ROCHELLE BLUE;
STAFF SERGEANT JONATHON BLUE, U.S. ARMY
Rio Rancho, New Mexico; Tikrit, Iraq

## A Soldier's Story
# LOVE LETTERS

*Staff Sergeant Jonathon Blue:* I proposed to her on Valentine's Day, 2002. Originally, we were saving up for a wedding in Las Vegas—we had already started paying on it. But when we found out I was going to Iraq, we couldn't do it. I ended up having to arrange going down to the courts, and we got married there. When I first got to Iraq, we didn't have any kind of luxuries. We were still eating MREs, and we were worried about how much water we had left. Letters were very important. They would take weeks to get there, but as soon as I would open them up, I could smell her perfume. Then the civilian contractors started coming in and putting up the cyber cafés and the phone centers. But even then, it was really sporadic. You could go in there and the Internet would be down all day. Sometimes it would be down all weekend. So mail was very important to me. It let me know that life isn't exactly what is going on right now where I'm at. That we have a very happy life and I've been blessed with a lot of things. Being out there for that time period, you forget sometimes.

*Rochelle Blue:* The phones would cut in and out. He would call me, and I would just say, "I love you, I love you, I love you!" so I could get it in before the phone would go *beeeep* and cut out. I bought one of those little voice recorders, and I sent him one, too, so we would send each other tapes. It was a way for me to just hear his voice.

*Jonathon:* When I first got these pictures of her, I was like, who the heck took these?

*Rochelle:* I had mentioned to my mom that I wanted to do pictures like that for him, but I didn't want to go to Glamour Shots or anything. And my mom was like, "I'll take 'em for you." My mom and I are like best friends, so eventually, I opened up and let her take them. And she had fun with it, too. She was like, "Okay, now turn around this way." After he got the first ones, and he loved them, it turned into a trend. Different outfits, different themes.

*Jonathon:* I bought her a little outfit as a gag for Halloween, a "sexetary" outfit. And I would send her pictures, too. At Christmas, what could I give her—some Iraqi dirt? So I sent her this picture [left]. When I got to Iraq, I was 130 pounds, and then I lost almost 15 pounds. That picture that I sent her, I was almost 170 pounds. Me and my partner had made it a point to work out every day and eat every meal. And I tried to show off my wedding ring. Show her that I loved her, and that this is what I'm doing for you and our future. We have a daughter now. I'm set to be in Iraq again by Christmas.

*Rochelle:* My mom has a video camera. I want to send video of our daughter, because with Janessa, everything is new. He's going to have an overload this year.

**04.19.2003**
**SERGEANT**
**ROB WOODWARD,**
**U.S. ARMY**
**Baghdad**
"It was just after I
arrived in Baghdad,
and I saw this soldier
from the 101st Airborne
Division carrying his
helmet by the straps,"
the photographer says.
"Soldiers write stuff on
their helmets; I had a
picture of my girlfriend
in mine. That photo
is of someone back
home who this person
was missing."

**03.20.2003//PETTY OFFICER FIRST CLASS AARON ANSAROV, U.S. NAVY//Kuwait, near the Iraqi border**
After the photographer arrived in Kuwait with his Seabee battalion, "it was a few weeks of waiting, waiting, waiting to get
the call" to invade Iraq, he says. With little to do, "everybody had their way of disappearing into their own little world."

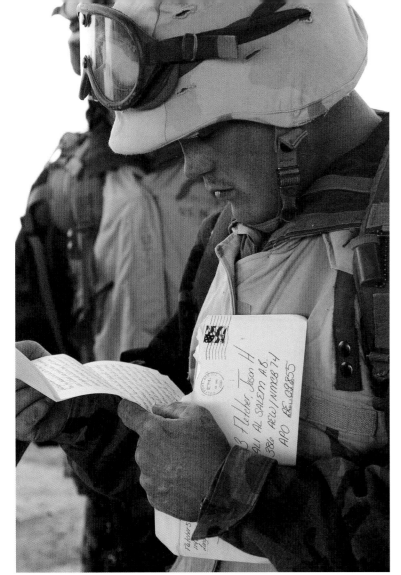

**03.27.2003**
**PETTY OFFICER**
**FIRST CLASS**
**AARON ANSAROV,**
**U.S. NAVY**
**South of Baghdad**
During work on a bridge
somewhere south of
the capital, after three
days without "morale
communications"—
the army's term for
personal mail—Builder
Third Class Jason
Fletcher reads a letter
from home. "We never
knew where we were,"
the photographer
says. "We were always
just forward-deployed,
that's all I know."

**07.2004**//**SPECIALIST COLE AUGUSTINE, U.S. ARMY**//**Camp Duke, An Najaf**
"We hadn't gotten our mail in like a month or so," says the photographer, who was stationed at a base near An Najaf.
The rest of his company, which had stayed behind in Baghdad, hadn't forwarded it. The men heard it would be
on a helicopter, but when the chopper arrived and took off and there was still no mail, "we all ran outside
pretty much screaming, 'What's up with this?' We were just in the middle of nowhere, and it felt sort of messed up."

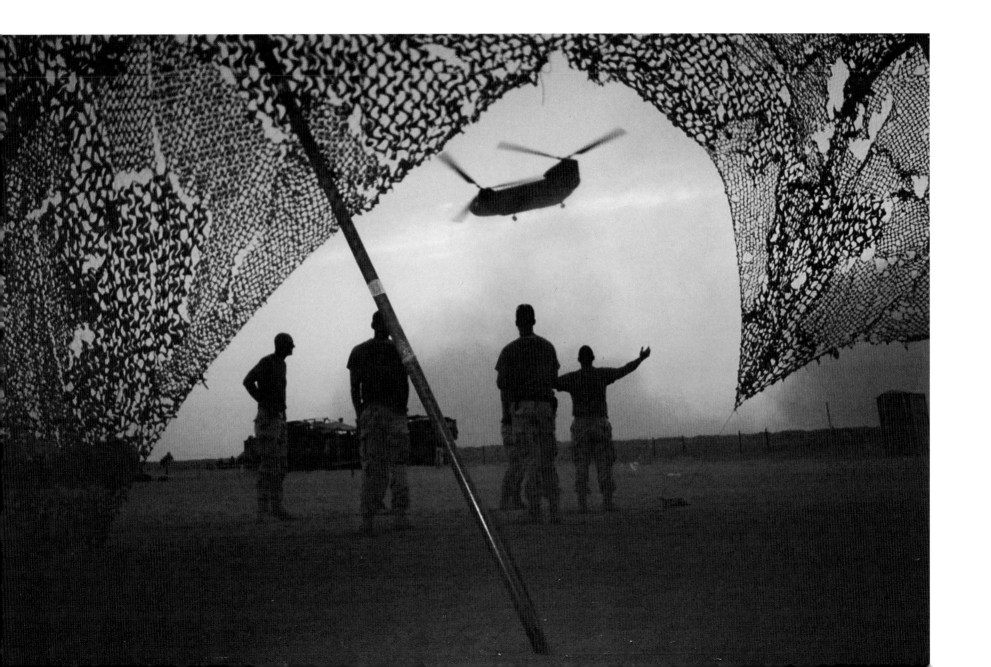

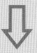

## A Soldier's Story
# POSTCARDS TO MY WIFE

In April 2003, Alvin Benjamin arrived in Kuwait with the rest of the men and women of the 3rd Brigade, 4th Infantry Division, out of Fort Carson, Colorado, and a few weeks later they pushed on into Iraq. In February 2004, he was medevaced from the Iraqi theater after he'd contracted a serious skin disease. In the intervening ten months, Benjamin moved throughout Iraq, going on combat missions and patrols; he camped out at an air base in Samarra and in mud huts in Daquq; he kept watch over the streets of Tikrit and the borderland near Iran. And he documented the whole experience with his 35-millimeter camera.

Benjamin is a career military man. He enlisted when he was 18, just before Desert Storm, in which he served for five months, and he has served continuously since. He knew Operation Iraqi Freedom would be a different sort of mission. "I didn't talk to my wife about it," he says. "But I assumed it was going to be far more difficult. Desert Storm was sandbox warfare. This one is up close and personal; it's urban warfare." He counts the day he left his family—his wife, Andrea, and his four children—as his toughest of the war.

Alvin Benjamin is a howitzer-section chief, which means he's responsible for an M109A6 Paladin howitzer and its ammunition-support vehicle. He commanded nine men, whom he lived with, fought alongside, and felt responsible for during the ten months he was there. But besides God and his rifle, Benjamin considered his wife to be his closest confidante in Iraq. They talked on satellite phone and, after the signal company had set it up, on a landline, whenever it worked. "She wrote constantly, and I got a package every seven or eight days," Benjamin says. "And every week I'd send out a letter, too. I missed her birthday, being over there, so I sent her a love letter and some Middle Eastern perfume I picked up in Balad." But the best way he had of bringing her into his world was through his photographs. He'd send her a roll whenever he finished one. He showed her life with his men, the meal he ate for Thanksgiving, the vistas he took in from the hatch of his howitzer, the body bags that came back to base the night three insurgents were killed, the children he met on the street, life inside his enormous mobile gun. Over the course of his tour, he took almost a thousand pictures. This is Alvin Benjamin's Iraq story, the way he told it to his wife.

09.2003
PHOTOGRAPHER
UNKNOWN
Samarra East Airfield
"We got to the airfield
on the first of July,"
Benjamin says.
"I remember because
it was my daughter's
birthday." A few months
later, the men stationed
at the base raised the
American flag for the first
time. "It felt real good
to raise the flag,
and that's why I went
out there and had my
picture taken. Of course,
a little while later they
decided it wasn't in
our best interest to
have it raised—it might
offend the locals—and
they took it down."

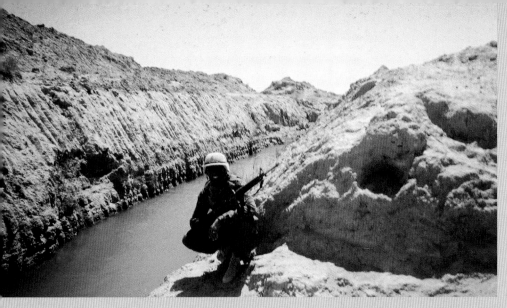

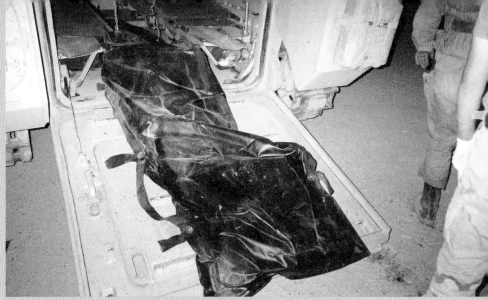

**09.2003//Outskirts of Samarra East Airfield**

**09.25.2003//Samarra East Airfield**

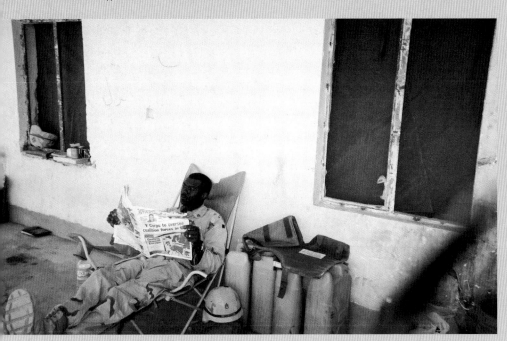

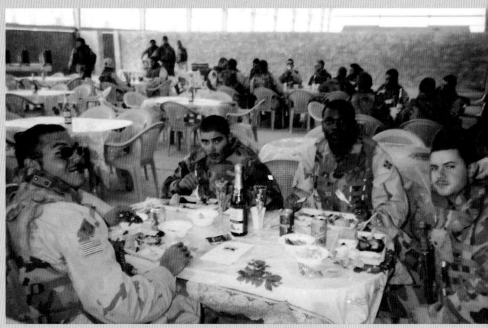

**05.2003//Daquq**

**THANKSGIVING DAY, 2003//Samarra**

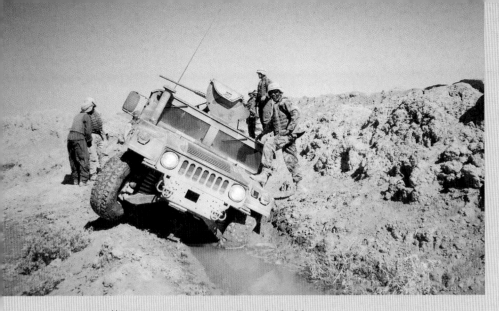

08.2003//Outskirts of Samarra East Airfield

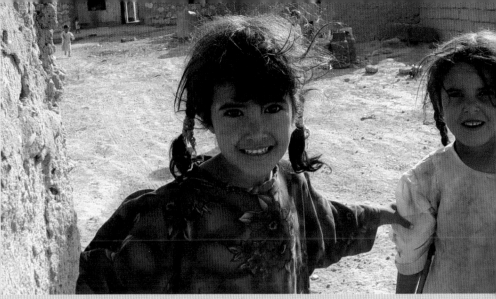

06.2003//Daquq

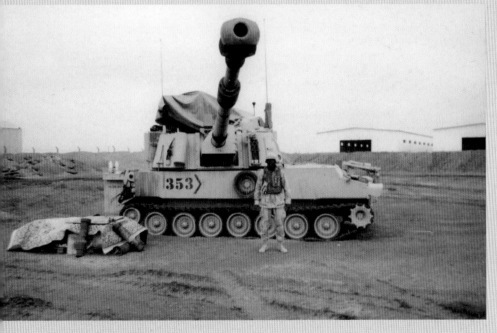

10.2003//Samarra

06.2003//En Route to Samarra East Airfield

**11.2003**
**ANDREA BENJAMIN**
**Fort Carson, Colorado**
Staff Sergeant Benjamin kept in close contact with his wife throughout the year he was gone. "She told me that whenever she was depressed, she'd get a letter or a phone call, and boom, she felt better," he says. "We chatted like crazy on Yahoo Messenger." Andrea Benjamin sent these pictures while they were chatting online.

**07.2003**
**STAFF SERGEANT ALVIN BENJAMIN, U.S. ARMY**
**En route to Samarra East Airfield**
"That's Lovato right there," the photographer says, referring to Lawrence Lovato, pictured behind him in this self-portrait. "He was my number one guy—meaning his job title was number one cannoneer." The duffel bags in the background are their unit's belongings. "That howitzer is our house, and we kept all our stuff right there on the roof."

⇩

# "I DOCUMENTED MY EXPERIENCE PRETTY GOOD. I TOOK TONS OF PICTURES—I DON'T KNOW HOW MANY ROLLS—AND I WOULD SEND THEM BACK TO MY WIFE. IT WAS LIKE, 'HERE'S SOMETHING FOR YOU.' AND SHE WOULD GO RUSH TO WAL-MART AND DEVELOP THEM. IT WAS A WAY FOR ME TO LET HER IN ON MY LIFE."
—STAFF SERGEANT ALVIN BENJAMIN, U.S. ARMY

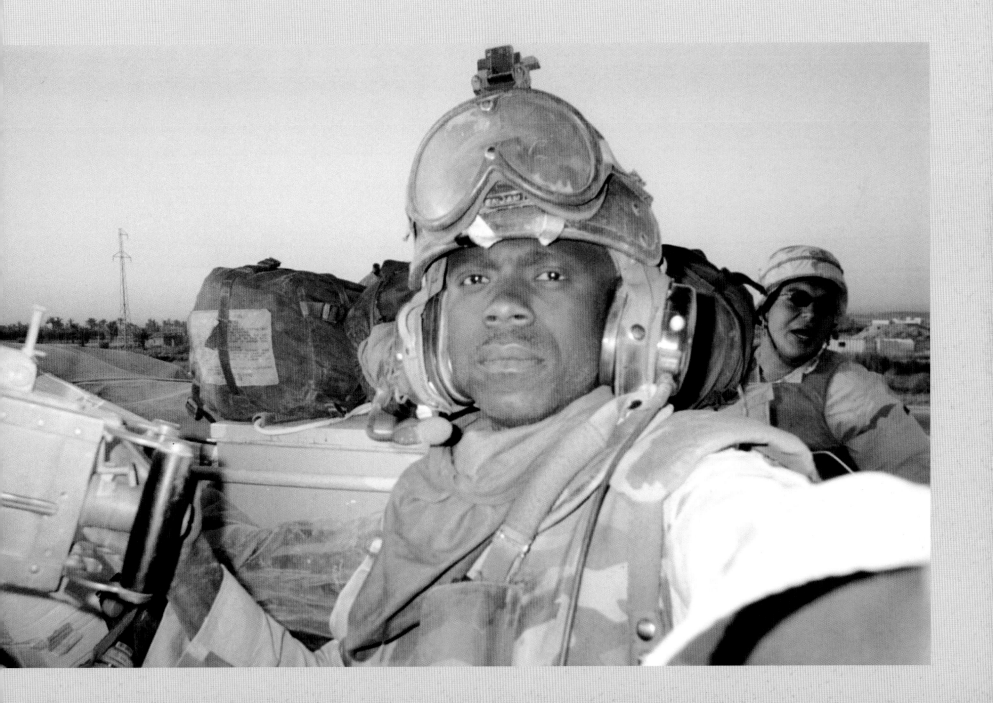

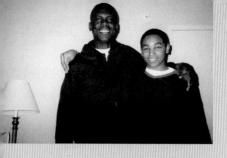

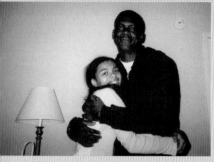

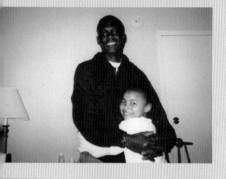

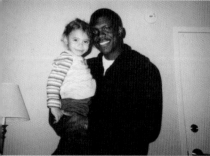

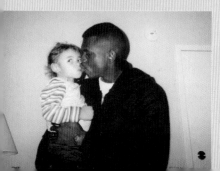

**02.2003**
**ANDREA BENJAMIN**
**Walter Reed Army Medical Center, Washington, D.C.**
On the day he was reunited with his family, Alvin Benjamin poses with his four kids, (from top) David, Nadine, Michelle, and Mirah. "It was nearly a year later," he says. "The kids had probably grown a foot and a half each."

**02.2003//ANDREA BENJAMIN//The White House, Washington, D.C.**
After they came to visit him at Walter Reed Army Medical Center, where he was recuperating from a skin disease, Benjamin took his family on a tour of Washington, D.C., that included the White House and Arlington Cemetery. "For service members, Arlington is an important place," he says. "A lot of great souls are there. And being that I had survived my encounter over in Iraq, it put a real reality check on me."

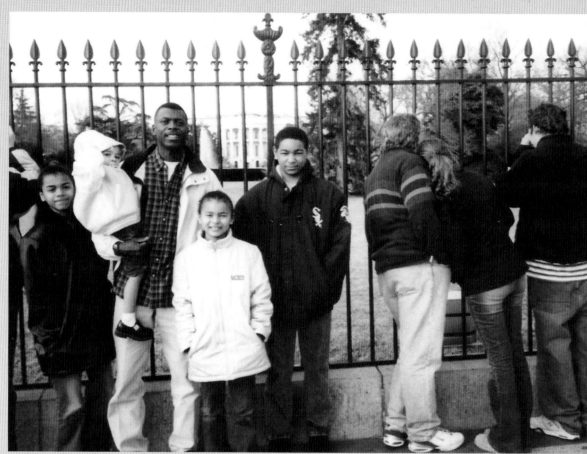

**04.08.2003//ANDREA BENJAMIN//Fort Carson, Colorado**
Staff Sergeant Benjamin gathers his four children before him on the day of his departure for Iraq. "We had only been in Fort Carson a little while," he says, "so I was nervous about leaving my wife and kids there. They didn't know anybody."

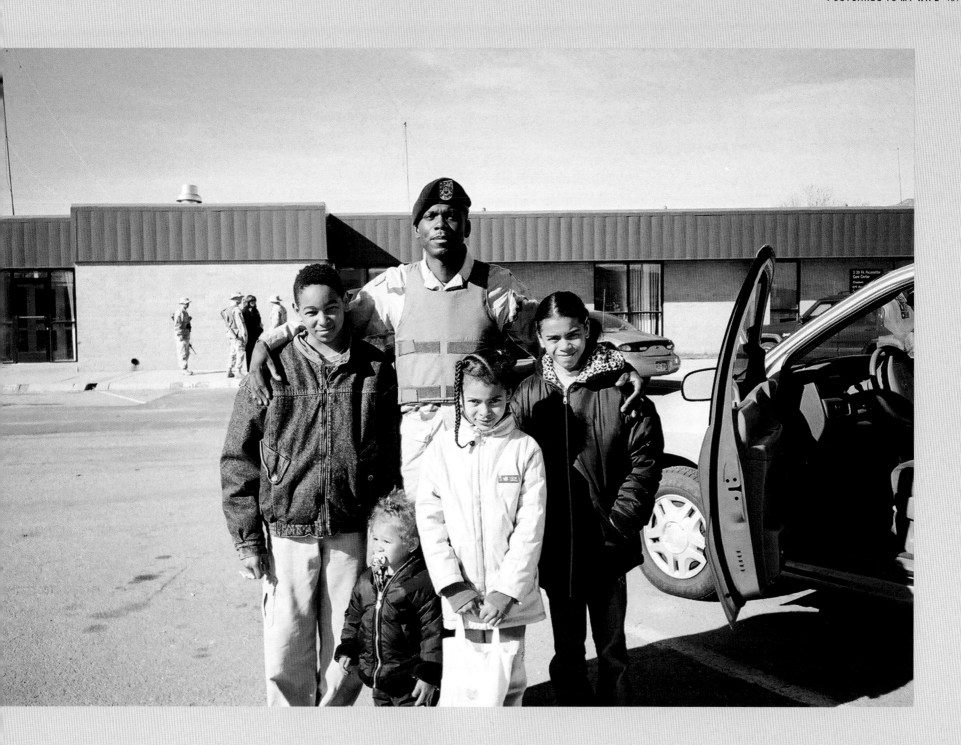

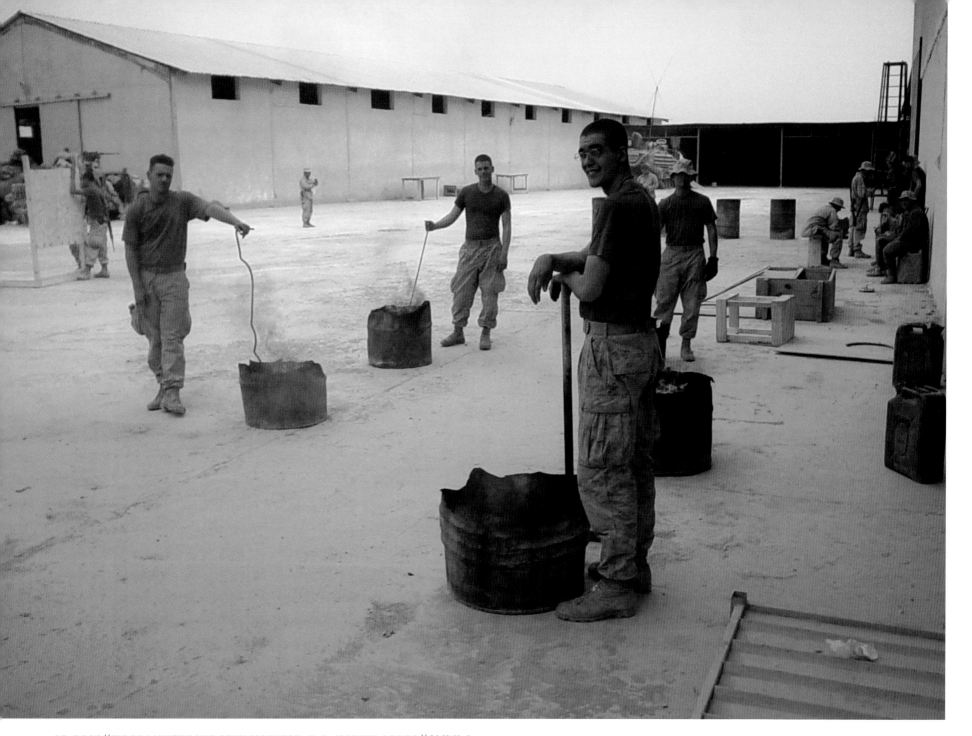

**05.2003//FIRST LIEUTENANT SETH MOULTON, U.S. MARINE CORPS//Al Hillah**
Approximately two months after the initial invasion of Iraq, these Marines found themselves in Al Hillah, where an
old date warehouse served as a makeshift base for their unit. In the absence of proper facilities, the Marines
had to burn their waste in metal barrels. "There's a rotation, but it's pretty much the boots that have to do it," says
the photographer, a platoon commander. "By the end of the job, they're usually completely blackened."

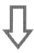

"WE DIDN'T HAVE SHOWERS. WE WENT TO THE BATHROOM IN A HOLE AND THEN BURNED IT WITH GAS. IT WASN'T ALWAYS FUN. BUT THAT'S ONE THING ABOUT SOLDIERS, MAN. EVEN IN THE WORST OF THE WORST, WE STILL MANAGED TO HAVE A FEW LAUGHS."
—SERGEANT FIRST CLASS DARRYL DELLAROSSA, U.S. ARMY

**05.2003
CAPTAIN
JEROD MADDEN,
U.S. ARMY
Baghdad
International Airport**
Before the photographer's unit—the army's 151st Postal Company—took delivery of several modern port-a-johns, they used "the Throne," a plywood structure set atop three sawed-off fifty-gallon drums.

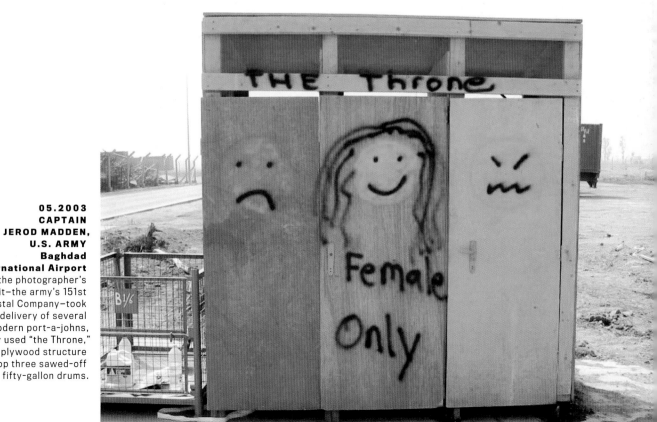

**03.2003**
**CHIEF WARRANT OFFICER**
**BRENT McKINNEY,**
**U.S. ARMY**
**Camp Dogwood,**
**West of Baghdad**
Members of a medical
battalion supporting
the 3rd Infantry
Division watch Fox
News via satellite
during their downtime.
"Believe it or not," says
the photographer,
"television was our best
source of information
about the war."

**03.2003//PHOTOGRAPHER UNKNOWN//Camp Udairi, Kuwait**
Soldiers with the 507th Medical Company play a game of cribbage while
waiting out a routine chemical-warfare practice exercise. "The drills were
to help us get used to performing our day-to-day operations while wearing
suits and masks," says Brent McKinney, who submitted the photo. "You get
used to it after a while. Everything just takes a little longer to do."

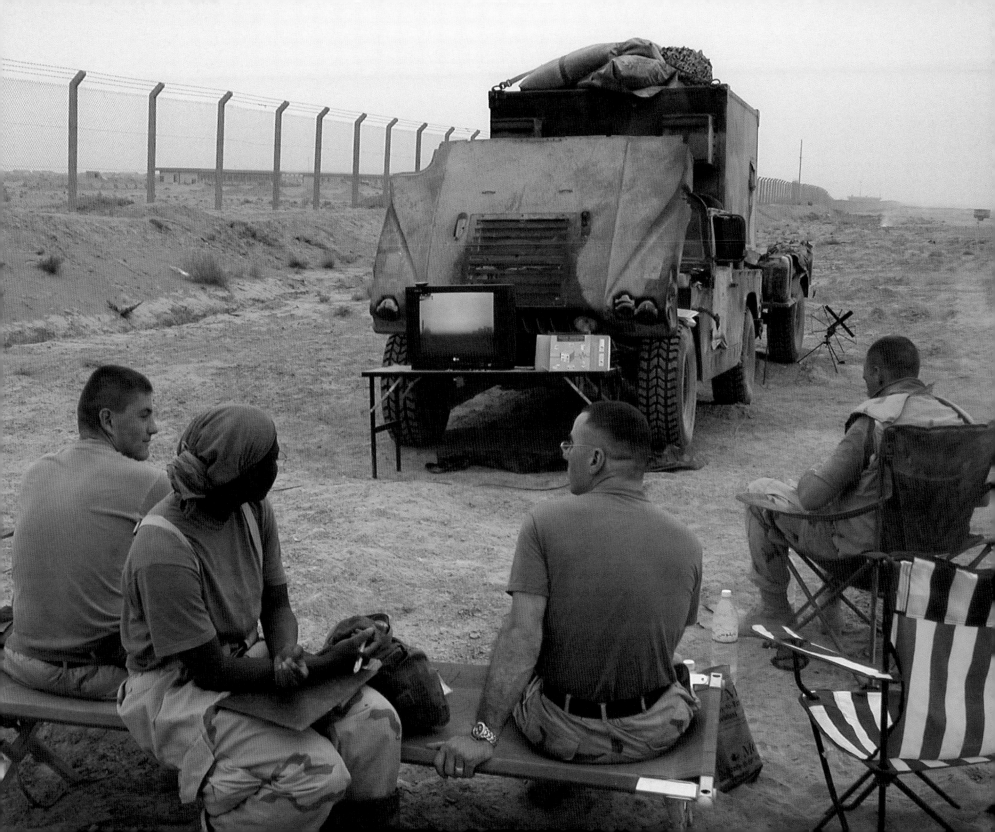

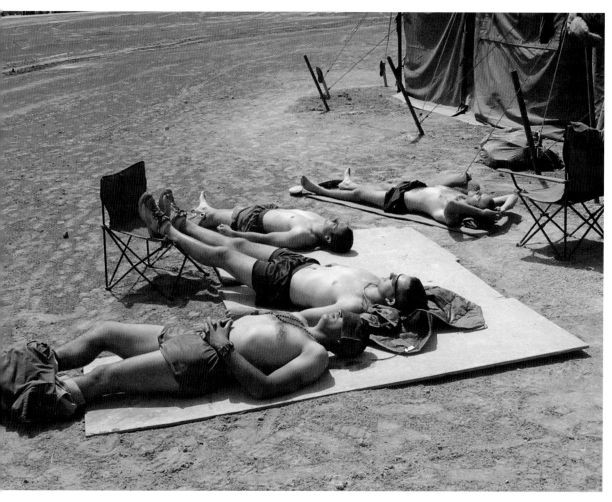

**04.16.2003**//**LIEUTENANT JOHNNY V. RODGERS, U.S. NAVY**//**Al Kut**
Every day, helicopters airlift in the wounded from the battlefield: Iraqi children who've stepped on land mines, troops in need of medical attention, and sometimes, fatalities. During a brief lull, these four surgical technicians work on their tans.

**02.11.2003**
**PETTY OFFICER**
**FIRST CLASS**
**BRIEN AHO,**
**U.S. NAVY**
**Iraq-Kuwait border**
A company of Seabees clean their weapons and play cards as they try to relax before combat begins. In a few weeks, they will be rebuilding bridges and roads during the first phase of the war.

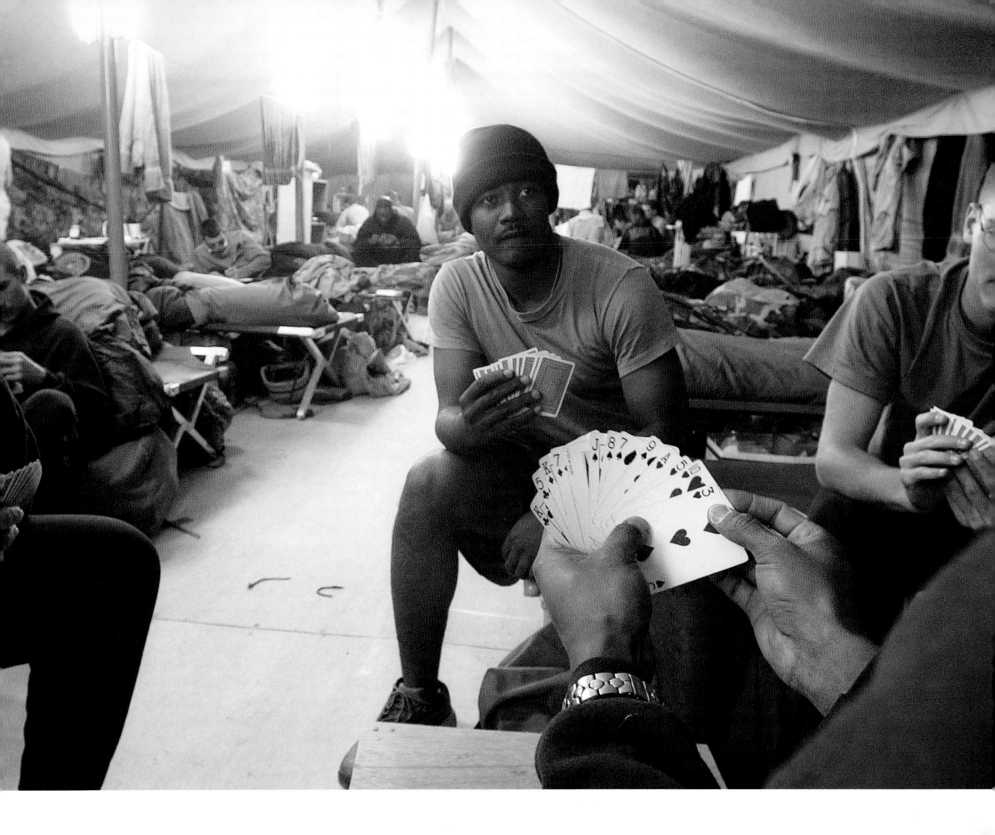

**09.2004
STAFF SERGEANT
LYNN HUBER,
U.S. AIR FORCE
Kirkuk**

"For the first couple of months, we were allowed to wear civilian clothes in the dorm," says Huber, who occupied this room at a converted Iraqi air base. "There were four of us roommates. It was kind of like a slumber party. We'd sit and eat candy and talk." But it wasn't college: Everyone had different shifts and someone was always sleeping, so "we had quiet hours twenty-four hours a day, seven days a week."

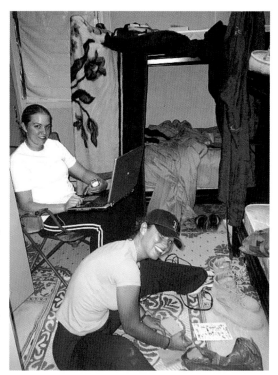

**09.2004
STAFF SERGEANT
APRIL OWENS,
U.S. AIR FORCE
Kirkuk**

Staff Sergeant Lynn Huber shows off her body armor in the women's dorm at Kirkuk Air Base. "In the Air Force, we never really leave the base," says Huber, an air-traffic controller. "Still, they give everybody a helmet and body armor, and we have to wear it between certain hours. Sometimes it's a pain in the butt, but you never really know when the insurgents are going to launch a rocket or mortar."

**03.03.2003
PETTY OFFICER FIRST
CLASS BRIEN AHO,
U.S. NAVY
USS *Comstock*,
Persian Gulf**

On landing ships like the *Comstock*, the well deck, when flooded, can be filled with hundreds of Marines in amphibious assault craft, preparing to go ashore. Many in the ship's crew like it better when it is drained; it's the perfect place for a basketball court.

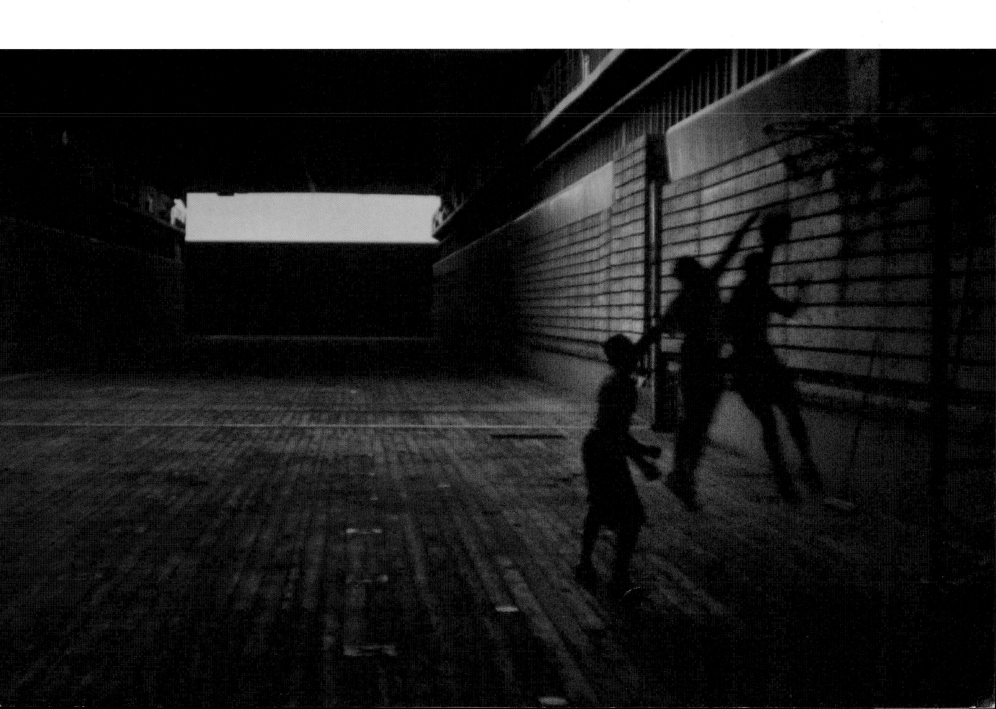

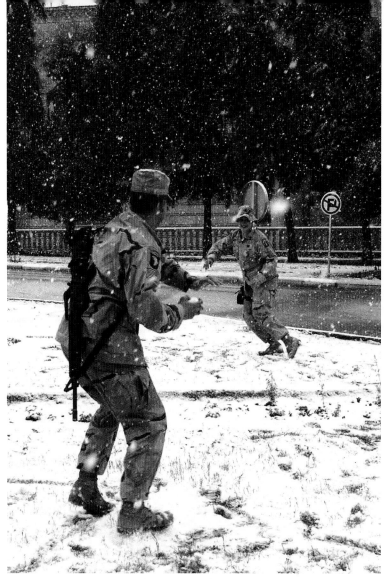

**02.22.2004**
**SERGEANT JUSTIN HARRIS,**
**U.S. ARMY**
**Mosul**

"The weather had been
really weird," says Harris,
"in the 60s during the
day and 35 or 40 at
night." One particularly
cold morning, a lieutenant
walked into the office,
shook some white stuff
off his jacket, and swore
it was snowing outside.
Harris didn't believe him
at first. "But next thing
you know, fifty soldiers
are running around outside,
goofing off." By early
afternoon, there wasn't
a trace of snow left.

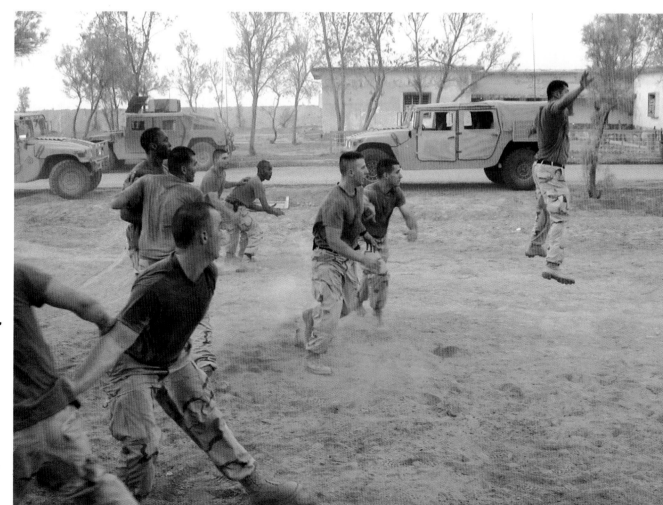

**01.15.2004**
**STAFF SERGEANT**
**REYNARD BIBBINS,**
**U.S. ARMY**
**Fallujah**
Some soldiers from a
military-intelligence battalion
blow off steam with a rough
game of tag football before a
major operation in the troubled
city. The photographer and his
unit had been sent to Fallujah
to aid Marines pacifying
the area in preparation for the
January 30, 2005, elections.

**03.2003**
**LANCE CORPORAL**
**TIMOTHY BROWN,**
**U.S. MARINE CORPS**
**Tikrit**
Lance Corporal Colin Smith, a gunner with Combat Support Service Battalion 10 of the Marine Corps, show off the day's kill: a gazelle found on one of Saddam Hussein's private ranches. Early stretches of the war could be uneventful, and this herd of gazelles, raised for hunting purposes, provided a welcome diversion. "At first, I was gonna shoot it with an M16, but I figured firing rounds could lead to some confusion," jokes Smith. Instead, he cornered the animal against a fence and finished it off with a standard-issue Ka-Bar knife. The gazelle didn't die in vain: Smith and his fellow Marines caught five, all of which they grilled in a makeshift barbeque pit. "It tasted like venison," he says. "Easily the best eating we had all month."

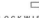

CLOCKWISE
FROM UPPER LEFT

**03.2003**
**PHOTOGRAPHER**
**UNKNOWN**
**Balad**

**DATE UNKNOWN**
**PHOTOGRAPHER**
**UNKNOWN**
**Iraq**

**03.2003**
**PHOTOGRAPHER**
**UNKNOWN**
**En route to Baghdad**

**08.2003**
**STAFF SERGEANT**
**MURPHY MILLER,**
**U.S. ARMY**
**Balad**

**08.16.03**
**PHOTOGRAPHER**
**UNKNOWN**
**Baghdad**
First Lieutenant Kelly McCay sent this photo straight home to his mother, who had shipped him a golf club to boost his spirits. "She bought me this $30 club," he says, "and it took forever to get to me, and when it did, it was all beat to hell. It was kind of a joke, a morale thing. I mean, I play, but it's more of an excuse to drink beer. I think the golfing thing goes back to that show *M*A*S*H*. But it's funny for Iraq, too, seeing how it's basically a big sand trap."

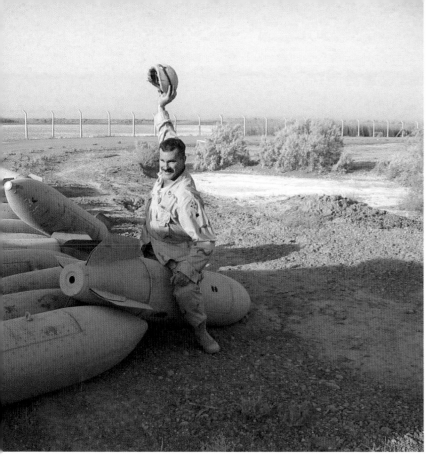

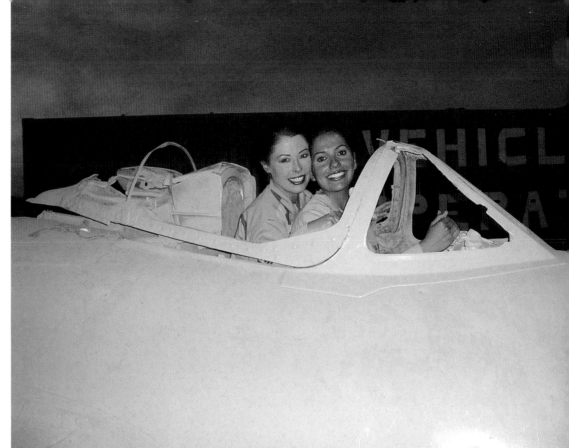

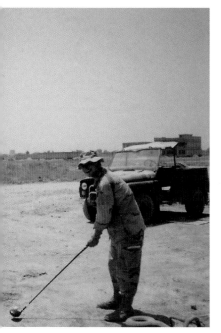

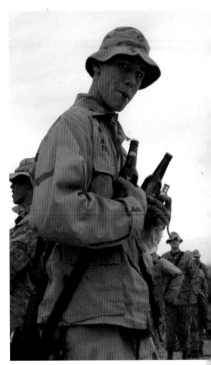

**12.2004**
**FIRST LIEUTENANT**
**SETH MOULTON,**
**U.S. MARINE CORPS**
**An Najaf**
Lance Corporal Shawn Friesen (right) and First Lieutenant Jeremy Sellars (below) enjoy beer day at Camp Hotel in An Najaf. Members of the 1st Battalion, 4th Marines, received two bottles of Bud Light "and a nip of rum," the photographer says. "The thing to understand is that they don't allow drinking in Iraq. In two deployments, each lasting eight or nine months, my battalion had a single day when we were allowed to drink. I'm not a big Bud Light fan, but it tasted great."

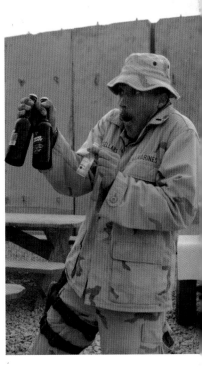

**04.20.2003**
**PETTY OFFICER**
**SECOND CLASS**
**DANNY EWING JR.,**
**U.S. NAVY**
**USS *Harry S. Truman*,**
**Persian Gulf**
Lieutenant Dewey Lopes enjoys a light moment on the flight deck of the *Truman* during a "steel beach party." The celebration was in recognition of more than ninety days of continuous sea time.

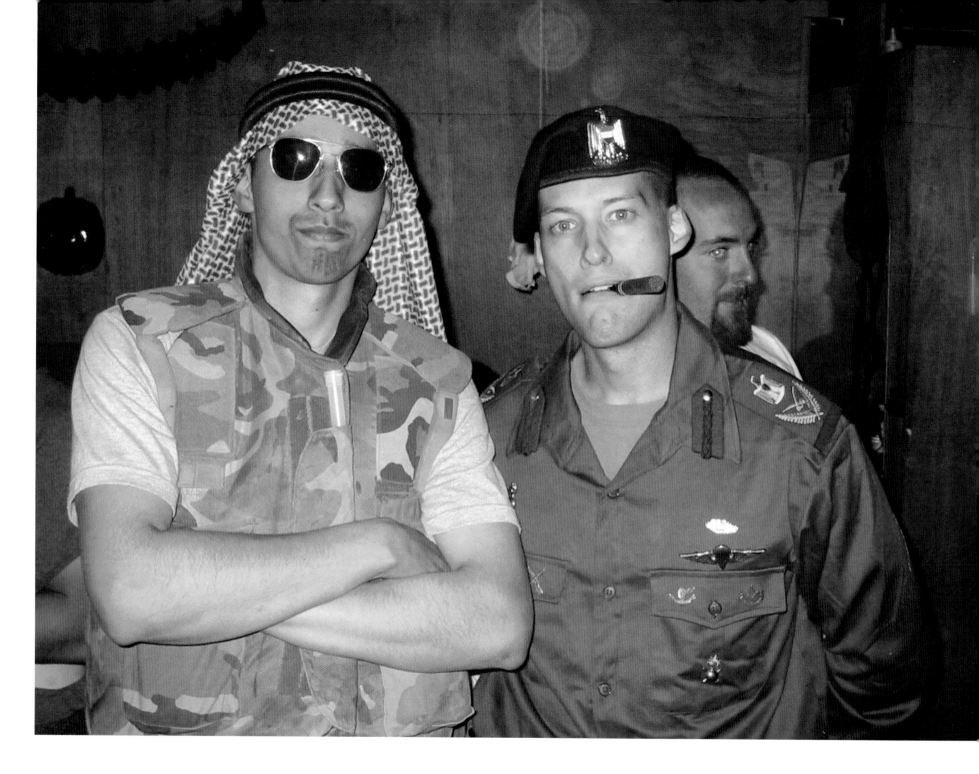

**10.31.2003**//**PHOTOGRAPHER UNKNOWN**//**Baghdad International Airport**
Captain Jerod Madden (right) and another soldier from his unit attend a Halloween costume party. "Life could be pretty monotonous at times, so we were always looking for things to do to keep busy," says Madden. At the airport, members of the 394th Postal Company constructed a room out of plywood to host the soiree, and the soldiers provided their own costumes. "I actually found a bunch of leftover Iraqi uniforms lying around the airport," Madden says. "And an Iraqi guy working at the camp gave me all the pins and trinkets." Not that it was the kind of Halloween party Madden would have had back home in Iowa. "No booze," Madden says.

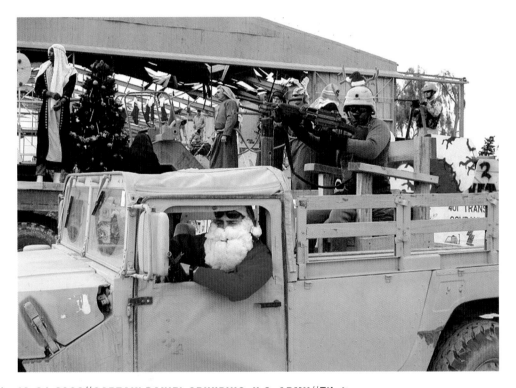

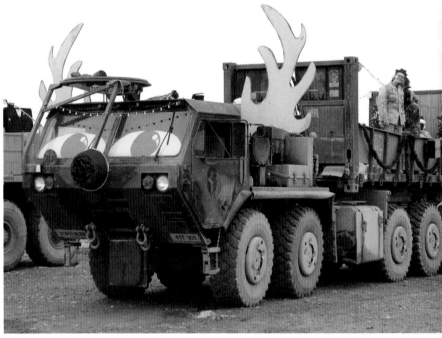

**12.24.2003**//**CAPTAIN DANIEL GRUNDVIG, U.S. ARMY**//**Tikrit**
The photographer organized a Christmas parade for the army's large base near Tikrit. "It was to take our minds off what was really going on," he says. "We were just trying to make it normal." Each unit on the base decorated at least one vehicle. In the foreground, Grundvig's battalion commander, as Rudolph, rides in the back of a jerry-rigged gun truck used to protect convoys. In the background, a unit that has just arrived in Iraq rehearses "a sort of Arabian Nativity scene."

**12.24.2003**//**CAPTAIN DANIEL GRUNDVIG, U.S. ARMY**//**Tikrit**
Palletized load system trucks are designed to haul ammunition. This one "was taken out of the rotation for a few days," says the photographer, while the army's 41st Transportation Company turned it into a float for the Christmas parade. The plastic trees, lights, and garlands were sent by military-support groups in the United States.

**08.16.2004**
**STAFF SERGEANT**
**DAVID E. GILLESPIE,**
**U.S. ARMY**
**Near Balad**
One of the stars of
the Miller Lite "catfight"
commercials, Tanya
"Tastes Great" Ballinger,
signs autographs for
troops and Halliburton
contractors beside
the swimming pool
at a U.S. Army camp.

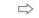
FOLLOWING PAGE

**3.14.2003
PETTY OFFICER
SECOND CLASS
ANDREW MEYERS,
U.S. NAVY
Kuwait, near
the Iraqi border**
After weeks of waiting,
this Seabee battalion
was informed they'd be
shipping out the next
day. To vent some of
their excitement, they
built a makeshift
ring of sandbags and
wrestled all night,
using the headlights on
their trucks when
the sun went down.

**12.24.2003//LIEUTENANT COLONEL MICHAEL PIERSON,
U.S. AIR FORCE
Green Zone, Baghdad**
After caroling in the palace halls, Pierson—a communications officer for
the Coalition Provisional Authority—gathered some of his unit into
what they'd heard had been the office of deputy prime minister Tariq Aziz
to watch *It's a Wonderful Life.* On Christmas day, insurgents shelled them
for five hours straight, after which the unit had a dinner that included
turkey, roast beef, and an ice sculpture.

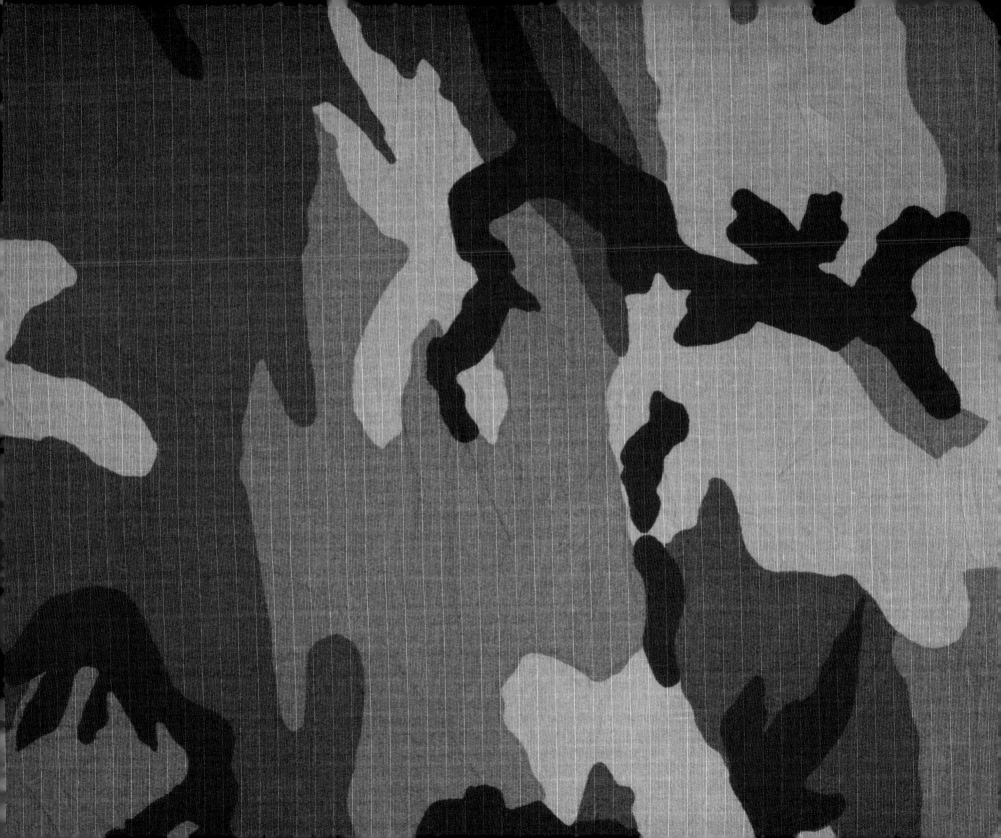

# 6. THE FALLEN

⇩

"WHEN YOU'RE THERE, YOU DON'T SIT AROUND AND THINK ABOUT IT. SURE, IT HURTS AND IT SUCKS AND IT'S TOUGH. IT'S EVEN TOUGHER SEEING LITTLE KIDS AND GOOD FRIENDS GO. BUT YOU'RE THERE TO DO A JOB, WHICH HELPS YOU COPE. IT'S NOT UNTIL YOU COME BACK THAT IT REALLY SETS IN—WHEN YOU REALLY HAVE TIME TO REFLECT ON IT. THAT'S WHEN IT REALLY HITS YOU."
—CHIEF WARRANT OFFICER BRENT MCKINNEY, U.S. ARMY

**04.30.2003//PETTY OFFICER FIRST CLASS KEVIN H. TIERNEY, U.S. NAVY//An Nasiriyah**
Chief Warrant Officers Andrew T. Arnold and Robert W. Channell were killed by a rocket-propelled grenade near Al Kut. With only live rounds available during the field memorial service a few days later, the twenty-one-gun salute was fired into the ground

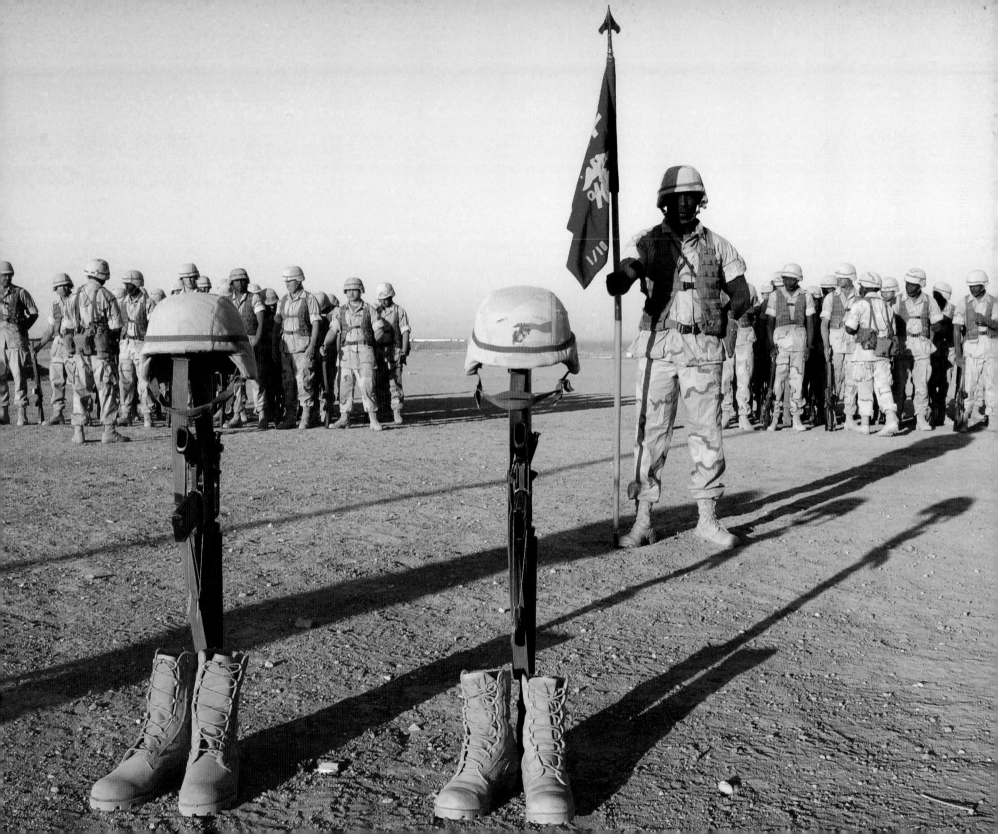

**12.25.2004//FIRST LIEUTENANT SETH MOULTON, U.S. MARINE CORPS//An Najaf**
A memorial service is held on Christmas day for Corporal Roberto Abad and Sergeant
Yadir G. Reynoso, killed during the August battle in An Najaf between American troops
and Moqtada al-Sadr's Mahdi Army. Both Marines lost their lives during the three days of
brutal fighting in the An Najaf cemetery.

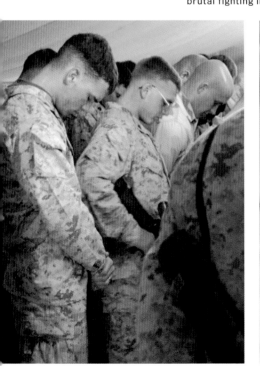
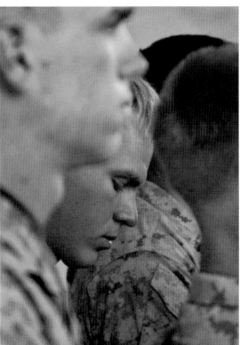
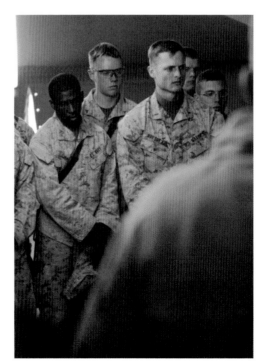

"THESE SERVICES ARE ALWAYS VERY MOVING,
FAR MORE THAN A PICTURE CAN CONVEY.
I KNEW BOTH OF THESE MARINES. THEY WERE IN
THE PLATOON RIGHT NEXT TO MINE IN THE
AN NAJAF CEMETERY WHEN THEY WERE KILLED."
—FIRST LIEUTENANT SETH MOULTON, U.S. MARINE CORPS

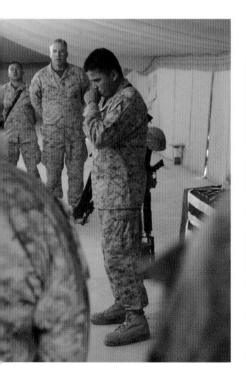
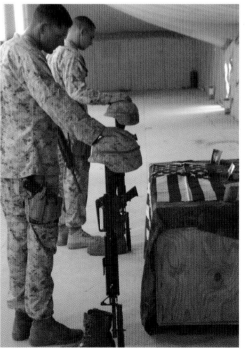
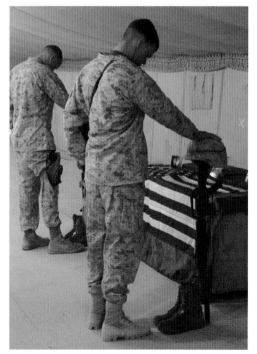
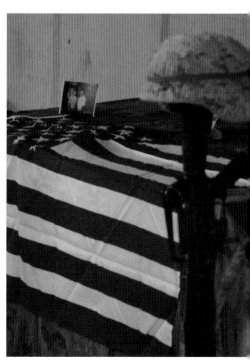

## A Soldier's Story
# A MILITARY FAMILY

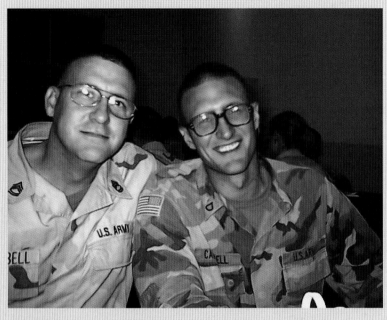

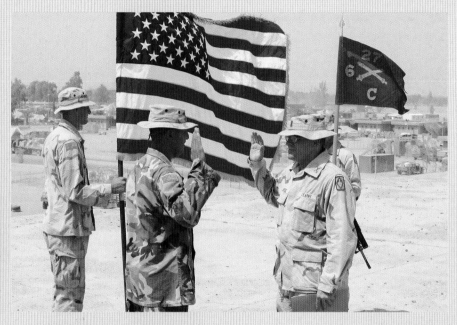

**10.2003**
**FIRST SERGEANT**
**WILLIAM LANGLEY,**
**U.S. ARMY**
**Near Balad**
Father and son Rodney
and Christopher Campbell
of Harrison, Arkansas,
came to Iraq with different
units but were sent to the
same base, LSA Anaconda
near Balad. Here, the
two pose for a photo at
a mess hall table. Photo
contributed by Larry E. LaRoe.

**07.2003**
**STAFF SERGEANT**
**RODNEY COULTON,**
**U.S. ARMY**
**Near Balad**
Private First Class
Christopher Campbell
holds the American flag
as his maintenance-pool
mate Staff Sergeant
Armando Luna reenlists
with their captain,
Larry E. LaRoe, who
contributed the photo.

That picture (far left) was taken in Iraq while my son Chris and I were both there. We were in different units, but both at LSA Anaconda. He had come over to visit me that night, and we went and ate dinner together. My first sergeant had his camera and took a picture. It's my favorite picture from the whole ordeal. We lucked out that we were just a mile and a half apart. We spent a lot of valuable time together.

Chris and I had been real close up until he was probably 16, and then he kind of went his way, into his rebel years. He was sharp, a computer genius, but he would get bored with his school. And he started to go down a real wrong track, running around and doing things he shouldn't. It wasn't until Iraq that we were able to rekindle everything that we'd lost.

For the five months we were stationed together in Iraq, Chris would come over to my office, usually between six-thirty and seven, and we'd just talk and talk. It was almost like he was 14 years old again. He'd usually stick around till nine, nine-thirty, and I'd drive him back. Then he'd stay up, I guess, sometimes till two or three in the morning, trying to get through to his mama or his girlfriend. He mentioned to his mama a few times that he was scared. He didn't ever talk to me about it—macho thing, I guess. Except once, after he'd gone on a mission down in Baghdad. He got shot at, and he had to shoot. He told me that really made him nervous.

He got to come home right before Thanksgiving, but I had to stay in Iraq. His unit was at Fort Sill, Alabama, which actually was

⬇

## "FOR THE FIVE MONTHS WE WERE STATIONED TOGETHER, CHRIS WOULD COME OVER AND WE'D JUST TALK AND TALK."

real fortunate. It was only six or seven hours from home, and he'd come down every other weekend on leave.

He had wanted to purchase some land here next to us. My brother was selling a parcel that adjoined my property, and just in the last year of Chris's life he had decided he wanted to purchase it so he could build himself a house one day. And I thought that was really neat. You know kids—usually they want to get as far away from mom and dad as possible, but he was starting to appreciate home and heritage.

One Saturday morning in February, about seven, my commander came and woke me up. He said, "There's been an accident." I thought it was some of our guys—we were running IED missions. But he handed me his sat phone and said, "You need to call home. One of your boys is dead, and I think it's Chris." I was on a plane to Arkansas by ten. At first you go through this guilt: "What could I have done different?" All this stuff goes through your mind. Then I was mainly concerned with how my wife was going to handle it. The couple times I talked to her en route, she was just on the verge of having a breakdown.

He had been about six miles from the house in Harrison, on his way home, and he decided to take a dirt road because it went by his girlfriend's house. Another vehicle was coming up the road in the opposite direction, and the guy was drunk, and he hit him. It was about three in the afternoon.

I have a lot of faith in God, and I know there must be a reason out there for everything. I've thought, "Well, maybe Chris's death will help this kid that hit him. Maybe this is the only thing that's going to keep this kid from killing himself or more people." He got the max sentence—negligent homicide, ten years. It was his second DWI. It's getting to the point where you can accept that there's a reason, that's the hard part.

What's got us through all this is we have a granddaughter by my other son, Eric. As long as we get to see her, it really helps. I take off work just to be her babysitter. Eric's a year younger than Chris; they were real close. You wouldn't believe it—he just went and talked to the army recruiter. He's thinking real seriously about doing it. That's going be real tough to think about.

— FROM A CONVERSATION WITH SERGEANT FIRST CLASS RODNEY CAMPBELL

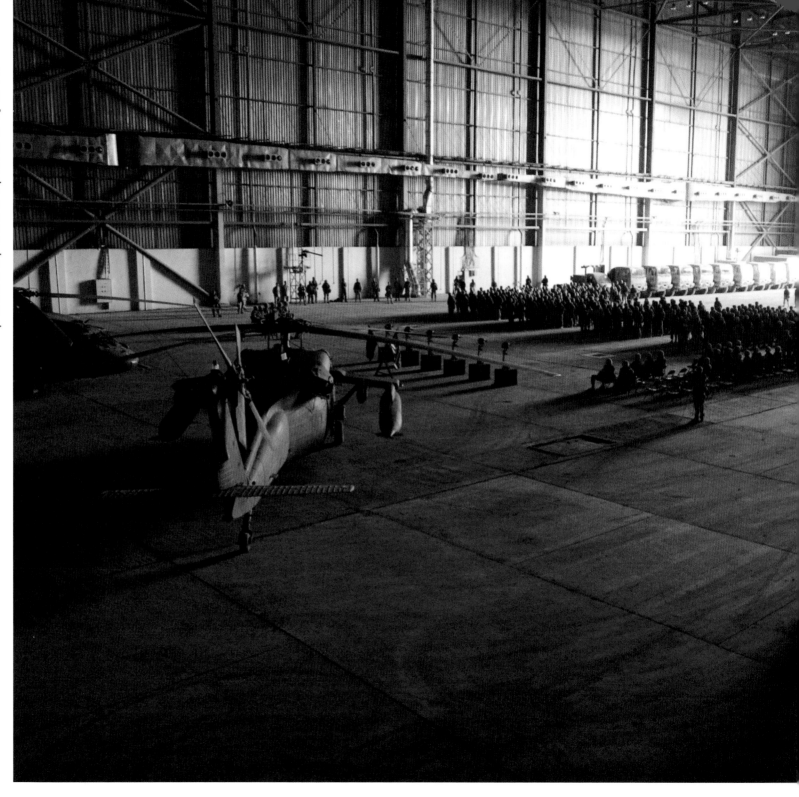

**04.12.2003**
**SERGEANT**
**FIRST CLASS**
**DAVID K. DISMUKES,**
**U.S. ARMY**
**Baghdad**
**International Airport**
Soldiers of the 3rd
Infantry Division attend
a memorial service.
Six members of their
aviation brigade were
killed when a Black Hawk
was shot down outside
Baghdad during a
nighttime supply run.
To honor aviators, a set
of night vision goggles
is added to the traditional
gun, helmet, and dogtags
that are displayed
for every soldier lost.

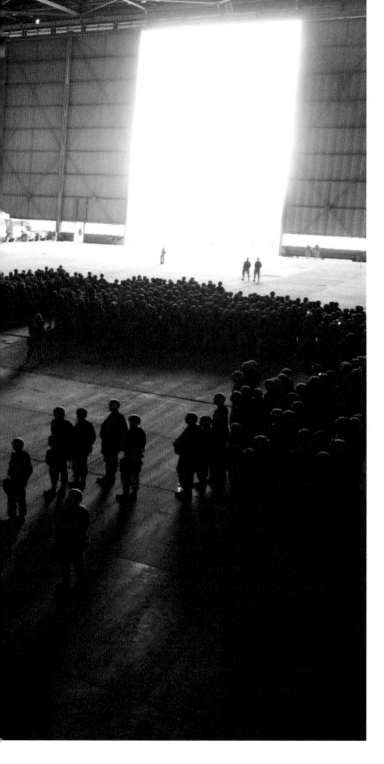

**10.2004//CAPTAIN J. PHILIP LUDVIGSON, U.S. ARMY//Mosul**
A pair of boots left by someone in the photographer's battalion
hang from an electrical wire. One of the boots is splattered with blood.

**04.12.2003**
**SERGEANT**
**FIRST CLASS**
**DAVID K. DISMUKES,**
**U.S. ARMY**
**Baghdad**
**International Airport**
After the ceremony
(left), members of
the 3rd Infantry
Division embrace each
other. "That was in the
beginning of the war,"
says the photographer.
"It was the first
time we lost that many
soldiers at once."

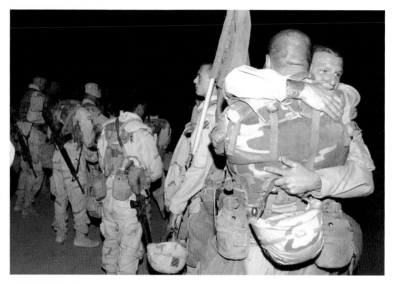

**11.26.2003**
**SPECIALIST**
**CHRIS JONES,**
**U.S. ARMY**
**Mosul**
Sergeant Major William
Plemmons (right)
embraces Captain
Joseph Anderson at a
memorial service for
Command Sergeant
Major Jerry Wilson and
Specialist Rel Ravago,
Wilson's driver, who
were ambushed and
killed three days earlier.
Anderson and Wilson
had known each other
for seventeen years.

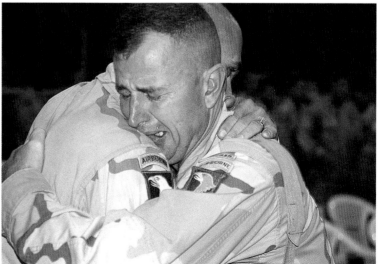

# 7. LAST SHOTS

⇩

FOR SOME FAMILIES, PHOTOGRAPHS
FROM IRAQ ARE THE LAST IMAGES THEY
HAVE OF THEIR LOVED ONES.

11.12.1984//05.09.2005
LANCE CORPORAL
TAYLOR B. PRAZYNSKI,
U.S. MARINE CORPS

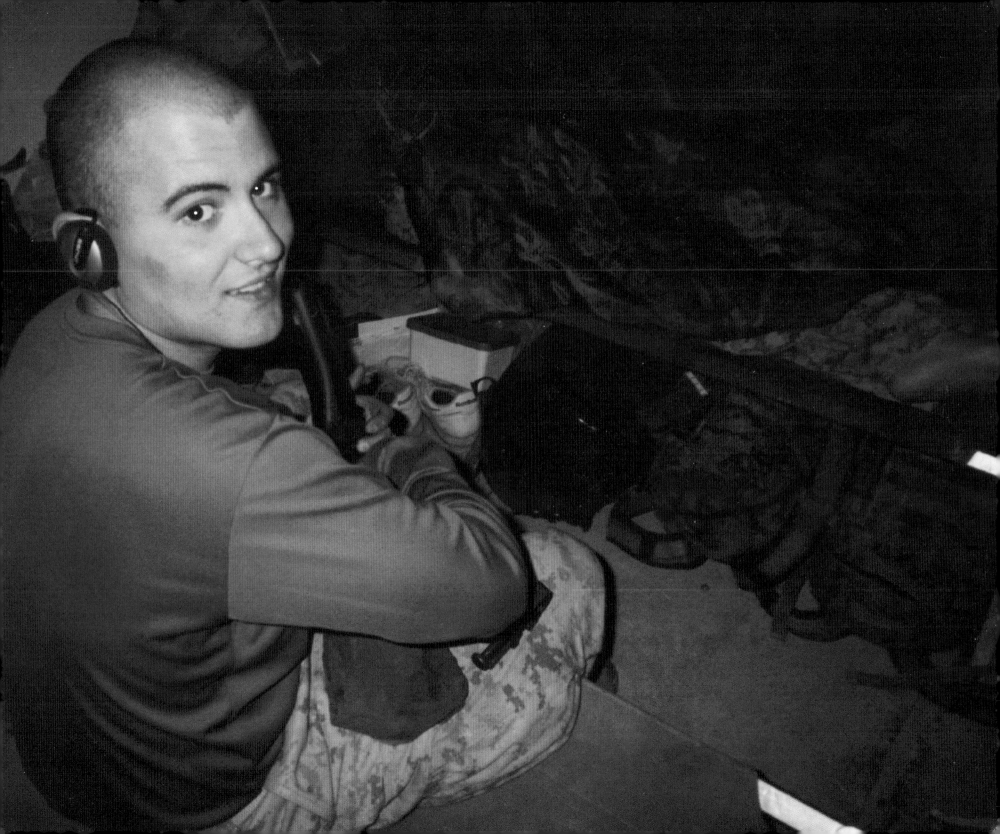

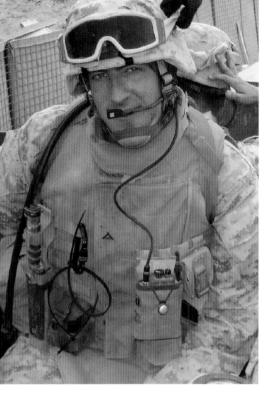

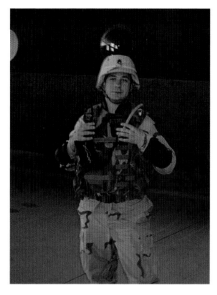

06.16.1983//07.05.2004
LANCE CORPORAL
JOHN J. VAN GYZEN IV,
U.S. MARINE CORPS

03.20.1983//05.08.2005
LANCE CORPORAL
LAWRENCE R. PHILIPPON,
U.S. MARINE CORPS

10.18.1977//04.09.2004
STAFF SERGEANT
TOBY W. MALLET,
U.S. ARMY

09.25.1982//07.05.2005
PRIVATE
ANTHONY M. MAZZARELLA,
U.S. ARMY

10.22.1981//07.05.2005
SPECIALIST
BRIAN S. ULBRICH,
U.S. ARMY

09.07.1980//04.16.2005
SERGEANT
TROMAINE K. TOY SR.,
U.S. ARMY

08.06.1981//05.16.2004
SECOND LIEUTENANT
LEONARD M. COWHERD,
U.S. ARMY

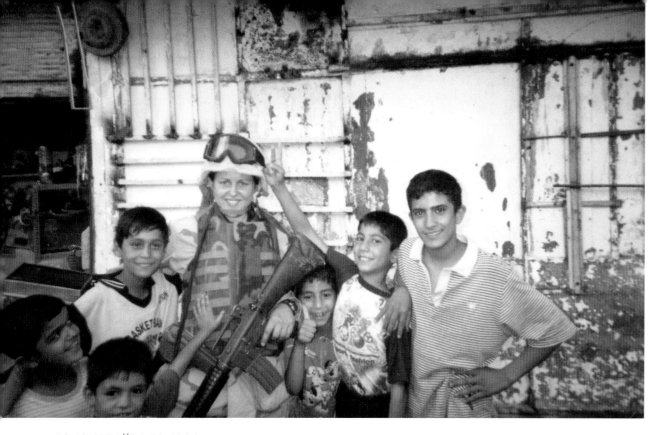

02.13.1984 // 04.09.2004
SPECIALIST
MICHELLE M. WITMER,
U.S. ARMY

11.24.1980 // 01.26.2005
SERGEANT
JESSE W. STRONG,
U.S. MARINE CORPS

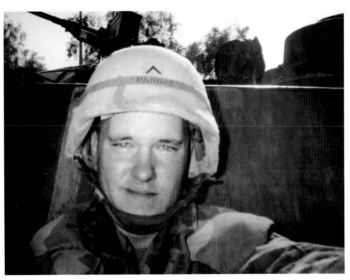

**12.12.1982**//**01.10.2005**
**STAFF SERGEANT**
**ROBERT W. SWEENEY III,**
**U.S. ARMY** *(pictured at left)*

**11.02.1977**//**06.16.2003**
**PRIVATE FIRST CLASS**
**SHAWN D. PAHNKE,**
**U.S. ARMY**

**04.22.1981**//**07.06.2003**
**SPECIALIST**
**JEFFREY M. WERSHOW,**
**U.S. ARMY**

03.27.1970//11.15.2004
CAPTAIN
PATRICK MARC M. RAPICAULT,
U.S. MARINE CORPS

05.31.2004
SERGEANT
JOSE L. GARCIA,
U.S. MARINE CORPS
**Western Iraq**
Dog tags of slain
Marines are
hung from the
pistol grip of an
M16 rifle for a
Memorial Day
ceremony in which
the names are read
to the more than
500 members
of the regiment.

"I WAS WALKING ON THE GROUND WHERE SEVENTEEN
SOLDIERS HAD JUST DIED. I FELT LIKE I WAS DREAMING.
I DIDN'T SAY A WORD THE WHOLE TIME I WAS THERE
TAKING PICTURES. NOW IF ANYTHING HAPPENS IN
IRAQ, I KIND OF WONDER, WHO'S THERE? WHO'S TAKING
PICTURES? WHAT ARE THEY THINKING?"
—SPECIALIST CHRIS JONES, U.S. ARMY

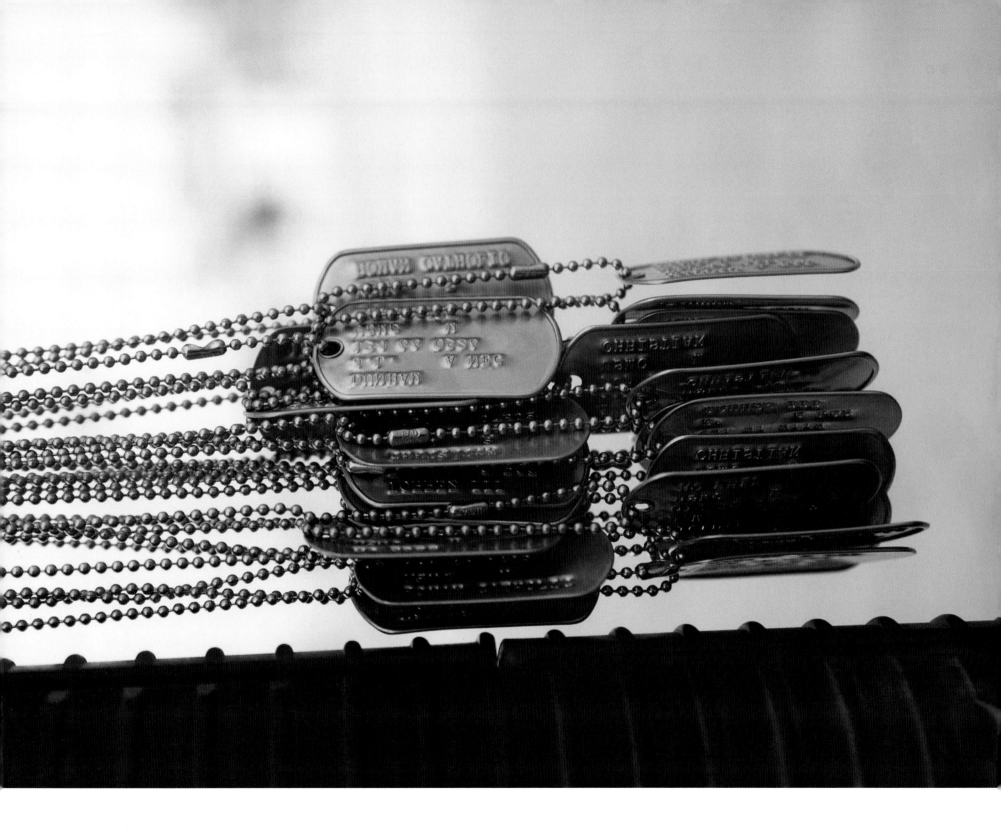

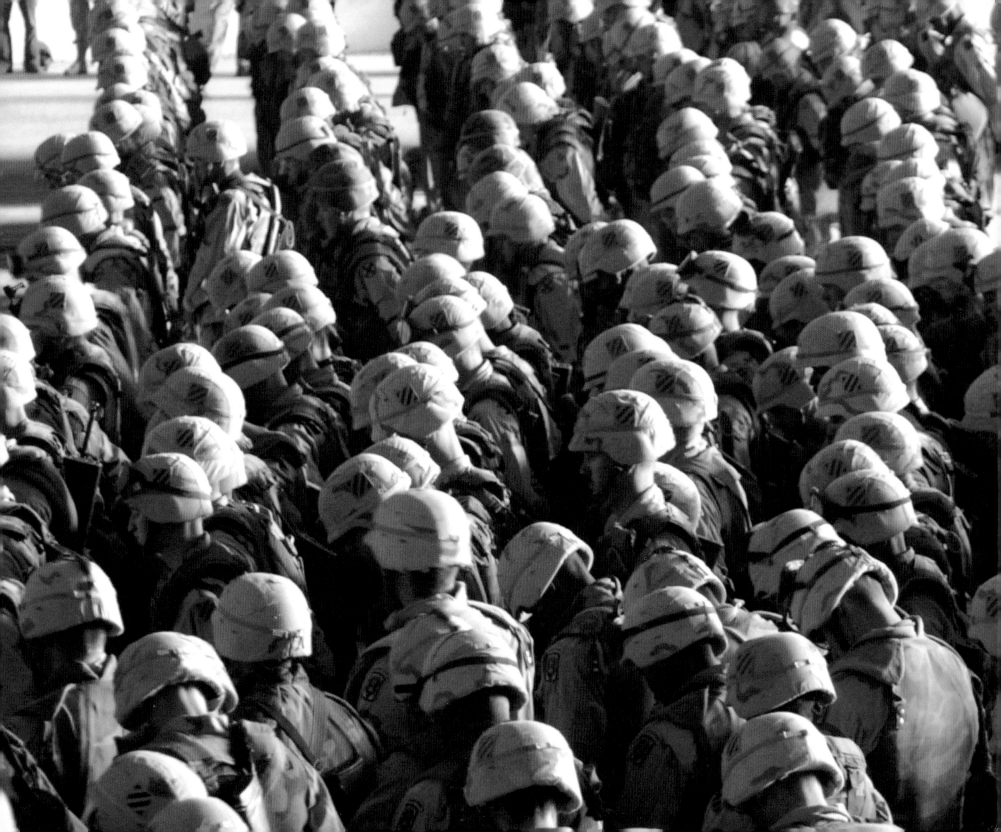

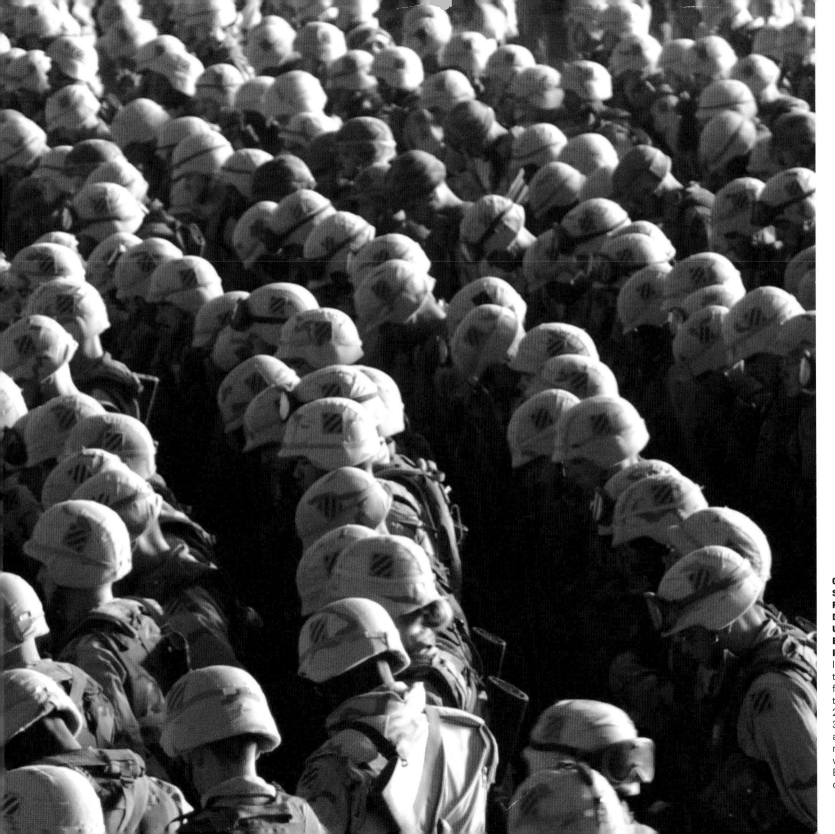

**04.12.2003
SERGEANT
FIRST CLASS
DAVID K. DISMUKES,
U.S. ARMY
Baghdad
International Airport**
In a Baghdad hangar,
three days after the
fall of the Iraqi capital,
the soldiers of the
2nd Battalion,
3rd Aviation Regiment,
at last can pause to
mourn six comrades
who were killed in a
Black Hawk helicopter
crash ten days before.

The following servicemen and women contributed photographs to this book:
Luis R. Agostini, Brien Aho, Aaron Ansarov, Cole Augustine, James Baumgardner,
Alvin Benjamin, Reynard Bibbins, Eric Bigham, Jonathon Blue, Rodney Campbell,
Cortland Carrington, Frankie Davis, Andrew DeKever, Harry J. DeLauter,
Darryl DellaRossa, David K. Dismukes, Danny Ewing Jr., Jeffrey M. Gardner,
David E. Gillespie, Edouard H. R. Gluck, Christopher Grisham, Daniel Grundvig,
Justin Harris, Travis Howell, Lynn Huber, Charles Ikins, Crystal F. James,
Chris Jones, Ryan Kelly, James Kimmerle, Richard Klinger, Larry E. LaRoe,
Christopher L'Heureux, J. Philip Ludvigson, Jerod Madden, Michael S. Madura,
Stephen D. McCane, Kelly McCay, Brent McKinney, Andrew Meyers, Murphy Miller,
Brian Mockenhaupt, Seth Moulton, Brad Nelson, Adam Nuelken, John Wayne Paul,
Stacy Pearsall, Michael Pierson, Mike Pilarte, David Pillsbury, Tori L. Porter,
Annette Ramirez, Shawn C. Rhodes, Matthew Richards, Johnny V. Rodgers,
Mark S. Shepard II, Jeremy Sivits, Colin Smith, Tom Sperduto, Edward Staystork,
Michael Teegardin, Kevin H. Tierney, Samuel Valliere, Joe Vargas, Bob Weibler,
Kristopher Wilson, Rob Woodward, Lisa Zunzanyika

→ THIS IS